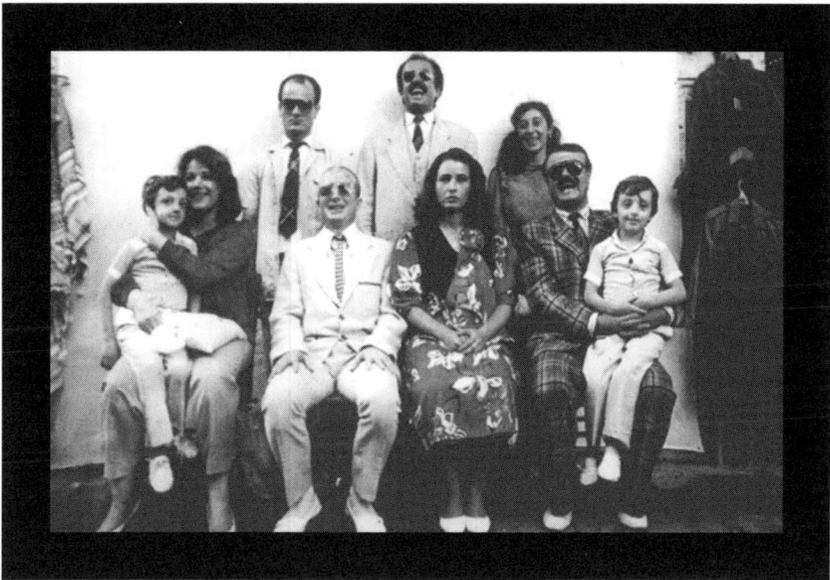

Nujum al-Nahar (*Stars in Broad Daylight*) by Oussama Mohammad, 1988.

INSIGHTS INTO SYRIAN CINEMA

ESSAYS AND CONVERSATIONS WITH CONTEMPORARY FILMMAKERS

EDITED BY

RASHA SALTI

ArtɘEast
www.arteeast.org

AIC FILM EDITIONS
RATTAPALLAX PRESS

Rattapallax Press
532 La Guardia Place, Suite 353
New York, NY 10012 USA
email: info@rattapallax.com
www.aicfilms.com

ArteEast
490 Third Street, #2
Brooklyn, NY 11215 USA
email: info@arteeast.org
www.arteeast.org

ISBN-13: 978-1-892494-70-2 (paperback)
ISBN-10: 1-892494-70-1 (paperback)

LIBRARY OF CONGRESS CATALOGING-IN-PUBLICATION DATA
Insights into Syrian Cinema:
Essays and Conversations with Contemporary Filmmakers.
Rasha Salti, editor;
ISBN-13: 978-1-892494-70-2 (pbk); ISBN-10: 1-892494-70-1 (pbk);
1. Film Studies 2. Cinema 3. World Cinema 4. Film Criticism
5. Syria 6. Middle-East Studies 7. Film Festivals 8. Arab
I. Salti, Rasha. II. Title.

First Edition: August 2006 / LCCN: 2006924084

This publication has been made possible with generous support provided by the

Ousseimi Foundation (Switzerland) Fondation Ousseimi
 Genève
and the Department for Middle Eastern and Asian Languages and
Cultures (MEALAC) at Columbia University.

CONTENTS

Acknowledgements, Editor's Note, and Translator's Note

> "*Yidrab el-hobb shoo bi thell.*" (Damn, love can be humiliating.)
> – Ghawwar el-Tosheh from the Syrian television series, *Sahh el-Nom*

Most cultural production, certainly when it takes place at the margins but admittedly in the center as well, is a labor of love. However, working on a showcase of Syrian cinema and planning to tour it in the United States of America in the bilious years between 2003 and 2006, required a whole other kind of amorous fervor. This is the time period when Syria has been identified as a pole in the "Axis of Evil," and when a US-led economic embargo governs all exchange between the two countries. It is also the time when the prevailing climate of cultural philanthropy in the US is cautiously policed for subversive engagement in the "War on Terror," and attempts to build bridges to independent cultural actors in officially sanctioned rogue nations is studiously monitored and sometimes harshly punished.

From the beginning, every step seemed like an insuperable hurdle that could not be overcome without the strategic involvement of someone who saw the great value in the success of this project and in putting together this book. Their interventions were not mere acts in a labor of love, they were genuine leaps of faith. It is miraculous that the film showcase was able to tour the North American continent and the book has been published, but neither achievement was a miracle. Miracles involve some unique, transcendental, unexpected intervention, and these two feats are the exact opposite of that. They are the proud, hard-earned fruit of the work and support of people who gave generously and stubbornly of their time, energy, wisdom and resources without once surrendering in the face of what seemed insurmountable, impossible, or politically suspect.

I ought to begin by thanking the filmmakers who were the soldiers in the trenches in Damascus and Paris: Oussama Mohammad and Omar Amiralay with whom the dream was first born; Abdellatif Abdul-Hamid whose kindness, enthusiasm and prudence unlocked doors adamantly and repeatedly slammed in my face in Damascus; Orwa Nyrabia and Diana el-Jeiroudi who worked overtime and after hours to secure a significant bulk of films

and mediate conversations between New York and Damascus above and beyond jarred diplomatic relations; and Hala al Abdalla Yakoub whose tireless keenness soothed the brunt of the thankless and impracticable.

Next, and no less important, thanks are owed to institutions and individuals without whose support neither the film program nor the book would have been possible, namely our funders, the Ousseimi Foundation (Switzerland) and the Department for Middle Eastern and Asian Languages and Cultures (MEALAC) at Columbia University. Their interventions were the genuine leaps of faith in this prevailing climate of terror, fear, and demonization. I want to express my gratitude especially to Maria Ousseimi al-Akhaoui, whose continued trust, beneficence and friendship went far beyond the call of duty in clearing clouds that darkened our horizons.

I also want to express my gratitude to all those who contributed to the publication of this book. Beginning with Ram Devineni, our publisher, whose limitless largesse, patience and good spirits rendered the tedious and nerve-wrecking after-hours labor delightful; Hilary Clark, the behind-the-scenes editor whose humbling grace, sagacity and gentleness guided the transformation of my inchoate translations into sound English; Shareah Taleghani for assisting at the eleventh hour with the translation of "Scenes from Life and Cinema," film-maker Nabil Maleh's contribution; Alisa Lebow, Basak Ertür and Nisreen Salti for their illuminating comments, their boundless diligence and friendship; and Hamid Rahmanian for lending his talents and designing the book cover.

I would also like to extend my appreciation to all those who contributed texts to this project, namely, Richard Peña, Hamid Dabashi, Oussama Ghanam, Cécile Boëx, and those who granted us permission to translate and reprint interviews: Mohammad Soueid Tahar Chikhaoui and Hala al Abdalla Yakoub. Special thanks are owed to Lawrence Wright for his trust and patience. Acknowledgements are also owed to Elias Khoury, editor of Mulhaq al-Nahar, for granting us permission to translate and reproduce Mohammad Soueid's interview with Omar Amiralay, and to Elisabetta Pomiato, director of Cinéma du Réel for facilitating the permission to translate and reproduce Hala al Abdalla Yakoub's interview with Omar Amiralay conducted specifically for the 2006 edition of the festival's catalogue.

And last, but certainly not least, are the emotional and embarrassing thanks due to my family for enduring with me the upheavals of this project, their open-ended love was my sustenance, and to my partner in this adventure and project, Livia Alexander, whose devotion, steadfastness and confidence were my strength.

Had I been the sole author of this book, I would have liked to dedicate it to my beloved and luminous Levantine Arab Ottoman, Samir Kassir who was assassinated in Beirut on June 2, 2005. He was a fervent admirer of Syrian cinema, and a friend and comrade in arms to Omar Amiralay, Oussama Mohammad and Mohammad Soueid. He dwells in my heart and inspires my conscience, his presence accompanied me faithfully every hour in the making of this project. I will never stop seeking his approval, nor will I ever be without the exaltation of his smile.

This book was first conceived to be the conventional catalogue of the touring film program. Considering the paucity of funds and the impossibility of filmmakers accompanying their films throughout the tour, we hoped it would help in informing the audience's engagement with the films and as such, it was intended to give voice chiefly to the filmmakers, and less so to critics or academics. It includes texts by those seasoned filmmakers who have earned recognition, praise and awards in Syria and worldwide for their stellar achievements and whose works were included in the showcase. It slowly transformed into a book project after we recognized the scarcity of books and primary sources on Arab and Syrian cinema in English. A defining conversation with Ram Devineni, who became the book's publisher, sealed our determination.

The selection of writings presented here was made in concert with the filmmakers; they were invited to propose texts they deemed important in representing their views on their craft, or propose interviews they deemed particularly successful in fulfilling that task. Because filmmakers are not writers or academics, ultimately the collection of texts is diverse and unconventional; while they do not really fit the canon of essays or structured reflections by filmmakers, they convey more truthfully and acutely the state of mind, the poetic imaginary, the cultural and artistic idiom and the emotional universe of their authors. In this regard, and considering that (regretfully) a large number of practicing filmmakers have not been included, this book by no means purports to be a comprehensive primer on Syrian cinema. Admittedly, the emerging generation of Syrian filmmakers, whether living and working in Syria or elsewhere in the world, has not been given a voice

(again, regretfully) in this book. It is my hope that our humble collective effort will spark an interest in Syrian cinema and inspire the publication of an all-inclusive conventional work. This book is meant as a modest but groundbreaking step in breaking a silence and initiating a conversation between filmmakers and audiences, worlds removed.

The scarcity of funds was such that I had to translate all the texts from Arabic and French. That too was a labor of love, and I hope my affection shines through to the authors and readers and redeems errors in judgment or misunderstandings on my part. Amongst the most arduous challenges was reconciling the infelicitous and incorrect translations of institutions and film titles conventionalized in Syria with more correct and faithful formulations in English. So for example, while al-Mu'assassah al-'Ammah li al-Sinama, the state institution entrusted with film production and distribution in Syria, should translate as the General Establishment for Cinema, or the General Organization for Cinema, it is widely known as the National Film Organization. I have opted for the latter formulation only to avoid misguiding research. Also, sometimes film titles are given different English translations, for example, Abdellatif Abdul-Hamid's film *Rassa'el Shafahiyyah* appears alternately in English as *Oral Messages, Verbal Messages* and *Verbal Letters*. In this case, I have opted for *Verbal Letters* because it is the most faithful translation of the original Arabic title.

Between the labyrinthine and obscurantist drudgery of negotiating with public institutions attached to mammoth state structures on one end, and the sinister zealotry of the "War on Terror" on the other, this labor of love was put to the test too often not to come close to humiliation. Surrendering to the pull of either of these dark forces was never an acceptable option however, not to me, those involved in the project and certainly not to the filmmakers. Their entire lives have been spent in defying surrender and they set the example of ingenuity, integrity, tenacity and hopefulness, with their cinema and in the conduct of their everyday lives. Armed with their solidarity and commitment, the tragicomic, almost epic, saga of the film showcase was crowned with a happy end. The moral of the story is one almost never found in Syrian cinema, namely, that love can conquer all, and that it is not humiliating, rather, it is humbling.

FOREWORDS

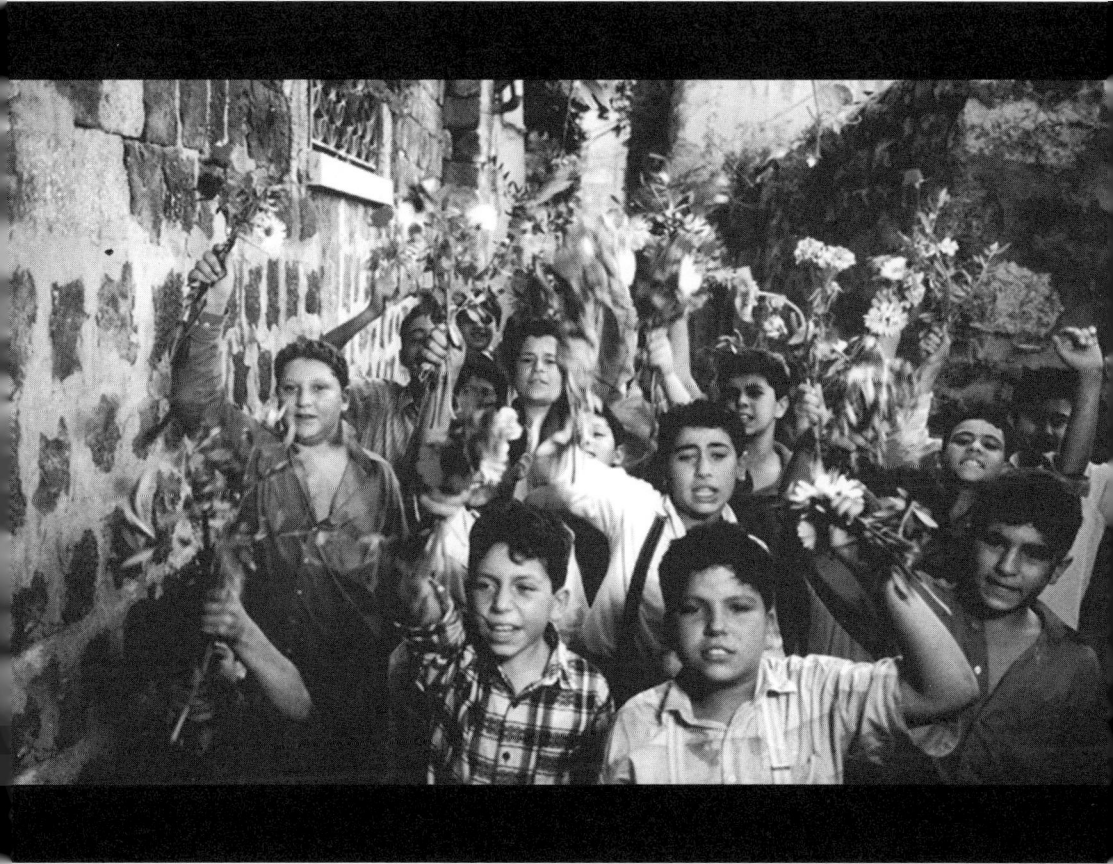

Al-Tirhal (Exodus) by Rémond Boutros, 1997.

This book accompanies a comprehensive showcase of Syrian cinema, organized by ArteEast and curated by Rasha Salti, which will tour North America this year. Highlighting the outstanding achievements of Syrian cinema, the showcase and book have been long in the making. Both are the product of three years of arduous work and numerous trips to Damascus and elsewhere, collecting and reviewing films, interviewing filmmakers, and making connections. ArteEast is very proud to see the fruits of this labor of love come to life.

The goal of this program, and by extension this book, is to support and promote an outstanding cinema and a group of very talented and dedicated filmmakers, who at times work under the most dire circumstances. In order to generate a broader discussion and contextualization of cinema, we believe that it is not enough to focus on screenings alone. Rather, we hope that this humble book will provide readers with additional insights that exceed the image and sound of film, reaching into the realm of the written word with critical commentary and personal reflection from those most intimately acquainted with Syrian cinema.

Within the broader context of Arab cinema, Syrian filmmaking is rather distinct. With its strong emphasis on formalism, aesthetic composition and symbolism, it is unlike any other cinema produced in the region. A cinema strongly influenced by the training of a whole generation of filmmakers in the former Soviet Union in the 1970s, it stands apart from contemporaneous Egyptian film's neorealism with its gritty on location shooting in the streets of Cairo or, alternatively, the national mobilizing force propelling Palestinian film production. While Egyptian, Palestinian, or for that matter Moroccan and Tunisian cinemas all engage to various degrees with burning political and social issues, Syrian classics, such as Oussama Mohammad's *Nujum al-Nahar* (*Stars in Broad Daylight*, 1988) or Abdellatif Abdul-Hamid's *Layali Ibn Awah* (*Nights of the Jackals*, 1989) are striking in their poetical examination of a nation's collective memory past and present.

The emergence of new technologies and the democratization of media are empowering a new generation of filmmakers throughout the Arab world. While Syrian filmmakers haven't traditionally had the same access to these developments as their peers in other Arab countries, these advances will undoubtedly have a lasting impact on future film production in Syria, as more youngsters turn towards filmmaking as a profession and an art. The establishment of new regional film schools in places such as Amman, Dubai and Cairo are surely positive steps in that direction. We hope that ArteEast's presentation and critical discussion of this remarkable cinema will serve to not only promote its visibility worldwide, but also inspire those young directors making their first steps in filmmaking.

The program would have not been possible without the devotion, dedication and utmost professionalism of program curator and book editor Rasha Salti. I would like to express my deepest gratitude to her for standing up to the many curveballs thrown our way. This book is a testament to her dedication and expertise.

I first discovered Syrian cinema for myself in the early 1980s. Back then, Syrian films and I were both newcomers to international film festivals such as Rotterdam and Cannes. Samir Zikra's *Hadithat al-Nusf Metr* (*The Half-Meter Incident*, 1981) impressed me with its sly humor and candor about the June 1967 War; but what really caught my attention — and many other people's too — was Mohammad Malas's *Ahlam al-Madinah* (*Dreams of the City*, 1983). Exquisitely made and directed, the film offered one of the most skillful weavings of personal story and historical consciousness that I had ever seen. Over the next few years Syria would reappear at festivals with works such as Abdellatif Abdul-Hamid's *Layali Ibn Awah* (*Nights of the Jackals*, 1989) and Oussama Mohammad's *Nujum al-Nahar* (*Stars in Broad Daylight*, 1988), but then in 1992 came Malas's second film, *al-Leyl* (*The Night*, 1992). Simply a masterpiece, *The Night* seemed the perfect next step beyond *Dreams of the City*; its innovative blending of personal and historical narratives was even more provocative, and his style was further enhanced by various surrealist touches. Clearly, something was going on in Syrian cinema.

Happily, in 1995 I had the opportunity to visit Syria in the course of watching films for what became the Film Society's "Centennial of Arab Cinema" (co-curated with Alia Arasoughley and August Light Films) in November 1996. Beyond having the chance to see again friends such as Mohammad Malas, Omar Amiralay and Oussama Mohammad (both close collaborators with Malas on *The Night*, as well as fine filmmakers in their own right), I also got to see and review a large portion of Syrian production from the mid-1980s to the mid-1990s, and to discover the impressive breadth that characterized that cinema.

What is immediately striking about Syrian films is simply how well made they are. Many of the filmmakers — Malas, Oussama Mohammad, Rémond Boutros, Riyad Shayya, among others — studied filmmaking at the Russian State Institute of Cinematography (VGIK), the great Soviet film school in Moscow. All are fine exemplars of the VGIK style, an approach that opts for carefully composed, almost iconographic shots — the opposite perhaps of the more fluid, hand-held style adopted widely after the explosion of the French New Wave. For their narratives, Syrian filmmakers often rely on allegory, the microcosm of a single family

serving as stand-in for the nation. The films also don't shy away from making big statements. Historical events are never far off screen, and they often permeate even the most intimate personal relations. With an annual production never exceeding more than one or two feature films, many filmmakers are forced to wait years between projects (fifteen years passed between Oussama Mohammad's first and second features); consequently, filmmakers are intensely aware that each film, each shot, really has to count.

The films selected for this Syrian film series cover a wide range of subjects. Some offer highly critical views of their own government and society; other films take positions on subjects such as the Palestinian issue that are rather controversial. Working under what can only be described as very difficult conditions — ranging from the watchful eyes of the censors to the lack of a real industrial infrastructure for film production — Syrian filmmakers have nevertheless managed to create a powerful and provocative cinema, films brimming with both personal expression as well as perceptive social analysis that are often startling in their courage and commitment.

I f one were to see a few random, but fairly representative samples of the masterpieces of Syrian cinema — say, Mohammad Malas's *Ahlam al-Madinah* (*Dreams of the City*, 1983) Oussama Mohammad's *Nujum al-Nahar* (*Stars in Broad Daylight*, 1988) Abdellatif Abdul-Hamid *Layali Ibn Awah* (*Nights of the Jackals*, 1989) or Omar Amiralay's *Tufan fi Bilad el-Ba'th* (*A Flood in Baath Country*, 2003) — one could not help imagining a rich and variegated cinematic culture from which these films have emerged. But what is astonishing about Syrian cinema is the very limited (outright scarcity) national cinematic production in Syria. Every one of these films, and a few others like them, constitute their autonomous cosmovision at the very same time that they are telling their own stories.

Syrian cinema is perhaps contemporary Arab cinema's best kept secret. Endemic censorship, scarcity of annual production, an institutional absence of international distribution systems, the vagaries of a lazy and cumbersome governmental agency in charge of these cinematic gems, have all come together to keep much that has happened in Syrian cinema over the last quarter century hidden from global attention. In the past two decades, television productions from Syria have become exceedingly popular in the Arab world, breaking the monopolistic hold of Egyptian production and slowly draining attention and resources from film production. The result is a particular mode of national cinema defined as much by the paucity of its representative samples as by its distinct and pronounced visual vocabulary.

The cinematic influences on Syrian cinema are not too difficult to trace. In a casual conversation with a number of leading Syrian filmmakers in July 2004, following a crash course of watching their work, I recognized an extraordinary resonance with Soviet formalism. Similar influences might be found in locations as diverse as African, Central Asian, and Afghan cinema — places, in other words, once prone to the cultural influence of the former Soviet Union. What is perhaps most evident in Syrian cinema, adjacent to these resonances of Soviet formalism, are the remnants of successive generations of Arab nationalism, with particular reference to the Palestinian predicament. This, however, does not give as much a political disposition to Syrian cinema as it does induce an aesthetic of

self-reflective meditation. Watching Syrian cinema is like stumbling upon a hidden treasure of visual meditations entirely unexpected in one's visual imaginary.

What Syrian cinema seems to lack, however, is the global audience it has long richly deserved. In the absence of that audience, Syrian cinema has been hibernating within itself and self-reflecting on its own internal terms — like a rare and surreal object imagining itself in a mirror it wished it had. The effective absence of a variegated audience has thus translated into an unconjugated visual lexicon. There is something discrete, inaudible, invisible, and even mute about Syrian cinema — all for the lack of its having been seen.

What these precious few Syrian films do propose, however, are fault lines in the very idea of "world cinema." For here is the constellation of a magnificent œuvre of exquisite cinema — with as varied stylistic modulations as between Oussama Mohammad and Mohammad Malas — that in the absence of any significant global recognition has been engaged with a cinematic cosmovision entirely its own. It is easy to simply say the world is that much poorer for having yet to recognize Syrian cinema, but the problem that Syrian cinema poses for the notion of "world cinema" is the vacuous disposition of its invention at lucrative and trend-setting film festivals in Europe. Here is a cinema that is yet to be incorporated into "world cinema," and yet it speaks and projects a language worthy of worldly attention and a global audience.

The regret one might have is that Syrian cinema, representing a rich and diversified national cinema, is finally acknowledged outside the Arab world at a time when national cinemas are losing their distinct visual vocabularies to a vacuous globalization that manufactures aesthetic consent with the same rapidity that it dismantles it. Perhaps, one might argue, so much the better for the timeliness of this discovery, for we are all getting to see Syrian cinema at a particular juncture when as a defining category "national cinema" has all but lost its historic resonances and yet the distinct disposition of Syrian cinema demands a particular theoretical attention. What the particulars of that theorization might be is precisely the reason why we need to look at these films and ponder their aesthetic and political disposition.

ESSAYS

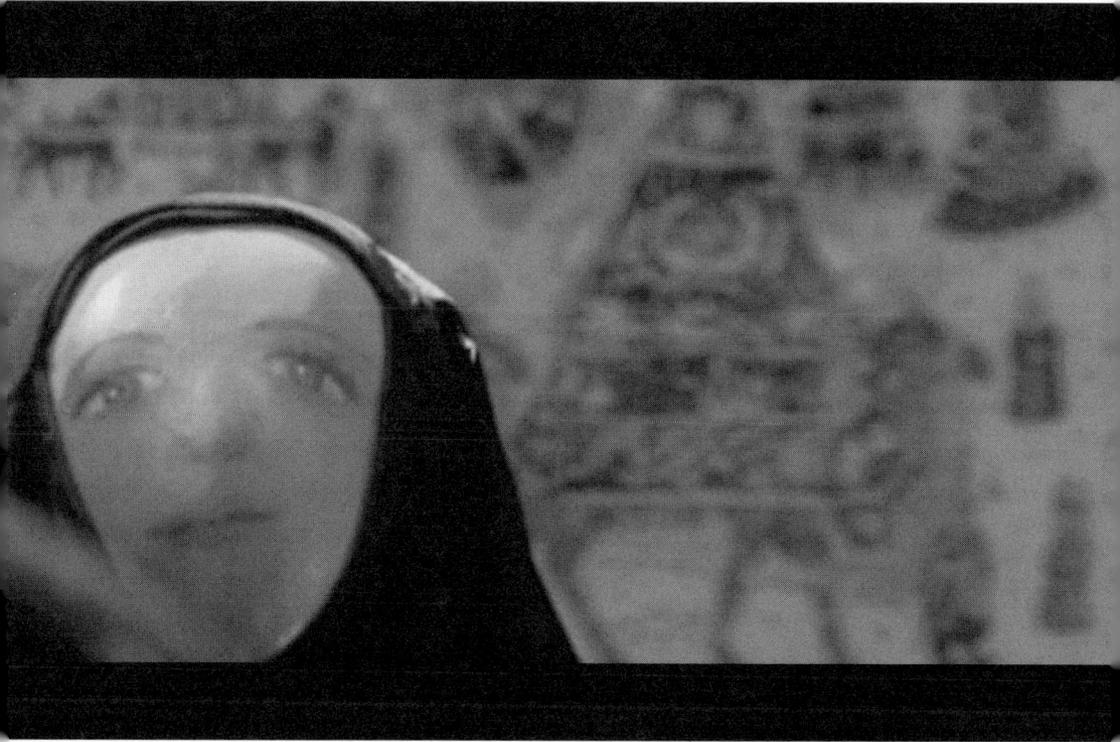

Al-Qarura (The Pot) by Diana el-Jeiroudi, 2004.

CRITICAL NATIONALS:
THE PARADOXES OF SYRIAN CINEMA

To Syrian film critics, historians of cinema and filmmakers alike, to speak of Syrian cinema, as a national cinema, smacks of hubris. Invariably, one is met with a retort that is some variation on "there is no Syrian cinema, there are only Syrian films and Syrian filmmakers." In Meyar al-Roumi's *Un Cinéma Muet* (*A Silent Cinema*, 2001), a documentary that interrogates the government's allocated place to films and film production in contemporary social life in Syria, Syrian film critic Bandar Abdul-Hamid reiterates that claim. He speaks from the privileged position of first-hand, insider knowledge. If, objectively, Syrian cinema does not bear any of the attributes associated with a national cinema, an industry, or a sector in production of culture, when one views a significant selection of Syrian films from the past three decades, it is nonetheless very difficult to discount the cogent body of work produced by Syrian filmmakers as a mere collection of "Syrian films and Syrian film-makers." That body of work performs the role of a national repository of aspirations and sentiments, the record of lived experience, collective memory and the realm where the saga of collective national traumas and shared canons find expression, representation and signification. This is the first paradox.

Nothing about the structure of film production, distribution, dissemination or the social life afforded to these films suggests that there is an industry to speak of: film production is almost entirely controlled by the state, resources are scarce, and the output is as humble as one or two films per year. Efforts at international and regional distribution for exhibition and dissemination at best are dismal and mostly non-existent, the local network of movie theaters, whether in the capital or the rest of the country, is gravely dysfunctional. When Syrian films travel to film festivals worldwide, they almost always garner critical acclaim and awards, but all initiatives for their screening originate from outside their country. Inside their country, Syrian films are barely known. The national repository of aspirations and sentiments may be unabashedly genuine, piercing with honesty and enchanting with creativity, but they are remembered by a shy minority of stubborn cinephiles who have sought them out against the odds. This is the second paradox.

Amongst all fields of cultural production, Syrian cinema is the premier realm of artistic expression in contemporary Syria, where a lucid, intelligent and subversive critique of the state has forged a site for the manufacture of meaning and image. The remarkable feat accomplished by Syrian filmmakers is how they have succeeded in carving out an independent, critical and often subversive cinema under the sponsorship of a vigorous state ruled by a single party actively invested in suppressing dissent and coercing an official dogma. This is a state-sponsored cinema at the furthest possible remove from a cinema of propaganda or a cinema that serves to anchor and disseminate the tenets of the state's hegemony. This is the third paradox of Syrian cinema.

These three paradoxes are perceptible to those who begin to engage with Syrian cinema more closely. But they do not account for the surprise of those who come to encounter Syrian cinema for the first time and marvel at the cinematic gems, the plurality of genre, approach and voice, the mastery of the craft. Freed from the debilitating demands of the profit-generating creed of market-driven production, public funding has enabled Syrian cinema to revel as a medium of artistic expression in its own terms. What is often referred to as "Syrian cinema" effectively refers to the productions from the 1970s up to today and mostly means films of the "cinéma d'auteur" (produced from the 1980s until now). Thus is Syrian cinema a national cinema made up of profoundly subjective and independent-minded auteur films. This is the fourth paradox.

This essay will tell the story of Syrian cinema and attempt to disentangle these paradoxes. It will focus primarily on filmmakers who have started working since the 1980s, and conclude with a brief allusion to an emerging generation of filmmakers who are marking a sharp turn in this field of cultural production. Their work, although still in its budding stages deserves attention; it heralds a sweeping trend of radical change in film-making in the Arab world, but also across the region.

The Making of a National Cinema: A Cinema to Call their Own

Since the early 1960s the Syrian state has been actively invested in and held monopoly over film production, but the history of cinema in Syria extends much further back in time. The first film to have ever been screened in Syria took place in a café in Aleppo in 1908. The Ottoman administration established the first movie theater in Damascus in 1916. It was inaugurated by the infamous Ottoman governor Jamal Pasha, but burned down barely a month later. By the time the colonial French mandate administration took over Syria, a number of movie theaters peppered Damascus's urban fabric.

The story of film production began in 1928, rehearsing the biography of film production in the Arab world, with Egypt holding the vanguard, pioneering role. By 1928, film houses and theaters were familiar to most urban centers, and attending film screenings had become a familiar social practice to the elite urban bourgeoisie. Historians of Syrian cinema cite the silent black and white feature *Al-Muttaham al-Baree'* (*The Innocent Suspect*, 1928) as the first Syrian film, specifically because it was produced entirely by Syrians. Only a year earlier, the first film had been produced in Egypt. *The Innocent Suspect* was thought of then, and is remembered now, as one of the many attempts by a nascent nationalist intelligentsia to defy the cultural dominion of French rule and forge a national culture. The film was written, directed and filmed by Rashid Jalal, and produced by him with Ahmad Tello, Ayyoub Badri and Mohammad al-Muradi (who also comprised the cast of the film), under the auspices of the first film production company they formed, Hermon Film. Inspired by real events, it told the story of a band of thieves and thugs who terrorized the neighborhoods of Damascus. Working against insuperable odds to make the film, they regarded their labor as part and parcel of the struggle for national liberation. The artistry and technical command of *The Innocent Suspect* could not possibly match the numerous French productions screening in cinema houses at the time, and yet it was received with euphoria by the general public precisely because it was emblematic of the desire for independence and sovereignty. The French authorities in Syria — as the British authorities in Palestine — were apprehensive about the emergence of an indigenous cinema and tried, in vain, to prevent the screening.

Sadly, almost immediately after the release of the second black and white feature produced in the country, *Tahta Sama' Dimashq* (*Under the Damascus Sky*, 1934), Syrian cinema houses were conquered by Arabic-speaking Egyptian productions. *Under the Damascus Sky* was a silent feature that had been in production for two years and was widely publicized in the local press. Produced by Helios Films (another film production company established by Rashid Jalal in 1931), it was written and directed by Ismaïl Anzour. But it was overshadowed completely as its release coincided with the opening of the first Egyptian musical talkie, *Unshudat al-Fuad* (*Song of the Heart*, 1932) featuring a cast of prominent stars and singers. *Under the Damascus Sky* turned out to be a crushing commercial failure and was soon banned by the French mandate authorities. The production had exceeded initial budget allowances, but most punishing was a penalty fee extracted by the French administration for the production's use of a musical piece without paying copyright dues.

At a time when Arabs had come into a collective consciousness of themselves in the tenor of an Arabist worldview, articulating their right to self-determination and sovereignty, and began to fight the onslaught of European colonial designs as a cultural group bound in solidarity by history and culture, Egyptian cinema was widely perceived as a cinema all Arabs could proudly claim as their own. Syrian nationalist fervor waned amongst the handful of producers, directors and actors, and under the lure of quick profits local entrepreneurs and financiers quickly transformed into importers and distributors of Egyptian productions. Like their Lebanese and Palestinian kin, Syrian talents migrated to Cairo and integrated into its booming film industry.

In 1947, a year following Syrian independence, Nazih Shahbandar established a film production studio furnished with equipment that he had mostly manufactured or modified and improved himself. He produced the first Syrian talkie, *Nur wa Thalam* (*Light and Darkness*, 1948), a year later, written by Mohammad Shamel and Ali el-Arna'ut. Its cast of actors would later shine and acquire fame as Syrian cinema's film stars (Rafiq Shukri, Yvette Feghali, Anwar el-Baba, among others).

Local film production took off at a more regular pace by the middle of the 1950s, in the hands of private financiers and producers. At that time, it was mostly regarded as a commercial venture in pursuit by box-office receipts. Artistically, these productions took their cues from the commercial successes of the wealthier studios in Egypt. But returns were uneven as the problem of distribution proved an arduous challenge. By the mid-1960s significant profits were generated as the comedic duo Doreid Lahham and Nuhad al-Qala'i transposed their widely successful television serial (it was not called situation comedy then) into film. Beginning with *'Aqd al-Lulu* (*Necklace of Pearls*) in 1965, the duo produced numerous films, often at the rate of two per year. There was little creative effort invested in these burlesque comedies, tirelessly and faithfully crafted according to a simple single formula, and yet they garnered significant popular success.

Al-Mu'assassah al-'Ammah li al-Sinamah, or the National Film Organization, was instituted in 1963 as an independent arm of the Ministry of Culture to oversee the production, distribution, import and export of films in Syria. The immediate impetus for the establishment of the institution came from the demands of a politicized intelligentsia and groups of artists who expected their state to foster artistic production. Their aspirations and expectations were organically embedded in the prevailing ideological mindset of the Ba'th Arab Socialist Party that had seized power that year. The National Film Organization repatriated some of the Syrian talent that had migrated to Egypt and summoned kin Arab nationals to assist in the establishment of a national structure for film

production. In the context of a world polarized by the Cold War, and against the backdrop of humiliation and anger felt after the defeat of Arab armies in the war with Israel in 1967 (remembered bitterly as *Naksa*) and the loss of the territories of the Golan Heights to Israeli military occupation, the Syrian state became actively invested in monitoring and policing cultural production as well as disseminating its official discourse with vigor. Syrian society had long witnessed an active and plural political life, with a multitude of parties on the left and on the right competing for power and mobilizing constituencies. Since independence from French rule however, the country had also endured a series of coups d'états and regime changes. The Ba'th party's ideological proclivity for virile coercion of public discourse found legitimacy in the country's recent experience with political turbulence, allowing it to gradually marginalize, demonize and silence political dissent, democratic pluralism, and a critical engagement with authority. In 1969, the National Film Organization was granted a strict monopoly over production, distribution, import and export of films, while private ventures wilted until they became nearly extinct.

The prime force that had fueled private entrepreneurs to invest in film production — profit-making and box-office receipts — was suddenly rendered insignificant as the state effectively became the sole producer guided by an entirely different creed, namely, to invest in crafting a national cinema. Film scripts once weighed by accountants and gauged against the measure of a balance sheet were now weighed by a censorship bureau and gauged against the dogma of a regime.

Filming the Nation

The Syrian intelligentsia at the helm understood the power of the medium. On the one hand, cinema was induced to play the simple and straightforward role of rescripting the nation, the country, its geographical diversity, its folk and their lore. Filmmakers were dispatched to the far corners of the country to celebrate in film, the beauty of the landscape, the wisdom of its people, their local particularisms, their crafts and customs. Filmmakers were also expected to document — and hail — the great achievements of the state, the construction of roads and highways, dams, the impact of agricultural reform, the provision of health services, housing and education. Thus the organization initially produced documentaries in large numbers. Syrian television had begun broadcasting by 1963, it promoted the production of documentaries as well. Film clubs were set-up in cities throughout the country and the National Film Organization oversaw their circulation.

The Arab world — masses and intelligentsia alike — were then gripped by revolutionary fervor, articulated in the vocabulary of socialism conjugated alternately with

Al-Makhdu'un (The Dupes) by Tawfeeq Saleh, 1972.

idioms of pan-Arab nationalism or local nationalism: Egypt in 1952, Iraq in 1958, Algeria in 1962 and Syria in 1963, but also, further afield Tunisia, Libya, Yemen, and Oman. The loss of Palestine and the dispersal of its people, the defeat of the Arab armies (first in 1948 and a second time in 1967), were endured with humiliation and anger, fueling revolutionary fervor. Syrian cinema was willed as a cinema that was socially and politically engaged, it was not crafted to entertain, it was impelled by a duty to crystallize the aspirations of the people and to represent their struggles.

After the Palestinian *Nakba* (Catastrophe) of 1948, Syria accepted expelled Palestinians as refugees to settle in camps around Damascus. After the defeat of 1967, or the *Naksa*, residents of the Golan Heights were themselves displaced overnight and turned into refugees. Filmmakers, like other artists and popular opinion at large, were captivated by the plight of their Palestinian brethren. The Syrian state had plural stakes in sponsoring the documentation of the tragedy of Palestine and used the medium of cinema to raise awareness in the world of that historic miscarriage of justice. The output of documentary films is impressive, amongst the most accomplished are those directed by Iraqi filmmaker, Qays al-Zubeydi. His films, to name two, *Bai'dan 'an al-Watan* (*Far from their Country*, 1970) and *Shahadat al-Filastinyyin fi Zaman al-Harb* (*Testimonies of Palestinians in the*

Time of War, 1972) retraced, respectively, the lives of Palestinian children in refugee camps and the impact of 1967 on their parents. All these documentaries circulated throughout the Arab world with resounding impact.

By 1965, Palestinian political resistance movements emerged, reclaiming political agency and espousing armed struggle as the path to liberation. Palestinians then too cast their calling in the vocabulary of a transformative, regenerative political idiom, their movement of liberation became a revolution, and the Palestinian refugee, jolted from forgetting and misery was reborn as a freedom fighter, a *fida'i*. He was fearless in the face of death and unrelenting in his pursuit to redress injustice. He would coin a trope, a motif that would permeate a universe of shared canons throughout the Arab world. Everyday people, illiterate peasants, the poor and the *wretched of the earth*, were now at the core of the national imaginary in contrast with the sophisticated, educated urbanites who led the "national" struggle for liberation. In documentary and in fiction, Syrian cinema took it upon itself to sing those unsung heroes, the faceless and nameless martyrs of tyranny.

Making Heroes from "the People"

The first long fiction feature produced by the National Film Organization, entitled *Sa'eq al-Shahinah* (*The Lorry Driver*, 1967) told the saga of a poor man who tried to make a living as a truck driver and faced the greed of the company's owner and his abusive labor practices. Its author, filmmaker Poçko Poçkovic, who hailed from Yugoslavia, had joined the National Film Organization and lived in Syria. The film featured a narrative familiar to a society gripped by a political system that purported to redress social inequities. The central protagonist epitomized a small village working class hero, overcoming awesome adversity to pursue a life of dignity. Long feature fiction films also began to transcribe into cinema the novels of renowned Arab authors, today considered the great classics: Ghassan Kanafani, Haydar Haydar and Hanna Mina.

The ensuing productions garnered wide popular acclaim, to mention two, Nabil Maleh's *al-Fahd* (*The Leopard*), based on a story by Haydar Haydar, released in 1972, and Tawfeeq Saleh's *Al-Makhdu'un* (*The Dupes*, 1972). *The Leopard*, Maleh's first full-length feature, told the story of a poor peasant jailed after his land is confiscated by wealthy landowners. He escapes from prison and fights back. Taking up arms, he hides in the mountains and becomes a hero fighting against injustice and the abuses perpetrated on villagers in the region. While he wins their sympathy, he is unable to mobilize them to join him and remains alone. Eventually he is betrayed and hung in a public square to set an example. Film critics saw a lonely hero in the effigy of Che Guevara, but his figure also

Al-Fahd (*The Leopard*) *by* Nabil Maleh, 1972.

strongly evoked the predicament of Palestinian peasants, betrayed by landowners and forced into a struggle with Israeli colonists. Like the hero of *The Lorry Driver*, the hero of *The Leopard* was forged in a cultural universe where the wretchedness of Arabs became conflated in symbol and signification with the actual tragedy of Palestinians. The tragic but real heroes of the contemporary Arab world, galvanized with the call for revolution, were no longer the nationalist urban intelligentsia, but poor simple peasants, whose unwavering commitment to challenge injustice was intuitive and fearless. *The Leopard* was awarded first prize at the Locarno Film Festival, and the film's popularity remained unmatched until the late 1980s and early 1990s, with Abdellatif Abdul-Hamid's first two features, *Layali Ibn Awah* (*Nights of the Jackals*, 1989) and *Rassa'el Shafahiyyah* (*Verbal Letters*, 1991). Nabil Maleh's second feature, *Baqaya Suwar* (*Fragments*, 1979) also told the story of poor peasants captive to the tyranny of feudal landowners and poverty.

The National Film Organization had summoned Arab filmmakers to collaborate on productions in Syria. Most renowned was Tawfeeq Saleh, an Egyptian filmmaker, also one of the stellar figures associated with the trend of neo-realism in Egyptian cinema after the 1952 coup d'état, with landmark works such as *Yaomiyyat Na'eb min al-Aryaf* (*Diary of a Country Prosecutor*, 1968), *Darb al-Mahabil* (*Fools' Alley*, 1955), *Siraa' al-Abtal* (*The*

Struggle of the Heroes, 1962), *al-Mutamarridun* (*The Rebels,* 1968). Saleh's influence was defining for generations of Arab filmmakers. He adapted Ghassan Kanafani's canonical novella, *Men in the Sun,* in the film *The Dupes.* In a survey a decade ago, *The Dupes* was cited by a widely polled Arab audience as one of the top ten most important films in the twentieth century. The film told the story of three young Palestinian men captive to a bleak predicament in refugee camps, who decide to join the droves of Palestinians — and other Arab youth — to go and find their fortune in the booming, labor-hungry economies of the Gulf countries. Entry to these countries was then very cautiously policed. Without visas, the three men had no option but to smuggle themselves across the border. They hide in an emptied metal water barrel, in the back of a truck shuttling goods. Presuming the processing of papers at the border would only take ten or fifteen minutes, the truck driver covered the barrel at the crossing point. The story turns to tragedy when the guards at the crossing drag their feet and the truck is parked in the sun for much longer than a dozen minutes. The three young men asphyxiate in the heat of the desert, trapped in the barrel, their screams muffled by the locked lid.

Another notable set of fiction films produced in that era also borrowed their scripts from renowned Syrian novelists such as for instance, Qays el-Zubeydi's fiction feature *al-Yazerli* (*The Yazerli,* 1974), based on a novel by Hanna Mina. The film narrates the struggle of a family of recent migrants from the countryside who fend for their lives in the big city. This film, highlighting the uneven expansion of the economy and massive rural migration spurred by state-planned growth biased towards urban centers, typifies another common theme of socially engaged cinema of that period. Films cast everyday people, socially and culturally disempowered, overwhelmed, as they attempted to integrate into an urban polity, corrupt, unjust and alienating.

National Traumas and Auteur Cinema

In 1970, a radical wing in the Ba'th Party, self-styled as the "Correctionist Movement," staged a coup and seated Hafiz al-Assad at the head of the government. It was comprised largely of disaffected elements from the military and security forces turned reactionary, who sought to enforce stability and consolidate power with the rule of a single party. They implemented more forcefully the "emergency measures" introduced in 1963.[1] In 1973, the October War between Arab states and Israel resulted in another defeat that strengthened the hold of the Israeli state over the Syrian territory of the Golan Heights.

The *Nakba* of 1948, the *Naksa* of 1967 register as traumas to Palestinians in particular, but also to Arabs in general. The October War of 1973 is particularly traumatic

to Syrians as their defeat marked the definitive loss of the Golan. On the political scale they are the markers of humiliating defeat in the face of the Israeli state and thus of an injured Arab self-image. On the collective social scale they signpost the displacement of hapless, poor people, their expulsion and unsettled settlement elsewhere in the Arab realm, a chronological register of their experience of denizenship. In the articulations of enduring "humiliation" and recovering from injured self-image, the notion of "betrayal" occupied a vital space: people were betrayed by their governments, soldiers by their military command, and individual Arab states were betrayed by their fellow Arab allies. The question of Palestine, the lived experience of struggle for its liberation and bearing witness to the historic injustice, have occupied a foundational position in the universe of modern Arab consciousness. That central position, loaded with its many significations, is encapsulated in the saying, "Palestine as a metaphor." As with all metaphors traveling in time and the particularisms of localities and subcultures, its signifying power multiplied and conjugated with lived experience and the representations of other traumas. In recovering from an injured self-image, the metaphor of Palestine was a key motif for citizens to question the legitimacy of the rule of their own regimes. At the same time, self-appointed ruling power elites used that same aspiration for recovery to ground the legitimacy of their undemocratic seizure of power and authoritarian governance in the metaphor of Palestine. Arab regimes subverted vital resources from attending to pressing social problems, to invest heavily in building their defense forces in the name of that metaphor. The metaphor's powerful evocation was used simultaneously by those in the seat of rule and those dissenting.

In the lexical universe of Syrian cinema as the repository of national sentiments, collective aspirations and traumas, the script of history and the record of cultural identity, the metaphor of Palestine was a vital idiom. Precisely because of its structure as a metaphor, its evocative power unraveled and thrived within one of the fundamental paradoxes that shapes Syrian cinema. Namely, a state-sponsored cinema whose most renowned filmmakers offered an alternative, critical and subversive narrative of the "national" lived experience of traumas that directly contested the official state-enforced discourse. The evocative power of the metaphor provided a space where traumas specific to the contemporary Syrian realm were narrated anew. Almost invariably, the metaphor of Palestine was either in the foreground or in the background of virtually every film produced after 1980, it was central to the dramatic construction of the story or of the characters.

In the humble lot of films produced in the 1970s, these traumatic milestones were either featured at center stage or in the background, but they were written into scripts as

objective historical events. Their metaphoric power only began to appear in what critics have identified as the "auteur" turn in Syrian cinema which dates to the 1980s.

In the 1960s, when establishing the infrastructure for film production sought skill and expertise, Cairo was the only Arab city to provide educational and technical training in cinema. By the late 1960s, the National Film Organization and the Syrian state provided scholarships for young talents to study in the Soviet Union (mostly Moscow and Kiev) and the Eastern Block. Nabil Maleh[2] was one of the first to earn a degree in Czechoslovakia and return to find work in Syria in the mid-1960s. Samir Zikra graduated from the famous Russian State Institute of Cinematography (VGIK), in 1973, followed by Mohammad Malas in 1974, Oussama Mohammad in 1979, Abdellatif Abdul-Hamid in 1981. This second wave of Syrian filmmakers, who repatriated after their studies to produce the most challenging and exciting works that make up Syrian cinema, are the generation whose work constitutes the cinéma d'auteur.[3]

Beginning with Samir Zikra's *Hadithat al-Nusf Metr* (*The Half Meter Incident*) in 1980, storylines of psychological drama weaved protagonists' lived experience with traumatic historical moments. The drama of history resonated with interior psychological drama as the subjectivity of characters took center stage in plot lines. A number of these films were autobiographical, full-fledgedly or to some extent, but most were set close to the native home of the filmmaker. The grand sweep of history found itself retold in the modest experience of simple folk, its traumatic upheavals narrated in the canon of coming of age stories, set in the filmmaker's native hometown or small village. The first film to confirm the auteur trend with self-assurance and to cast explicitly the filmmaker's own biography, was Mohammad Malas's *Ahlam al-Madinah* (*Dreams of the City*), released in 1983. Unabashedly subjective, visually captivating, the film was staged against the backdrop of the coup d'états that punctuated the early history of the modern Syrian state in the 1950s. It tells the sad story of a recently widowed young mother and her two sons who are forced to move from their native village to Damascus and live with their stingy and brutal grandfather. The film narrates the moment of the end of innocence for the generation that would come into full-fledged adulthood around the time of the "national traumas" that laid the ground for the Ba'th coming to power in 1963, the *Naksa* and the 1970 coup d'état. Deeb,[4] aged thirteen or so and the eldest of two sons is the central protagonist, but orbiting around him, secondary characters are granted full enough body for the film to represent a rich mosaic of a popular neighborhood in Damascus as the city grapples with political upheaval. Among the reasons *Dreams of the City* is regarded as a subversive film is the manner in which the history of that time is re-written, namely in a vein that does not agree

with — even runs counter to — the official version endorsed by the regime. Although spoken in the subjective, personal voice of a single protagonist, it resonates loudly with a collective memory of the experience of these political events and the rich plurality of that experience is restored to its full truth, without nostalgic reconfiguration. In that small street where young Deeb comes of age, we find young men who are Arab nationalists, communists, and Ba'thists. Some he looks up to and others he fears, some are handsome, others not, some greedy, some gentle, some virile, funny and violent. Almost all are chauvinists, and almost all carry their political commitments openly. That small neighborhood of Damascus in the 1950s is resurrected in its full color and lore without nostalgic idealization. So are defining political moments, such as the short-lived unification between Egypt and Syria and its dissolution. These moments, as others, are cast in the film from the perspective of that humble street and its everyday folk. They punctuate Deeb's passage to manhood, they are as much external events as they are internalized by the young man, as they shape his consciousness of himself and of the world.

Less autobiographical, but nevertheless very close to home, three of Abdellatif Abdul-Hamid's films are set in the countryside from which he hails, the rural environs of the southern port city of Lattakia. In *Nights of the Jackals*, *Verbal Letters* and *Ma Yatlubuhu al-Mustami'un* (*At Our Listeners' Request*, 2003), the loss of innocence does not coincide with protagonists coming of age, but rather with the nation dispatching its handsome and able men to the frontlines of war only to return in coffins. While seasons come and go, and the price of harvested vegetables and fruits fluctuates with cruel arbitrariness — because the logic of planned economic growth betrays first defenseless poor peasants — the nation seems to be in a tireless state of a protracted war with Israel. In *Nights of the Jackals* and *At Our Listeners' Request*, the "good" son of the family is suddenly called to military service, just as his family is struggling to cope with the everyday hardships that life delivers. When he is returned in a coffin, an irreversible spell of tragedy is cast over the village and the family's destiny.

Abdul-Hamid's cinema is so removed from didacticism and dogma, it feels weightless in its freshness. His dialogue and plot so spontaneously laced with derision, the comedy is effortless, natural. There are no heroes to be sung or unsung, just everyday people with vices and virtues, mood swings, eruptions of gruffness and tenderness; there no are denunciatory speech acts and no staged symbolism. Not only does Abdul-Hamid write history with a lowercase h, he casts it as an infelicitous minor twist in the plot that frustrates commonplace events of life, such as a man's courtship with his beloved. In *At Our Listeners' Request*, residents of a village gather ritually every Tuesday morning under a large

tree in Abou Jamal's backyard to catch their favorite radio program on the only radio set in the village. The program, broadcast from Damascus, features song requests and messages from listeners throughout the country. Every one of the villagers has a story with a song, they all wait with bated breath to hear their request and messages broadcast on air. Week after week, Saleh crosses the fields to Abou Jamal's backyard expecting to hear the song his beloved Wathifeh asked him to request as a proof of his love. She will not marry him unless they play it. One time, just as his song begins to play, the broadcast is interrupted by a newscaster somberly announcing the Syrian army's swift action to thwart an air assault by the Israeli army. Saleh returns to his work disappointed. The following week, the program is cancelled because the live transmission of man's landing on the moon is being broadcast. Crestfallen, he walks back to work where Wathifeh waits eagerly for an answer. When the poor man announces to her that the song was not broadcast because an American man landed on the moon, she gets really angry at his outlandish excuses and turns him down for good. What the entire world remembers as a "great leap for mankind," Abdellatif Abdul-Hamid casts as an irritating setback to the flowering of love between two poor peasants in the Syrian countryside.

As people are put at center stage, the patriotic calling of history — a motif in state official discourse — is not only writ small, its self-righteous claim to overpower people's lives, aspirations and dreams is subverted. The wars that punctuate Syria's contemporary history are not venues for grand-standing heroism, they are represented as tragic chapters that snatch the young and brightest, if not the most able, from life, from their kin and beloved. In *Nights of the Jackals* and *At Our Listeners' Requests*, the pomp and circumstance that accompanies state-sponsored funerals for fallen soldiers rings hallow as their surviving kin and fellow villagers collectively contemplate the loss of innocence. In *Nights of the Jackals*, the young son's death causes his mother's heart to give out. In *At Our Listeners' Request* the young son's death leads his best friend Salim to commit suicide. These "coming of age" and "end of innocence" motifs are the cinematic and story-telling devices that express the critical awakening to the failed promises once pledged by the regime. They are one of the many ways in which auteur filmmakers carved out a site for critique and subversion.

Auteur Cinema: The Site for Critique and Subversion

The storylines and plots of auteur films marked a turning away from grand narratives of heroism and glory inspired by the official record of "national" victories or achievements. Cinema became the repository of thwarted "national" aspirations, failed

promises, and disillusioned subjectivity and citizenship. Its lens became critical, it began to furrow in the cracks and fissures of the social construct, unearthing the disruption between official discourse and lived experience, the national paradigm as it were, and its unfolding in everyday reality. This generation of filmmakers were self-conscious social agents, products of a society — and its structures — that had endured severe upheaval, intent on telling their own stories and the stories of their kin, animated to reclaim representation of themselves and their fellow citizens, to relocate themselves in the national universe and write themselves into its historical unfolding. The social fabric of every locale was transcribed in the full body of its complexity. In the rhythm of every frame, every line of dialogue, filmmakers consciously, carefully represented and narrated contemporary Syria — even when the films were not set in a contemporaneous instance in history — that challenged, undermined and satirized official discourse and state dogma. Furthermore, they were no longer motivated to sing unsung heroes, the nameless and faceless as did the cinema of the 1970s, rather, the motive was to represent the people's history and write people into history. And this is another way in which auteur cinema manufactured images and meanings that were deemed critical and subversive.

Evocations of the tragedy of Palestine permeate the basic storylines to build dramatic resonance, but also to defy and subvert its appropriation in the discourse of the regime. In Mohammad Malas's *al-Leyl* (*The Night*, 1993), the main character is a man trying to recover the lost memory/biography of his father, a poor peasant who had voluntarily joined the ranks of rebels — as did hundreds of peasants in the region — in the 1936 Great Revolt in Palestine. On his way to Palestine, his father had stopped in the village

© National Film Organization.

Ma Yatlubuhu al-Musstami'un (At Our Listeners' Request) by Abdullatif Abdul-Hamid, 2003.

of Quneytra, where his father had met the young woman who was to become his mother, and on his way back, he returned to marry her. As the young man endures humiliation in his own life, his troubles echo the hardship and humiliation that his father endured after he settled in Quneytra. The film does not aim at restoring heroism to forgotten heroes, far from it: with humility and eloquence, it gives the tragedy of Palestine and its struggle for liberation the face of a peasant, the build of a man, his wife and his son. It humbles that struggle to the size of the body and flesh of a fighter who was also a subject of the Syrian state, a citizen, a laborer, a father and a husband. The loss of his memory/biography is an erasure from the script of official history — self-congratulating and triumphalist. And the experience of the son's reclaiming of his father's story is coupled with enduring humiliation and disillusionment, precisely because all representation of the tragedy of Palestine and the struggle for its liberation (hence the state of war between Syria and Israel), are regarded by the regime as its exclusive dominion and a crucial anchor in the legitimation of its autocratic, iron-fisted rule.

The permanent state of war between Syria and Israel, the consequence of which is the militarization of society, systematic policing of all avenues of citizenship and the continued enforcement of emergency laws, are contained within evocations of Palestine as a metaphor in auteur cinema. It is a hemorrhaging wound in the collective experience of Syrians, not only because of solidarity with Palestinian brethren, but also because they have sacrificed and endured so much for the liberation of Palestine. What they have voluntarily given up is discarded from the official script, and what they are coerced to endure has done nothing to liberate Palestine. Worse, it has held them captive to poverty, illiteracy and misery. Furthermore, the loss of the Golan persists as an open wound. All evocations of the Golan, the loss of territory, the displacement of its people, the dispersal of the memory is also deemed subversive because it too falls under the exclusive dominion of the regime's representation and narrative. Much as Palestine was abstracted into political idiom in official ideology, so too was the Golan. Auteur films have not shied away from reclaiming that geography in the flesh of its people and their hardships. The village of Quneytra is a particularly poignant location because it is where the Syrian army issued orders to retreat in the face of Israeli might and barbaric destruction; in other words, it is the site of defeat. It is now a destroyed vestige, severed by the border between Syria and Israel. In Ghassan Shmeit's *Shay' Ma Yahtareq* (*Something is Smoldering*, 1993), Quneytra is continuously present, not quite as the actual setting for the film, but as the lost home of the characters in the plot. The story narrates the painful uprooting of a family from Quneytra, and the irremediable suffering — emotional, psychological and physical — that plagues the father

who seems unable to make a life for himself and his kin elsewhere in the country, relentlessly hounded by the humiliating brunt of poverty and disempowerement.

Yet another site that registers as a stage for national trauma, and whose evocation echoes in similar ways, is the city of Hama, where Hafiz al-Assad's regime orchestrated a bloodbath of the Muslim Brotherhood in the early 1980s. The very fact of staging a fiction feature in the city is deemed as treading on dangerous ground, both for its defiance of the regime's obscuring of the massacre's geographical theater and for acknowledging its traumatic memory. Both Rémond Boutros's *al-Tahaleb* (*The Greedy Ones*, 1991) and *al-Tirhal* (*Exodus*, 1997) are set in Hama, the filmmaker's hometown. In the former, morally corrupt siblings teeter between cynicism and ineptitude as they fight over inherited property. In the latter, set in a the same historical timeframe as Malas's *Dreams of the City*, a man working as a stone-carver struggles between making a living and escaping the grip of the secret police.

Perhaps the most salient motif that permeates Syrian auteur cinema is the figure of the patriarch who exercises his rule over the fate of his family and kin with absolute authority and administers violence almost arbitrarily. In Mohammad Malas's *Dreams of the City*, Oussama Mohammad's *Nujum al-Nahar* (*Stars in Broad Daylight*, 1988) and *Sunduq al-Dunya* (*Sacrifices*, 2002), Abdellatif Abdul-Hamid's *Nights of the Jackals*, *Verbal Letters* and *At Our Listeners' Request*, we find a family (the nuclear casing for society), where the figure of a patriarch (father, grandfather or eldest son) wields overwhelming power. If characters fail at over-ruling his authority, the filmmakers use plot twists and imagery to interrogate, deride and indict it, particularly in instances of violence and abuse. The intersection in the allegorical symbolism between the absolute-patriarch and the autocratic ruler — charismatic he may be or not — is certainly a salient trope familiar to Arab cinema, as well as Arab literature (to say nothing of other world cinemas). Syrian auteur filmmakers have consciously engaged in a profound critique of patriarchy as well as a critique of absolute rule, precisely as it articulates in Syria through the iron grip of a junta commanding the armed forces. In *Stars in Broad Daylight*, the resemblance between the patriarch and Hafiz al-Assad is too striking to ignore. The patriarch, one of the brothers in a large family, is played by filmmaker Abdellatif Abdul-Hamid. The man works as a telephone operator in the city near his native village where the family resides. He listens in on everyone's conversations with impunity, a scornful twist on the security forces' (*mukhabarat*) compulsive spying on citizens.

In *Nights of the Jackals* and *Verbal Letters*, the patriarch has direct ties to the military and his authoritarian rule over his family rehearses the austere disciplinarian

practices of the army corps. He claims moral high ground and legitimizes his absolute power by reference to having served on the frontlines in Syria's wars. In *Nights of the Jackals*, the father, who once served as a reservist in the Syrian military, is a disciplinarian patriarch perpetually angry and foul, administering the everyday affairs of his family as if it were a small army platoon. But the story does not end there. At night, the howling of jackals in nearby fields prevents him from sleeping, and they can only be silenced by a particularly strong whistle. To his great misfortune, he cannot produce that whistle, only his wife can, and in order for him to get a full night's restful sleep, he must plead with her to do it and scare the jackals away. Thus his self-assured power subverted, and the man who exercises unadulterated authority during the day must cajole his wife — one of the victims of his abuse — with humility.

The link between patriarchy as a foundational force shaping social relations and the militarization of society was eloquently and overtly depicted in Oussama Mohammad's first film, a short documentary titled *Khutwa Khutwa* (*Step by Step*, 1978). Step by step, Mohammad follows young boys in the countryside, tilling the land, tending to cattle, going to school, growing into young men, and enlisting in the military. Step by step, Mohammad documents how poor boys from the countryside transform from citizens to soldiers in search of a better living than misery on their farmland. In his second feature, *Sacrifices*, a father who served as a soldier on the front, returns home in the dark of a rain-drenched night to his wife, son and immediate kin who live in a large mud house in a remote village. In the next sequence we see him seated in the midst of a circle of relatives telling stories of his exploits. They listen breathlessly, particularly smitten by the citizen-soldier's story of seeing the nation's great leader in the flesh for the first time at a huge political rally. His journey home had been so long, he could not remember how long he had been walking, and sullied with mud and exhausted, he asks his wife to draw a bath for him. As she scrubs and lathers, mud slides off him onto the ground and his young son watches and waits for his father, the hero, to emerge clean and proud from under the dirt. In the next sequence, the camera circles around the chamber where the citizen-soldier is being cleaned; the son is still standing expectantly, but suddenly he freezes in astonishment. We discover as he does, a huge pile of mud stacked in the place of the father's body. The water that was supposed to wash away the dirt covering the figure of the soldier, the hero, instead revealed that there is only mud, no man, no soldier and no hero. In *Sacrifices*, the metaphor of the soldier-citizen comes full circle, to closure.

The militarization of society and ideological indoctrination with the nation's great military feats are openly ridiculed. In *At Our Listeners' Request*, the radio broadcast from

Damascus is interrupted the first time with news that the Syrian army downed Israeli planes. While the villagers waiting to hear their song requests suddenly burst in patriotic celebration, the spectators know all too well the regime's performance on the battlefield is the exact opposite. The triumphalist newscast is not only comedic, it also thickens the weight of tragedy at the end of the movie when the handsome son returns from the battlefield in a coffin. In *Stars in Broad Daylight*, the ridicule is pushed to caricature. In a wedding celebration sequence, the patriarch (who bears a striking resemblance to Hafiz al-Assad) pushes his twin boys, barely five or six years old, to the microphone to recite a "patriotic poem." Like trained monkeys, they sing in unison:

> *Papa got me a gift, a tank and rifle, me and my brother are small children,*
> *we learned how to join the army of liberation, in the army of liberation we*
> *learned how to protect our land. Down with Israel, long live the Arab nation.*

Their father, watching, glows with self-righteous pride. By contrast, his younger brother Kasser, flees to Damascus looking for a better future and stays with his cousin, a soldier in the army who serves on the border outpost. As they snuggle into sleep, Kasser asks his cousin about the great enemy, Israel. With sarcasm, bitterness and cynicism, the soldier paints a picture of the stale-mated confrontation, entirely antithetical to the regime's version. He tells him that soldiers perform guard duty day and night bored out of their wits, and that the most that happens is banter and insults hurled across the border.

From the figure of the lone renegade hero who defends the powerless and defies tyranny, the people's combatant echoing the Palestinian *fida'i* minted in the cinema of the 1970s, the cinema 1980s and 1990s delivers a rude awakening: the poor defenseless peasant is a soldier, whether he chooses to be one or not, and instead of redressing injustice, he gets caught in the system that reinforces it. As a child, he awakens to a world shaped by patriarchy, and as an adult, he comes to consciousness in world shaped by a political dogma that is entirely detached from his reality. And when he becomes a father, he is likely to become the patriarch his own father was. In *Step by Step*, the filmmaker asks a young peasant recently conscripted for military service if he would kill his kin if they were accused of treason. Without hesitation, the peasant turned soldier replies in the affirmative.

Representation and Censorship

Since its inception, the National Film Organization has had meager resources and could not produce more than one or two long fiction features per year and a couple of short films (fiction and documentary). With its cautious control over the production of representation and signification, film production is bogged down by bureaucratic

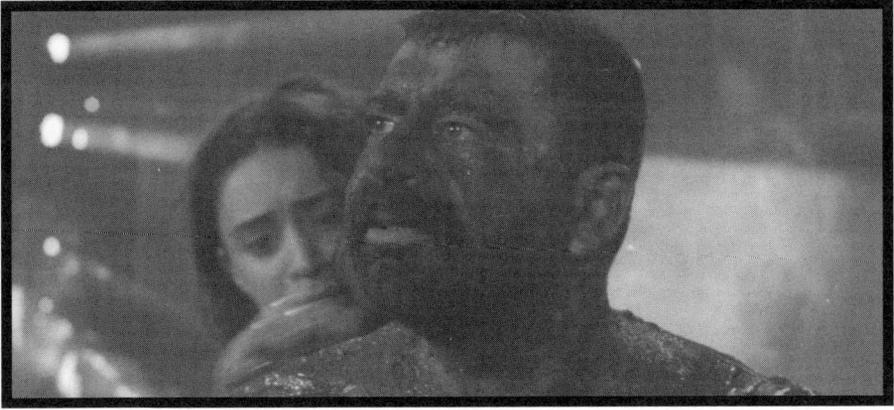

Sunduq al-Dunya (*Sacrifices*) by Oussama Mohammad, 2002.

procedures that are arduous, tedious and sometimes debilitating. Filmmakers lament feeling hostage to a system that affords them dismal yet steady financial and social security, but drains their creative energy, relentlessly policing their craft and artistry. Film scripts have to earn the seal of approval from committees, undergo endless petty trials, revisions and discussion, before making it onto the list of projects endorsed by the National Film Organization. On average, filmmakers of that generation have been able to produce no more than two films over the two decades since their return to Syria and joining the body of the Organization.[5]

Most of the red lines drawn by the censors are clear to the filmmakers. Their challenge has always been to operate through guises, stratagems, allegory and metaphor. From the beginning of production, film scripts have to pass that test, and at the conclusion of production, films are screened for a gathering of officials, high-ranking cadres in the Ba'th and other dignitaries of the state before the film is granted permission to be screened publicly. Some films pass the first test, but not the second. *Stars in Broad Daylight* was deemed to have "failed" a second such test.[6] The film was not officially censored by the Syrian regime, but it was not granted permission to be released in movie theaters country-wide. The film traveled outside the borders of Syria to prestigious festivals worldwide and earned awards and acclaim.

Amongst the films that were banned from screening is Omar Amiralay's *al-Hayat al-Yaomiyyah fi Qaryah Suriyyah* (*Everyday Life in A Syrian Village*) finished in 1974. It was Amiralay's second film, conceived in collaboration with late Syrian playwright and essayist Sa'adallah Wannus. Produced by the National Film Organization, the film delivered a scathing critique of the regime and denounced the failure of its policies. Amiralay has since established himself as a pioneering master-craftsman in documentary filmmaking in the Arab world.

Everyday Life in a Syrian Village was shot in a remote village in the Syrian hinterland, and depicted the living conditions of its dwellers, giving voice to people who had never been granted any regard, let alone a microphone. The film documented the failing of a national project that had heralded great transformation, progress and social redress, showed how the Ba'thist regime grafted itself onto and strengthened tribal and patriarchal bonds and their structures rather than fulfill the promise of bringing equality amongst subjects. The film also reveals a state more invested in policing people than in providing health services, education, jobs and a life of dignity. If the film remains banned to this day in Syria, its power is undimmed. The next documentary he produced, *al-Dajaj* (*The Chickens,* 1978), was yet another jab at state policy and its official discourse. Produced by Syrian television, it was also banned.

Since then, Amiralay has been working independently of any funding from any Syrian public or government related entity. In addition to his staunch dedication to claiming for documentary cinema an equal footing with fiction cinema in the Arab world, he has been a pioneer in defending independent production in Syria (as well as an inspiration for an emerging generation of independent filmmakers). Amiralay has continued to work in Syria and elsewhere, never flinching from his political commitments to the values of democracy, justice and equality; his courage and boldness unmatched. His most recent film, *Tufan fi Bilad al-Ba'th* (*A Flood in Baath Country,* 2003) is possibly the most explicit and compelling critique yet of Ba'thist ideology and the party's unforgiving absolute dominion over Syrian political life. The film's power lies in its disarming simplicity. Interviews with Ba'th party officials whose job it is to inculcate dogma to the constituency in their locale and represent their constituency's interests and concerns in state and party structures unravel to reveal the contradictions, the violence and the obsolescence of the ideology. The film also marks a closure in Amiralay's filmography because he chose to return to the village where he shot his first ever documentary, in 1970, for the National Film Organization, titled *Film-Muhawala 'an Sadd al-Furat* (*Film-Essay on the Euphrates River Dam*). Amiralay was then a young man filled with fervor and eager to document the big infrastructure projects undertaken by the Syrian state that promised to modernize distribution of water resources and bring electricity to rural areas. Several villages were flooded and new towns were built to accommodate displaced peasants. Thirty three years later, the filmmaker went back to film life in those villages, using the representation of that earlier time as a poignant yardstick for evaluating the regime and grounding critique from the living conditions of those deemed to be the popular core of the Ba'th.

Most of the filmmakers cited so far in this essay as the authors of stellar auteur films, have also directed documentary films. However, the fiction genre has been their preferred venue for filmmaking. Omar Amiralay is the only filmmaker in Syria to have directed only documentary films. He toyed with the idea of making fiction films; in the early 1990s he worked on a script inspired by the biography of the legendary singer Asmahan but the film never took off. As the years have gone by, he has grown increasingly skeptical of fiction cinema. Nonetheless, he has been intimately involved in the production of several fiction films, drawn by the deep ties of friendship that link him to peers like Mohammad Malas and Oussama Mohammad. Although his documentary filmmaking is never screened publicly in Syria, and his films have been made outside the confines of the National Organization's administrative and technical purview, he is at the center of the canon of Syrian auteur cinema. There is a tangible kinship in the recurrence of themes and approach between his work and the work of his peers in auteur fiction. One could easily speculate that *Everyday Life in a Syrian Village* and *The Chickens* are far closer in their approach to the representation of everyday folk in *Dreams of the City, Stars in Broad Daylight, Nights of the Jackals,* to cite a few, than in the cinema of the 1970s. The two main characters filmed in *A Flood in Baath Country,* namely the tribal chief turned parliamentary representative and the school headmaster, are in cogent lineage with the effigy of the patriarch-citizen-soldier that recurs in auteur films.

The Third Way: A Shining Path?

The generation of auteur filmmakers still dominates cinematic production in Syria. The National Film Organization remains the predominant producer of films, although for a little less than a decade now, coproductions have been permitted. Oussama Mohammad's second feature, *Sacrifices,* is one such recent example. It was co-produced by the National Organization, Arte (the French-German cable television channel) and a private French production company. Moreover, in the past three years, a number of filmmakers now estranged from the National Film Organization, like Mohammad Malas and Nabil Maleh, have relied fully on private sources of funding. The increasing currency of high definition digital video has already expanded the horizon of possibilities, and promises more in the future, because production budgets have become significantly reduced. Malas's most recent feature, *Bab el-Maqam* (*Passion*), released in 2004, was shot with a digital camera, as was Nabil Maleh's *Hunt Feast* (still due for release). As everywhere else in the world, digital technology promises to bring a revolution in filmmaking and open an uncharted horizon of possibilities.

A third wave? Perhaps more like a third way. The last of the crop to graduate from the VGIK was Nidal el-Dibs. Upon his repatriation to Syria, he joined the National Film Organization and produced his first short film, *Ya Leyl Ya 'Ayn* (*Oh Night*) in 1999. The film earned popular success unusual with short films when it screened commercially in Syria; it also toured a number of international festivals and earned a number of awards. El-Dibs has just released his first fiction feature, *Tahta al-Saqf* (*Under the Ceiling*, 2005), which is presently touring the festivals. He has also shot a short documentary for UNICEF on poverty-stricken children in Syria, which has roused the ire of the authorities. *Under the Ceiling* transposes on screen the angst of el-Dibs's experience with citizenship and subjectivity in Syria. A decade younger than the generation of auteur filmmakers, his coming of age occurred after the early 1980s and the regime's violent campaign of repression against the Muslim Brotherhood, independent and dissident unions and political parties on the left. His own generational peers have nearly all been drafted to work in the sector of private television production. At the beginning of the 1990s, both Syrian television and film production were well-set to accommodate co-productions with funds from the private sector, in addition to launching into satellite broadcasting and acquiring region-wide and worldwide viewership. Until then Egypt had claimed near absolute hegemony over production of serials in the region.

There is a long-standing history of Syrian television hiring directors trained as filmmakers for production of drama and historical serials. Veteran auteur filmmakers like Nabil Maleh, Omar Amiralay and Mohammad Malas directed documentaries for Syrian television, but for reasons of political disagreements, they became estranged from the administration of the television station. The satellite broadcast of Syrian television suddenly expanded viewership to the entirety of the Arab region, multiplying exposure by thousands-fold overnight. The airing of Haytham Haqqi's *Khan al-Harir* (*The Silk Khan*) in 1992, made it an overnight sensation; Arab audiences discovered with delighted surprise a dramatic historical series with unparalleled production standards. Haytham Haqqi, a graduate from the VGIK, has shone and continues to stand apart with his stellar productions. Consequently, the producers of television serials were emboldened to invest in production and now threaten to unseat Egyptian productions from the lead position (much to the ire of Egyptian producers and Egyptian media). Attracted by the lure of regional fame and financial reward, a number of filmmakers from Nidal el-Dibs's generation have turned to television instead of cinema. Over a decade later, Syrian serials continue to garner popularity but their quality is highly uneven. The boom in production has not inspired the establishment of sound structures for an industry, rather the opposite

has occurred. The sector is ruled by the chaos of market speculation unharnessed by regulation and animated by greed.

In the past couple of years, works by other Syrian filmmakers have begun to appear in international festivals of short, experimental and documentary films. In comparison to the generation of auteur filmmakers, they have made their films at a much younger age; they are in their twenties or early thirties. Meyar al-Roumi and Joude Gorani studied in France, Hisham al-Zouki studied in Norway, Husam Chadat studied in Germany, Fuad Nirabia studied in Canada while 'Ammar el-Beik and Diana el-Jeiroudi came to cinema almost by accident, without formal training. All are absolutely undaunted by the prospect of joining the National Film Organization. They are unabashed about experimenting with form, social and political critique and the search for their own voice and vocabulary. Despite their self-conscious distancing from the National Film Organization, and the rare opportunities for engaging with the work of their elder peers, many have collaborated with them on their films. To cite a few cases, 'Ammar el-Beik worked as an assistant to Mohammad Malas on the set of *Passion*, Meyar al-Roumi worked as director of photography on *A Flood in Baath Country*, and Joude Gorani worked as director of photography on Nidal el-Dibs's documentary for UNICEF.

Vaskeriet (The Wash) by Hisham el-Zouki, 2005.

They transit between Europe and Syria, relentlessly interrogating artistic and cutural expression in contemporary Syria, collective memory, the violence of the present regime, the overwhelming alienation of their generation, and the virtues of exile. In vocabulary, syntax, form and visual culture they are closer to their generational kin using digital video in Beirut, Cairo, Ramallah, Haifa, Casablanca and Algiers. So does this herald the end for the national chapter for Syrian cinema? A new chapter seems to unfold in almost every Arab country with each generation of filmmakers and videomakers. That revolution will not be televised, but digital technology seems to promise a new, unsuspected, shining path.

Notes

1 The state of emergency was declared on March 8, 1963, and still remains in effect. Emergency law empowers the prime minister of the republic, acting as the martial law governor, and the minister of interior, as deputy martial law governor, to arrest preventively anyone suspected of endangering public security and order; and to authorize investigation of persons and places at all times, and to delegate any person to perform these tasks. These broad powers have been exercised by various branches of the security apparatus, which for decades have arrested, detained, and interrogated under torture thousands in Syria without any form of judicial oversight.
2 His case is exceptional in that he was self-financed.
3 Oussama Mohammad testifies that amongst the many influences imprinted by his tenure at the VGIK, was that Soviet filmmakers in that time produced a cinema where they voiced a critique of authority, the regime and the official discourse.
4 He renames himself Adib when he, his mother and brother arrive to Damascus. Syria was ruled then by Adib al-Shishakli, who seized power after a coup d'état. As the bus drives into Damascus and its neighborhoods, the streets are adorned with banners pledging support to his rule.
5 With the notable exception of Abdellatif Abdul-Hamid.
6 When *Stars in Broad Daylight* was undergoing the process of "examination," an over-zealous informant deemed it necessary to alert the president's office to the danger the film represented. Arrangements were made for a private screening of the film at the presidential palace and a verdict was never officially issued to either allow for a public release or censor it. Official authorities interpreted the silence as an officious banning and no one wanted to shoulder the responsibility of organizing a public screening.

DISILLUSIONED

On the one side, it's a tragedy if you say I have made only two feature films in thirty years," Oussama Mohammad, one of Syria's most acclaimed directors, told me. "Yet from the other side, I see it as a miracle." We were sitting in al-Rawda Café, the center of Damascus's modest intellectual life, where television stars and screenwriters gather for leisurely midmorning chats. The clatter of backgammon games and the smell of apple-flavored tobacco from the ubiquitous *sheesha* pipes (waterpipes) filled the room. Occasionally, a man in a black jacket at the next table, who appeared to be reading a magazine, leaned into our conversation. "Syria is a special laboratory for filmmakers," Mohammad was saying. "We have this huge army of secret police and a complete absence of law — you can go to jail for thirty-five years and nobody will ask about you. So corruption becomes very attractive. It's not like the movie *Braveheart*. You cannot ask each one in this country who bears our history to attack the power. People have a sense of the balance of forces. They realize they are not strong enough to resist. In this laboratory, what we keep inside our imagination, what we don't tell, that is the main reality here."

Mohammad is a broad-chested man with wild, wiry gray hair streaming down his back, an unruly beard, and eyes that are the same color as his cigar. Even though the state is the studio in Syria, a surprising number of directors such as Mohammad have succeeded in creating sophisticated films, many of which are fiercely critical of the government. Their work, rarely, if ever, appears on screens inside the country, and DVDs are available only on the black market. By producing films that are essentially for export, the Syrian regime presents a far more open face to the rest of the world than it does to its own society. But the interchange between the artists and the regime, however circumscribed, is perhaps the only political dialogue that exists in the country.

Mohammad's two films, *Nujum al-Nahar* (*Stars in Broad Daylight*, 1988) and *Sunduq al-Dunya* (*Sacrifices*, 2002), achieved wide notice on the international festival circuit. *Stars in Broad Daylight* is a scarcely concealed attack on the effect of dictatorship on Syrian society as seen through the antics of an extended dysfunctional family. The older brother, who works for the phone company where he casually listens in on telephone calls, forces his siblings into engagements with people they despise in order to expand his land holdings or curry favor with the regime. "I have this obsession with facing the authority,"

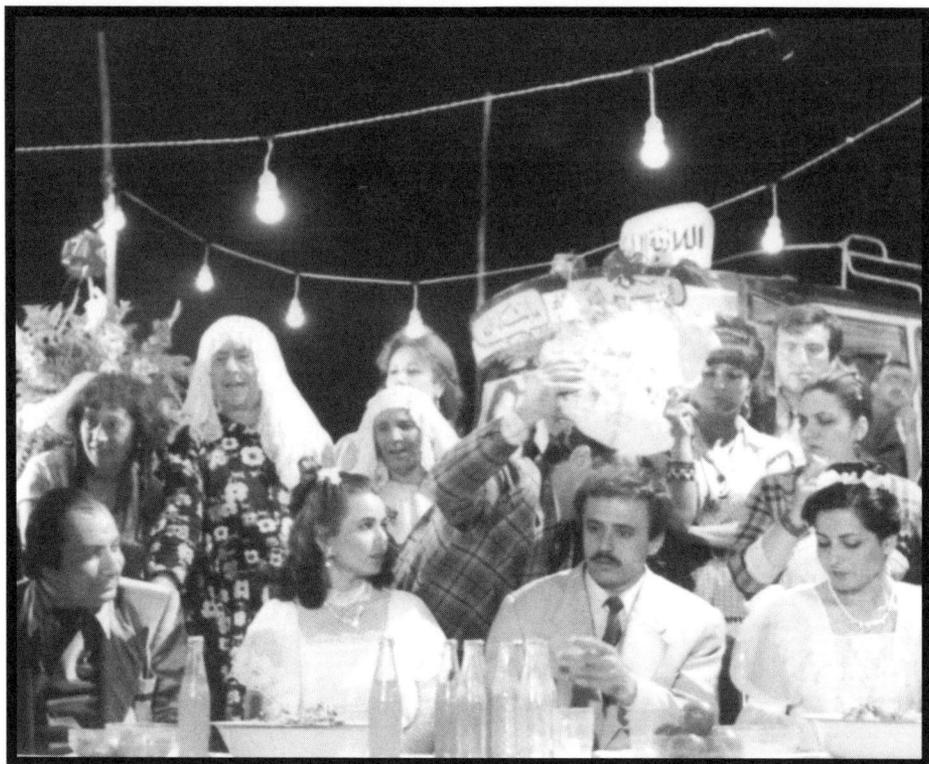

Nujum al-Nahar (*Stars in Broad Daylight*) by Oussama Mohammad, 1988.

Mohammad told me. "This society is responsible for creating the dictatorship — it's in our culture, our way of believing and thinking. I am trying to expose the authority inside us and the shadow of political authority in front of our doors." Funny, violent, and blunt, it is perhaps Syria's greatest film. It should have been the debut of a director of international stature — had he been able to freely practice his craft. The film went to Cannes and won first prize at the Festival of Valencia and the International Festival of Rabat. It even had a commercial release in several European countries. This film and his more allegorical second effort were effectively banned inside the country, leading many foreign critics to see him as a symbol of artistic victimization by the Ba'thist regime — a role he defiantly rejects. "Thank God we are thinking about art here," he said. "We are not only victims of power."

A look around the Rawda Café made me wonder about that. The creative class in Syria has a lot of time on its hands. Most of the filmmakers are employees of the government. One writer I met has a job counting the street lamps. Mohammad receives $250 a month from the National Film Organization, which is actually about twenty per cent above the average government wage. For the last few years, he has been adapting a memoir of a well known Syrian feminist, but has recently decided to set that project aside. In a

country that only produces one or two movies a year, there is a long line ahead of him, so there's no rush.

The government and the filmmakers have developed a strange, uncomfortable dependency upon each other. Lisa Weeden, author of *Ambiguities of Domination*,[1] a portrait of the cult of Hafiz al-Assad, rejects the notion that state-sponsored movies and television are tolerated and even encouraged by the regime simply as a way of letting off steam. "Political parodies, feature films, and jokes are where Syrian political vitality resides, and where critique and oppositional consciousness thrive,"[2] she writes. Many Syrians are harder on themselves. Ibrahim Hamidi, a Syrian correspondent for the pan-Arab daily *al-Hayat*,[3] which is published from London, said, "By allowing Oussama Mohammad and others to do movies financed by the government, the regime is harming the filmmakers' credibility and also trying to contain them. They get awards and prizes, which is good publicity for the regime. But at the same time Syrians aren't allowed to see the films because the government doesn't want these filmmakers to make a difference. They are isolated from the society. In the end, the regime is winning out of this game." While filmmakers are allowed to test the limits of government censorship, the regime gets an intimate sense of the mood of the nation's intellectuals. "The people who rule Syria are not stupid," Ibrahim said. "They play a very sophisticated game."

A few blocks from al-Rawda Café is the Syrian Parliament building, with its requisite portraits of Hafiz al-Assad, the Ba'th Party leader who took power in 1970 in a bloodless coup, and his son Bashar, who has run the country since his father's death, in 2000. Forty years of Ba'thist rule has resulted in a near total elimination of political opposition in Syria. In 1980, Hafiz al-Assad began a series of mass arrests in order to eliminate dissidents. Two years later, he ordered the destruction of Hama, a northern urban stronghold of the Muslim Brotherhood, the insurrectionary Islamist group, killing perhaps twenty-five thousand people in three days, then bulldozing the ruins as a testament to those who would question his authority. To this day, anyone suspected of belonging to the Brotherhood can be executed without trial. The Syrian secret police, meanwhile, filled the prisons with political detainees.

As it happens, the Parliament building stands on the site of Syria's first movie theater, which burned down a month after it was constructed, in 1916. Across the street is the al-Sham Palace, the only cinema in the capital capable of showing up-to-date movies. For the past several weeks, *Big Moma's House 2*, the slight Martin Lawrence comedy, has been running. When I went there last month, on a Thursday evening, there was a small audience of families with children.

In the face of the government's brutal actions, Syria's civil society, which had begun to flower in the years after independence, largely broke down. Movie-going is just a small part of the intricate web of communal behavior, but the regime saw it as a dangerous habit, since it drew people together and united them in a single experience. Baathist thugs began disrupting film audiences, who were already discouraged by the wan selection of movies officially offered to them and also by the deterioration of the theatres, which were forbidden from raising ticket prices to support the facilities. As the country's cinemas fell into ruins, Syrians increasingly stayed indoors.

One of nine children, Oussama Mohammad was raised in Lattakia, a town on the Mediterranean coast. "At that time, people could see films the same years they were produced," Mohammad said. "When *Spartacus*," the 1960 Kubrick classic, came to town, he recalled, "I didn't have money to go to the cinema, so I would steal from my brother Ali and invite my friends. Ali discovered this, and he brought a big stick and said, "For every lira (pound) you steal, I will beat you once." I thought about it, and the next day I stole three liras. It was worth it!"

Mohammad's father worked as a teacher at an elementary school where corporal punishment was commonplace. "But I am proud that my father didn't do that once," he said. "Going to school, I was punished hundreds of times. Once, I warned a teacher of military history who said that he was going to beat me. I had the experience of fighting on the streets. I said, 'If you strike me, I will hit you back.' He didn't believe me. So I beat him. I was sixteen."

Thrown out of the schools of Lattakia, Mohammad moved to Damascus to finish high school. The following year, his sister, a doctor, called with some good news. She had saved the life of a government official who was in charge of offering foreign-study scholarships to Syrian students. "Do you want to study in Russia?" she asked Mohammad.

"What?"

"Medicine," she proposed.

"No."

"Engineering?"

"No."

"Cinema director?"

Mohammad remembered *Spartacus*, and agreed. In 1974, he enrolled at the renowned Russian State Institute of Cinematography (VGIK), which had trained many masters of cinema, such as Andreï Tarkovsky and Vassily Shukshin. In Moscow, Mohammad met another Syrian, Mohammad Malas, who was in his final year at the VGIK. Malas introduced

him to his mentor, Igor Talankin, who agreed to accept the rebellious young filmmaker as his protégé.

The following year, a third Syrian arrived in Moscow, Abdellatif Abdul-Hamid. A calmer spirit than Mohammad, he had grown up as the son of a military officer in the Golan Heights. Once a month, a film — usually Egyptian or Lebanese — was shown in the public square of his little town. The screen was propped up on a car beside the square, and the movie could barely be heard over the roar of the generator. "For a month, I used to imitate all the sounds of the movie until the next one appeared," he told me.

Upon returning home from Russia, the three Syrians attempted to create an indigenous cinema. But their efforts coincided with the government's crackdown on artistic expression.

In 1974, Malas founded the Damascus Cinema Club with Omar Amiralay, another young filmmaker, who soon became the country's greatest documentarian. He had already fallen out of the favor with the regime by depicting the despair of rural peasants in his 1972 documentary, *al-Hayat al-Yaomiyah fi Qariyah Suriyyah* (*Everyday Life in a Syrian Village*), which sharply undercut the government's boasts about agrarian reform. The film was banned. Six years later, when Amiralay got another chance to work in his country, he made *al-Dajaj* (*The Chickens*), a satirical look at the government's clumsy efforts to stimulate private industry. He focused on a village near the Israeli border where the peasants put everything they owned in the poultry business, even turning their own houses into chicken coops. A plague among the chickens forced the entire village into bankruptcy, but they continue to pursue their ill-advised investment, still hoping to make their fortunes. At the end of the film, the clucking of chickens has drowned out the speech of the village's doomed capitalists.

"We decided to show the kind of films we dreamed to make," Amiralay recalled. Using projectors borrowed from the Soviet cultural center, they set up a screening room with a hundred chairs in a basement behind the Italian hospital. They discovered they did not have enough distance to project the film in front of the screen. They could project from the rear of the screen, but that reversed the image. So they turned to Nazih Shahbandar, an elderly man who had pioneered movie projection in Syria by making all the machinery himself, including the first sound projector in the Arab world. Shahbandar set the projector in the hospital's kitchen and projected the image into a mirror in the garden, then onto the rear of the screen. The cinema club burned through Bergman, Fellini, and Godard. "We weren't really looking for models," says Amiralay. "We were just trying to show that cinema was a vast world of invention and imagination." They showed few Syrian films, except some

shorts and documentaries. "Third world film, the world to which we belong, mostly has a very poor cinema, with the notable exception of India in the fifties and sixties, especially the movies of Satyajit Ray," Amiralay said. "He made from the tragedy of his country a noble cinema."

Impassioned debates followed screenings and provided a safe way of discussing the filmmakers' actual predicament. Members of the club held screenwriting seminars and technical workshops, and published a magazine, *Film*. The French comic genius Jacques Tati visited the club, and the Italian writer and director Pier Paolo Pasolini came to speak when he was shooting *Medea* in Aleppo. In 1978, the club sponsored two weeks of "cinema and politics" in collaboration with the prestigious French film journal *Cahiers du Cinéma*. There were two screenings a day in a seven-hundred-seat theater rented for the occasion. "We sold out every performance, and there were as many people waiting outside as we could admit into the theater," Amiralay recalled. The film critics of *Cahiers* had selected eighteen films, but the Syrian government banned more than half of them. Instead of showing the films, the distinguished French critic Serge Daney sat on the stage and narrated vivid descriptions of them. "It was a screening without an image — an absolutely beautiful happening," Amiralay said.

The Assad government's massive crackdown began two years later. Hundreds of dissidents were imprisoned and tortured. Omar Amiralay discovered his name was on the list of people to be arrested, so he moved to France. Most of the filmmakers who worked for the government, however, had little choice but to stay and practice their craft in a society that was cowed and broken.

Fares Helou is one of Syria's biggest movie and television stars. He is a burly man with tightly curled hair and a heavy but expressive face that everyone recognizes. Fares, who is forty-five, is also known for expressing outspoken views against the regime, even during a wave of recent arrests against dissidents. "I'm loved as an actor, so I'm protected," he said on another afternoon at the al-Rawda Café. Indeed, as we talked, fans approached him for autographs and snapshots. But his friends worry that Helou's career has been damaged by his political stance. "His star-o-meter is going down," one of them told me. "People are afraid to work with him. Maybe he's not as protected as he thinks he is."

Helou had always loved movies — *Z* and *Cinema Paradiso* were favorites — after studying at Syria's Higher Institute of Theatre, he was cast in a role in Mohammad Malas's second film, *al-Leyl* (*The Night*, 1993). Subsequent roles in television serials have made him known in his country and the Arab world. I asked him if things had changed in Syria since

Bashar al-Assad, who has presented himself as a reformer, has ascended to power. "We had the same amount of freedom or more in Hafiz's time," said Helou. "Hafiz at least was clear — with any position, you knew exactly the space that was allowed. But after the son came in, the freedom given us was not real; it was a trap. When voices started to be heard presenting new and modern ideas, they arrested those voices."

A young fan, clad in a jeans jacket and checkered shirt, approached the table. "I love you," he said to Helou, in Arabic. "I just want to exchange mobile numbers. I promise I won't abuse it."

To my surprise, Helou offered his number. "What's your name?" he asked the fan. "My friends call me Stalin," he said. "If you need any help, give me a call. I'm very well connected."

"Why do they call you Stalin?"

"Because I'm a killer."

Helou's eyes narrowed and he gave a dismissive nod.

I asked Helou about a scene he performed in Oussama Mohammad's richly visual second film, *Sacrifices*. Fares Helou plays a father who leaves Syria to fight in the 1973 war against Israel. When he returns to the fractured family he left behind in his remote mountaintop home, he is caked in mud. In a disturbing and brilliantly ironic scene, he gathers the family to tell his story. The women are beating cotton bolls on the table and a cow stands at the front door. Helou's character explains he was nearly killed in an explosion that had him buried for three days under the mud. It took that long for the Arabs to get a bulldozer to dig him out. "There was no fuel, it seems," the character says bitterly. "Where was the Arabs' oil when it was needed?" he wonders. He later pulls the male children aside and forces them to drink oil, ostensibly to toughen them up for the battle ahead.

Sunduq al-Dunya (*Sacrifices*) by Oussama Mohammad, 2002.

Helou said of his character, "The shock of being defeated made him an extremist. Embracing the illusion of authority makes him think he was victorious." But as the film shows, the legacy of violence is to create new perpetrators of violence. His character has learned to abuse power in the same way as the corrupt and incompetent state that sent him into the disastrous war.

Stalin was suddenly back at our table. "I have another phone," he said, pulling it out of the black leather bag strapped around his waist. "I want to give you the number. Very few people in Damascus have this. I even take it with me on operations."

By now, the young man had made it clear that he was with the secret police. He began to boast of his connections with the Assad family and offered his "unlimited service," because of his deep admiration for Helou.

"Is this your first time here?" Helou asked him.

"No, I'm always here," said Stalin. "We have spoken before. Usually, I am dressed in a military uniform, so perhaps you don't recognize me. This time, I decided to take your number."

Stalin asked if Helou was a member of the Ba'th Party. Helou responded saying he was not. "You cannot *not* be a member," Stalin said angrily, grabbing Helou's hand. "This is a real Ba'thist handshake! I will pay your dues for you!"

Stalin noticed I was taking notes on his conversation, and he began denouncing American and British aggression in Iraq and the interference of human-rights activists in Syrian affairs. "We should be able to discipline the peasants without outside interference," he said. "I quote Aristotle to his student, Alexander the Great, who said that you should treat the Greek people as gentlemen and the people of the East as slaves."

Stalin left, and I asked Helou to explain what had just happened. The mixture of fan worship, academic pretense, and veiled threats baffled me. "He came to deliver a message," Helou said. "He's telling me to take it easy, to calm down." I noticed his leg was jiggling furiously. Minutes later, Stalin returned again, this time carrying his coffee and a pack of Gitanes. He obviously intended to disrupt the interview. Bizarrely, he pulled out a third telephone from one of his jacket pockets. "This is my very most private number," he said to Helou. He pointed to an arrow on the phone's screen, beside Fares's mobile number. "This arrow goes *through* you," he said, laughing. He squeezed in next to Fares, who had now gone quiet.

"Do you work for the government?" I asked Stalin. He had broad shoulders, a long, unbroken eyebrow that stretched across his forehead, and a gold chain around his neck. "Of course, that's why I'm talking to you," he said, switching to English. "But I am very

open. I am not a spee. Do you say spee or spy?" He said he was also a journalist for a pro-government magazine and loved movies — "*Syrian* movies," he said. "I love the movies produced by the National Film Organization and the movies made by this man, regardless of the fact that he is not obedient."

I had heard that Syria had become more relaxed about the press since Bashar took over, but recent arrests signaled a newly hardened attitude, as if there were little to lose, with the Americans tied down in Iraq and the looming UN report, which would likely cause the regime to slam the door on the rest of the world. Stalin's bullying tactics were, apparently, a new approach. "In the past, they didn't bother to intimidate you," Helou told me. "They just arrested you."

Stalin took Helou's hand once more. "I feel the need to beat someone," he said, laughing into Helou's shoulder. "May I beat you?"

Helou pulled his hand away. Stalin's mood shifted abruptly. "I don't like Americans and British," he confided. "When I saw their tents in Baghdad, I lost my mind. I have been suffering from a nervous breakdown, worrying they are going to invade my country."

Helou was ready to get out of there. As we stood to go, Stalin grabbed my hand. "Welcome to Syria," he said.

"Syria is a dictatorship, but it would be a mistake to understand us as a totalitarian society," Omar Amiralay, the documentarian, explained. "For instance, the National Film Organization has made forty-five features, but there is not one propaganda film in the modest history of Syrian cinema." Indeed, the opposite seemed true, although the nature of protest in Syrian movies was often indirect, like the process of projection in the Damascus Cinema Club. The forces of fear and paranoia were often masked in allegory, but the films also displayed an admirable struggle to understand and challenge their fragmented culture. I thought about Mohammad Malas's 1983 film *Ahlam al-Madinah* (*Dreams of the City*), in which a young boy discovers the corruption behind the figures of authority; and Abdellatif Abdul-Hamid's first film *Layali Ibn Awah* (*Nights of the Jackals*, 1989), an angry account of the fading of traditional rural life. These films show a society that is, in Amiralay's words, "completely ruined."

The most brazenly subversive film that the National Film Organization has produced is Oussama Mohammad's first feature, *Stars in Broad Daylight,* a comedy about a family autocrat, played by Mohammad's Moscow schoolmate Abdellatif Abdul-Hamid, who, clad with sunglasses was made to bear an uncanny resemblance to Hafiz al-Assad. I

asked Mohammad how the movie came to be made. "Dictatorship is not like this monolith where everyone is the same," Mohammad explained. "No. Inside, you find a lot of people want to support you. *Stars in Broad Daylight* wouldn't exist without three or four Syrian cinematographers who read the script on behalf of the National Film Organization." Mohammad's colleagues knew that *Stars in Broad Daylight* would cause problems. The government wanted at the time to film an innocuous script by a different director, but the cinematographers had repeatedly rejected it. Finally, they made a deal, Mohammad recalled. "They said, 'We will give you this film, if you give us *Stars in Broad Daylight.*'"

There was an additional, personal concern. Mohammad's brother Ali, an electrical engineer, had been thrown in prison after government officials had invited him and several university professors to share their views on reform with members of the regime. "The next day, they were taken to jail," Mohammad recalled. The authorities threatened to send Ali from a prison in Damascus to one in Palmyra reputed as a torture chamber if Mohammad did not tone down his script. He refused to make any changes in his script. "My relationship with my brother is like this: to salute him, I will make my movie. That is how I support him!" Fortunately, Ali was released before the movie was made. During the filming, crew members began to get scared. "The game was to make love with the fear," Mohammad said. "It was, 'Yes, let's put Hafiz al-Assad *inside* my movie.'"

I asked Mohammad how he got away with making such a subversive film. "When you live in a garden of corruption, you learn the skills of bluffing," he said. "Some of my colleagues came and said, 'If this is not a piece of great art, you are going to be fucked.' When I was shooting, I forgot about this, but one day, when I was stuck in traffic, I thought, 'My God! What am I doing?'"

Stars in Broad Daylight is funny, but in a darkly knowing way that I was coming to think of as typically Syrian. The Assad figure and his brothers wear aviator sunglasses and ride through Damascus on motorcycles in a scene that pointedly conjures both the secret police and Marlon Brando in *The Wild One.* The most sympathetic character is the strapping brother of the patriarch, who has been rendered nearly deaf since childhood by a blow from his father, and who wanders through the movie in a kind of slow-moving rebellion.

It took Mohammad seventeen years to make his second project, *Sacrifices,* which tried to capture the essence of dictatorship and the breakdown of social relations. "It is the story of Syria," he told me. "A huge quantity of time has been lost by illusions — the illusions of heroism, religion, Arab nationalism — and by not dealing with the Other. The Other is not Israel. It is inside everybody." He decided to make a movie that was both far

more introspective and metaphorical than *Stars in Broad Daylight*, but just as daring in a personal way. "It's easy to insult the dictator," he told me. "It's much more difficult to find the dictator inside yourself."

When the script was completed, Mohammad submitted it to the National Film Organization. The scenario, about a dying man who oversees a sprawling family in which everyone competes for his blessing, was obscure but beautiful, and laden with references that the Organization found both mysterious and dangerous — like the child who places birds inside bottles. It was a powerful image, but what did it mean? Or the baby, who floats, like Moses, in a river in his bassinet?

"It's very pessimistic, but at the end we have the tree," one of the committee members observed. The story ends with a shot of a giant tree, old by several hundred years, just after the most sympathetic character in the film has crawled into a casket. "The tree is positive, yes? It is the homeland, yes?"

"No," replied Mohammad. "The tree is the tree."

He certainly wasn't making it easy for them. "You want to know my opinion about Syrian politics?" Mohammad recalls saying. "Is it democracy? Absolutely not. Is it dictatorship? Yes. What more do you want to know? But the script — if you want this country to have a democracy after a hundred years, then this is our work together right now. So don't bullshit me, and don't shit on my film." It took five years until the National Film Organization accepted the script, in 1998.

Mohammad 's brother Ali happened to wander into al-Rawda Café while we were talking. I recognized him — a white-haired man with kind green eyes — because he appears in *Sacrifices*. There is a vivid scene in which a pubescent boy is tied to a post after violating the fast of Ramadan. A Koran is tied into the knot of the rope. Ali enters and unties the knot. It is a deeply personal moment; Mohammad told me that Ali was the first in his family to deny the authority of religion.

"When I did that scene, Oussama took me aside and asked me to try to push my anger," Ali said. "So I told him a story. When I was in prison, someone came to take a thirteen-year-old boy to Palmyra. He was terrified. He held on to me and pleaded not to let them take him away. This shot is for that boy."

One scene, in particular, had troubled the head of the National Film Organization when he was considering the script. Three boys are taught how to slaughter a cow while reciting verses of the Koran. "All the West is attacking us because, for them, we are killers and extremists," the former director told Mohammad. "I know you don't want to say that." He demanded that Mohammad cut the scene.

Mohammad refused. In his opinion, violence was an essential part of culture. "You can't be a man unless you learn to kill," he declared. The scene speaks of the initiation of a new generation into the pathologies of Syrian life. It appeared that the project was at an impasse.

"I know a secret about you," Mohammad finally said to the head of the Organization. "When you were young, you jumped from one building to another to meet your girlfriend." According to Mohammad, the bureaucrat was astonished. "How do you know this?" he asked.

"Ask the man who jumped what he thinks. Does he like this sequence in the script?"

"It's amazingly beautiful."

"Please, follow yourself. Don't forget who you are."

"Go!" the head of the institute said. "Do it!"

Four years later, when *Sacrifices* was finally completed, a government committee, which includes cadres from the Ba'th party previewed the film and decided it would not be released in Syria. It was the price that Mohammed knew he would pay when he made the movie he wanted to make.

Sacrifices was screened at Cannes in 2002. It received enthusiastic reviews although some audiences were put off by its allegorical, highly compressed storytelling. Indeed, when I first saw *Sacrifices*, the references seemed so personal I wondered if this is what happens when a director no longer expects to have an audience; he makes a film entirely for himself. Even Syrian intellectuals who have managed to see the film on the underground DVD circuit were puzzled by the sumptuous but enigmatic scenes, like the opening shot of a naked boy being lowered into a cave to fetch a chicken or the one of a boy whose pants burst into flames, and struggled to understand the dialect of Mohammad's native Lattakia.

But Mohammed does not see the hermetic qualities of *Sacrifices* as a weakness. "The kitchen of cinema here is full of poisonous materials," Mohammad said, "but we are lucky as filmmakers to work in this kitchen. Because there is no audience, at least we don't have to worry about the censorship imposed by commercialism." He paused, then said, "Even if there was an audience, I would not change my way."

"Meet me in Salhieh Square in ten minutes," Orwa Nyrabia, a young Syrian filmmaker, said when I called him one afternoon to ask about the market in pirated DVD movies.

A bronze soldier stands in the center of the square atop a column; an actual Syrian flag flaps against his scabbard. "It's Youssef el-Azmeh," Nyrabia explained. "He was the minister of defense when the French Army invaded in 1921. He and a group of five hundred riflemen went to meet them because they didn't want to see the country occupied without any resistance. There wasn't a single survivor among them. I love this story. This could be a huge, epic film."

Nyrabia, twenty-eight years old, plans to become Syria's first modern independent producer. Digital equipment has reduced the cost of making films, and satellite television has created a potentially huge market for Arab cinema; it may soon be possible for Syrian directors to create work without government funding, though scripts will still require approval by the National Film Organization. Nyrabia and his wife, Diana El-Jeiroudi, had set up a production company, ProAction Films, a few years earlier. Diana has already made one short documentary for the company, in collaboration with Kunsthalle Wien, a museum of contemporary arts in Vienna. Titled *al-Qarura* (*The Pot*, 2003), it looks at Damascene women's views of their bodies during pregnancy, and was shown in several international festivals. She's now working on a film about the controversy surrounding *Fella*, the Islamic version of the Barbie doll, who wears a hijab and supposedly adheres to Muslim values. The film, for which she has already received a grant from a Dutch foundation, will be one of the first Syrian films in decades made entirely with private financing.

Nyrabia is big man with a goatee and close-cropped hair that makes his expressive face all the more imposing. We walked to Media Mart, a store by the square, which had a vast selection of pirated DVDs and computer software. In 2004, President Bush placed Syria under an embargo of American goods, except for food and medicine, because of the country's continued support of terrorism and its failure to control the movement of insurgents into Iraq. Kodak stock and chemicals were included in the embargo. "It would be a problem for our industry, if we actually *had* an industry," Nyrabia told me as we wandered among the small shops. Although hardware was harder to obtain now, software has always been cheap and illegal. "Piracy has been a great blessing," said Nyrabia. "Because of this, most members of my generation are computer literate." For their business, he and Diana decided to pay the market rate for software in order to avoid problems with compatibility. "A lot of guys would laugh at me," he said, noting that professional film-editing software costs several thousand dollars in the West, but "you can buy it in the Damascus market for twenty."

The Media Mart was crammed with recent movies, such as *Capote*, and *Sin City*. Nyrabia recalled, "When I was a kid, they had VHS rental stores, but everything was

censored. They were all stamped by the Ministry of Culture. Now, nothing is censored." Only pornography — and banned Syrian movies — were absent from the shelves. The Assad government has apparently decided that it can placate its citizens by allowing thousands of American films to circulate, as long as they are not watched in large groups. Nyrabia explained, "The regime has decided, 'Let's encourage people to stay home. It's safer.'"

Nyrabia purchased *March of the Penguins* and at my suggestion the Mike Nichols production of *Angels in America*. We wandered outside, past the al-Sham Palace to a coffee house named Aroma, which faces the grounds of the Parliament building. The flat roofs of the nearby apartments were topped with satellite dishes pointed west, like flowers inclining toward the afternoon sun. Nyrabia was telling me about a script he had just submitted for review to a committee of the National Film Organization, he hoped to direct himself. "It's about a family, husband and wife and child, and they pass a shop," Nyrabia said. "We just see the husband's eyes glance at a brown suit. The wife catches this and asks him, 'Should we go in? That suit would look beautiful on you.' But he declines, he's in a hurry. 'Every week, we are always the first ones to arrive at your mother's house,' she says. 'Take twenty minutes for yourself!' But, still, he declines. While they are arguing, their child runs away. But it's about the relationship of the man and the woman, and you tell everything just in the glances and the way they react to each other."

"What did the committee say?"

"They didn't get it. They wanted it to be all about the search for the child. But that would be banal, parents looking everywhere, you know what happens already."

I said I actually agreed with the committee. His idea seemed strangely inert.

I asked him about a protest march that had taken place the month before I arrived. On March 8, the annual celebration of the 1963 revolution that had brought the Ba'thists to power, about a hundred and fifty demonstrators peacefully gathered in front of the Ministry of Justice. Suddenly, hundreds of Ba'thist college students, who were members of a paramilitary brigade, stormed the demonstration, beating protesters indiscriminately. A well-known female novelist, Samar Yazbek, was severely injured while the Syrian police stood aside and watched.

Nyrabia had participated in another protest in December, 1990, just before the American bombing of Baghdad, when the government authorized a demonstration in front of the American Embassy that got out of hand. "It started out peacefully, but it became

violent," he said. The embassy was burned, along with the ambassador's residence, the American School, and the British Council. I asked him how he felt now about having been part of such a mob.

"It felt good," he said. "For the first time in my life, I was part of a violent protest, something which is normal all over the world. I believe this is the main problem in Syria. It's a very static society, so I'm happy when I see something dynamic happening. I mean, we don't even have crimes! This is not good. I might sound like an anarchist, but this even applies to the commercial film industry. Most action films in Hollywood couldn't be made here, because we don't have the action to put onto film! And you are forbidden to do movies about corruption, or comedies about the police or the army. Crime or horror films are also not allowed here. Where can you go to come up with a decent project to make a proper blockbuster? You need action thrillers or comedies, and we can't do either."

I pointed out that his own scenario had avoided the obvious action — the parents searching for their missing child. "That's not forbidden, surely," I said. "Maybe it's a problem of your imagination, that you don't allow yourself to think about action."

Nyrabia paused. "I don't know," he said. "Could be."

In 1991, Omar Amiralay, the documentarian, decided to return to Syria. "I was fed up with Paris," he said, and he sensed that he could probably return home without being arrested. Also, he had fallen in love with a Damascene woman. "When I came back the first time at the end of the sixties, it was a militant return," he said. "In the nineties, it was sentimental."

He has made more than twenty films, many of them biting political commentaries. Upon returning to Damascus, he had a particular score to settle. As a young documentarian, he had been given the chance to make a movie about the damming of the Euphrates River. *Film-Muhawalah 'an Sadd al-Furat* (*Film Essay on the Euphrates Dam,* 1970) was very much influenced by the school of Soviet documentaries of Dziga Vertov, with a reverent approach to the mighty instruments of labor —"a hymn to the crane," Amiralay sarcastically calls it now. He came to realize his film was actually an endorsement of the regime and its catastrophic policies, which was a source of shame for him. "When I returned to the region to make a documentary about the Ba'thists, I did not think about the dam. I was trying to make a film of fifteen shots, the fifteen reasons I hate the Ba'th Party. The fifteenth reason was that I hated myself for having been obliged to make a film for them. They have spoiled forty years of my life."

During his research, he was appalled to discover that the dam creating Lake Assad, as the massive reservoir is known, was built mainly because of the fear that Turkey, Syria's northern neighbor, would choke off water to Syria as a political gesture of hostility. Thousands of farmers were displaced and ancient villages were drowned as a consequence of this hypothesis. "I was also shocked to learn of the archeological crimes committed by this monstrosity," Amiralay said. "It changed the geology of the country. The thing that angered me the most is that I learned that this was the place where human beings became farmers for the first time, and left the hunting-and-gathering stage, eleven thousand years before Christ."

The powerfully felt 2003 sequel to his first documentary on the dam, titled *Tufan fi Bilad el-Ba'th* (*A Flood in Baath Country*) begins with his own bitter admission: "In 1970, I was a firm advocate of the modernization of my homeland, Syria, so much so that I dedicated my first film to the building of a dam of the Euphrates River, the pride and joy of the Ba'th Party then in power. Today, I regret this error of my youth."

Amiralay said, "For me, that first film is a deep wound in my heart. I have been able to make a career outside of my homeland. I don't regret it, but if they had given me the chance to live in Syria, maybe I and my colleagues could have created a better country." His rueful second look at the project concentrates on the people, not the machines, and the toll the regime has taken on the human spirit. It is a skillful and mature indictment of a system that has destroyed the people as willfully as it ruined the land.

I asked if *A Flood in Baath Country* had ever screened in Syria. Amiralay shook his head. "But when I finished, I decided to give it to some film pirates," he explained. "Two months later, everybody in Damascus had seen it," Amiralay said. "It was a digital flood."

In April, 2000, Nabil Maleh, one of Syria's first generation of filmmakers, started the Committee for the Revival of Civil Society, along with a small group of lawyers and intellectuals. Decades earlier, Maleh had directed some of Syria's most subversive movies, including *al-Fahd* (*The Leopard*, 1972), a highly suggestive film about a historical revolt against a previous Syrian regime. Maleh was old enough to recall a time in the 1950s when Syria had a vigorous press and numerous political parties, as well as a vibrant civic life. "All my childhood was in Damascus," he told me. "We had a lot of cinemas back then. Just two decades ago, there were a hundred and twenty cinemas in Syria. Now there are only six that are functioning."

After Maleh and other organizers got the movement going, allied committees began springing up all over Syria. Hafiz al-Assad died that June, which added to the

expectations that Syria could finally open up and change. In September, ninety-nine prominent Syrians signed a petition calling for an end to the restrictions on freedom of assembly, press, and opinion; a general amnesty for all political prisoners; and a decree allowing political exiles abroad to return. The regime responded by releasing six hundred political prisoners. It was a period of profound hopefulness.

In January 2000 more than a thousand prominent Syrians, some of them from abroad, signed a broader and more daring petition, called the Basic Document, drafted by Maleh's committee. The Basic Document called for an end to Ba'th Party domination. "Immediately came the crash," Nabil recalled. Bashar al-Assad warned that advocates for greater openness were outsiders who were undermining the stability of the country. The regime issued a dictum that all social, political, and cultural forums had to be approved in advance. A few months later, ten of the signatories of the Basic Document were arrested and tried for "spreading false information" and "attempting to change the constitution by illegal means." Maleh was threatened by government officials that he would never be able to make films again. The brief popular movement was extinguished without strenuous effort on the part of the regime. Indeed, it was able to give the appearance of liberalizing — by continuing the release of now elderly political prisoners and allowing some new journals with minimal political content to be published — while smothering the larger efforts of reform. "The development of civil society institutions must come at a later stage," Bashar al-Assad said in a 2001 interview with the pan-Arab daily *al-Sharq al-Awsat*. "And they are not therefore among our priorities."

"We lost the war without ever fighting it," Maleh admitted one evening at dinner in one of the old Damascene houses in the Christian quarter, now turned into a lovely, sparsely attended restaurant. I had observed that political opposition in Syrian often seemed only gestural, not real, so that making movies no one could see was a characteristic expression of Syrian dissent. Perhaps the society was so tamed by the regime that no more could be expected of it; but it was also possible that the regime was itself a characteristic political expression of a brutal and authoritarian culture.

In our first interview, Maleh had told me about an incident in his childhood, when he was seven years old. "I was with my family in a public park in Damascus," he recalled. "I wanted to use the swing. There were some children already playing there, and they were guarded by a soldier, probably a driver for some big shot. I don't know what I did to provoke it, but the soldier slapped me viciously. I was knocked some four metres away. I got a clod of dirt, threw it at the soldier, and ran away. From that moment, all my life has been connected with a hatred of the uniform and of authority."

This anger is palpable in his films, most poignantly in *al-Comparss* (*The Extras*, 1993), in which two lovers meet in a friend's apartment for an assignation. They suppose they have finally shut out the world that has prevented them from consummating their relationship, but they are unable to liberate themselves from internalized fears. The film borrows its title from the male character, who plays bit parts in theatrical productions, underscoring Maleh's observation that "we are all extras in this society." The real world breaks in upon them when the secret police barge into the apartment, supposedly concerned about a blind musician who lives next door. The fanciful male lover tries to prevent the musician's arrest and, in a reverie, imagines dispatching the police with a few judo moves, but his fantasy is broken by a slap that knocks him to the floor. He is humiliated and powerless in front of his lover — a devastating turning point in their relationship. "They enter the apartment as lovers," Maleh told me. "They leave as strangers."

I recalled other scenes in Syrian cinema in which physical abuse played a significant role, and how those scenes reflected experiences that the filmmakers had personally endured. In Oussama Mohammad's film *Stars in Broad Daylight*, a character is made deaf by a blow from his father. The punitive father is a familiar figure in Abdellatif Abdul-Hamid's films, like *Nights of the Jackals*, although he is also a complex and appealing figure. Abdul-Hamid had told me about going to see *Hercules* when he was a boy, then rushing out with a stick to wage war on the wheat fields. "My father beat me," he said with a smile. Omar Amiralay, whose father, a police detective, died in a car chase when he was five, told me, "I was only beaten by the slippers of my mother, and for this I am grateful. Such beatings awakened me."

I went to dinner one night in a restaurant with some of my new Syrian artist friends, and I brought up the subject of physical abuse. "It's common," the middle-aged woman across from me acknowledged. "This happens everywhere."

"No, it doesn't," I said. "Even in other Arab societies, I have never heard so many stories of being beaten by teachers or police or family members. I think it's very unusual."

"For me, it was a positive experience," she said.

"What do you mean?"

"I was twenty-six years old," she recalled. "First, I was hurt. I was living just to please others, for example my ex-husband and his family. Then I realized that a word from your mouth can make the difference between survival and destruction." She was staring at me with shining brown eyes that seemed strangely untroubled.

"Beating did this for you?"

She nodded. "It was like a revolution. It was like you are not living anymore to

please others. You suddenly become very brave. I was one step from death, but I was thinking of my children, and I was determined to survive. It was positive for me. This is when I decided to be a creative person."

"It was your ex-husband who did this to you?"

"No," she said quietly, so the other guests wouldn't hear. She took my pad and wrote: "Raped by the government."

I later asked Maleh if Syrian society had always been so abusive, or if it was the result of the dictatorship. "No, no, it became violent in the last forty years," he maintained. "Violence became a part of the daily practice." It was the Ba'thist abuse of power and the lack of democratic expression, he believed, that replicated itself in the relationships between authority figures and those without power — women, children, and the poor.

Most Syrian movies, I realized, are about victims. They reflect a passivity that comes from a profound hopelessness. Damascenes like to think of themselves as a pragmatic race of merchants who have survived millennia of intolerable governments. They compare themselves with their neighbors, the Iraqis, whom they see as defiant and bloody-minded. "When the Americans destroyed Baghdad in 2003, it was the twenty-fourth time in history this has happened," Ibrahim Hamidi, the Damascus bureau chief for *al-Hayat* told me. "Since the beginning of civilization, Damascus has never been destroyed." Omar Amiralay said that an archeologist who shared with him an image of a sheared face of cliff, with the strata of geological time clearly exposed. "You see this line?" the archeologist said, indicating a slender dark ribbon about ten centimeters in width. "It is eight thousand years of history." The whole history of Syria, Amiralay said, had been exposed to view. "I think the Ba'th period will be only 0.0001 millimeter on that scale," Amiralay told me.

I asked him if there was ever, in that whole long history, a moment where the people of Syria had lived free and happy lives.

"I don't care," Amiralay said, a little testily. "It's a beautiful image."

Although the filmmakers often talk about freedom, I detected in them a perverse desire to romanticize the artistic constraints of dictatorship. "The most beautiful Soviet films were produced in the era of Stalin," Abdellatif Abdul-Hamid told me. "When the Soviet Union collapsed and suddenly you could say whatever you wanted, the Russians began producing the most trivial films ever. Nobody should be forbidden to say what he wants, but it is a phenomenon that dazzles me — when you're repressed, you think better." The example that haunts Abdul-Hamid and many Syrian filmmakers is Iran, where artists suffer under even more restraints than in Syria. "They have to work within this box, but

they show their films all over the world," he marvelled. Hatem Ali, a prominent television director, has studied Iranian films intently. "The fact they have succeeded tells us a lot," he says. He gave the example of a scene in an Iranian film depicting an old woman who lives with her son. "She is in a wheelchair, and her hair is grey and unkempt," he said. "All the windows are closed off, and somehow this film is talking about the isolation of Iran. The surprise comes when you learn that this actress is not a woman, it's a man. My makeup artist showed me all the photographs of how it was accomplished. In Iran, it is not acceptable for an actress to show her hair, but it would not be realistic for this elderly woman to appear in her house in a hijab. So the director used a man." The lesson he drew from this was, "It is the art that is important, not the censorship."

"Arab cinema has few masterpieces, no more than ten," Omar Amiralay pronounced one afternoon over cappuccino. Among them he includes two Egyptian films, *Bab el-Hadid* (*The Iron Door*, 1958) by Youssef Chahine, and *Darb el-Mahabeel* (*Fools' Alley*, 1955) by Tawfeeq Saleh. Both films, he observed, were the director's first significant efforts. "It is a syndrome in Arab cinema that directors who make a remarkable first film rarely succeed in making another," he said. He included no Syrian films in his pantheon.

I asked where he placed his friend Oussama Mohammad. "Oussama has the profile of an exception," Amiralay said. "But he doesn't until now have the liberty to make an accomplished film, and, of course, he suffers from a lack of opportunity and experience." Syrian films have the potential to be great films, he continued, "but they miss the dimension of unity — the compact structure, the purposeful style, the visual sensibility. For instance, there is not a single Syrian film with decent sound. The actors are not sufficiently mature or experienced. This is true of most Arab actors. I always feel there is something wrong, as if they were ordinary people who were simulating acting. They are only playing themselves, but badly. And finally, the narration. We are so obsessed by the daily reality that script writers and even novelists don't have the courage to invent new realities from their own imaginations. Because of this, I think they are making bad documentaries and passing them off as fiction."

Now that Amiralay is back in the Middle East, he hopes to establish a school of cinema as a legacy for young Arab filmmakers. He is working in conjunction with the national Danish film school. He plans to open a campus in Amman, Jordan, initially but his real dream is to bring the institute to Damascus, when the political circumstances permit. "We have until 2008 to decide about our location," he said. It was one of the first notes of optimism I had heard since coming to Syria.

One evening, I went to the old quarters of the city with a Syrian cameraman, Samer Zayat, for a drink at Café Mar Mar, a sixteenth-century building with stone walls and twenty-foot ceilings. We walked into a room of upturned faces illuminated by the familiar flickering light of the cinema. I had stumbled upon the latest incarnation of the Damascus Cinema Club. I ordered popcorn and a martini (it's a very congenial club) and watched Big Fish. In attendance were many of Syria's film and television stars, who apparently have enough clout to keep the underground operation alive. "This is the only venue left for new movies," Samer told me. "They advertise by cellphone text-messages and show films every Monday night. Last week, we watched *Munich*." Unlike the old cinema club, however, the audience left quietly when the film was finished.

The week after I left Syria there was an announcement in one of the government-approved newspapers that Oussama Mohammad's *Sacrifices*, would be given a showing the following day in Homs, a provincial town north of the capital. The suddenness of the announcement seemed to be tied to the government's realization that this article would suggest that Mohammed was victimized by the regime, which refused to show his films. Mohammad raced to Homs, only to discover that, instead of his film, there was a Ba'thist youth rally underway. "I shouted and made a scene. Remember about the bluffing?" Mohammad told me, "I said I would call the governor. I really played the game."

Parts of the article were previously published in the May, 15, 2006 *New Yorker*, under the title "Letter from Damascus: Captured on Film."

Notes

1. Lisa Wedeen, *Ambiguities of Domination: Politics, Rhetoric, and Symbols in Contemporary Syria*. Chicago: University of Chicago Press, 1999.
2. *Ambiguities of Domination*, p. 36.
3. Lawrence Wright traveled to Damascus in late April 2006 for the purpose of writing this essay. He interviewed Ibrahim al-Hamidi and a number of filmmakers, actors and scriptwriters.

TIGERS ON THEIR NINTH DAY:
SYRIAN CINEMA IN A QUARTER CENTURY

Today, if someone asks a son of Damascus for directions to a place where they can catch a new film or even just see a recent movie shown under the standard conditions of a commercial screening, those directions will lead to one of the two movie theaters of Cinema al-Sham. Al-Sham, a colloquialism for Damascus, gives its name to this two-theater film house and the hotel in which it is located. Alone, these two movie theaters with modern outfitting serve three million souls living in Damascus and its suburbs, a city whose history has produced close to a hundred and fifty films in the span of fifty or so years. There are other movie theaters in Damascus — ten, at most — but since a law prevents their conversion to commercial venues, they screen the same bunch of old popular films. Dispersed around the city center, their marquees stand like headstones in a burial ground for cinema, while elsewhere in the world film thrived throughout the twentieth century, developing its form and expression, capturing the anxious march of history.

When asked where the store of visual imaginary for the city and its sons dwells, the hundreds of thousands of satellite dishes that punctuate the rooftops of Damascus's mostly squat buildings rise in reply. This is the first attribute of cinema in Syria: it is not present in its conventional sites. It does not beam onto huge, flat rectangular screens; rather, it is transmitted in various formats, ranging from videotape to DVD, shown on television screens in the privacy of homes, or broadcast to those selfsame screens by the ever-multiplying satellite stations that cover the Arab world. At least this has been the case for the past twenty-five years of the lifetime and awareness of the author of these lines. Doesn't this sorry state of affairs contradict the very pleasure promised by the paramount art of the twentieth century?

In 1996, without prior notice besides a dust-covered poster pasted on the glass vitrine of a movie theater that has since shut down, Emir Kusturica's *Time of the Gypsies* was screened. I watched it alone, on the second day it played, in that movie theater built in the 1960s. My eyes welled up as the fantastical, extraordinary fiction by Fellini's son unfolded in image and sound, narrating the story of how the predicament of the poor seems to invariably compel their life journeys to be subsumed by the world of the wealthy. That day, rain dripped — as it would have in Andreï Tarkovsky's cinema — from cracks in

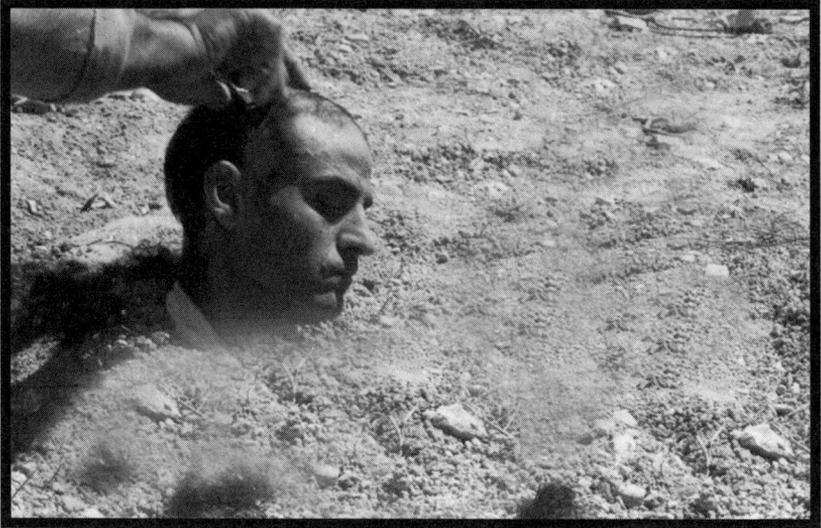

Layali Ibn Awah (*Nights of the Jackals*) by Abdellatif Abdul-Hamid, 1989.

the ceiling and onto the empty, metal seats. Later, word spread amongst the students of drama, fine arts and architecture. They flocked to the theater with their parents, whose generation was the last to experience cinema in Syria as a vibrant social and cultural manifestation in the 1970s. That was before television emerged, conquered, and established its absolute rule, before the deterioration of movie theaters, the collapse of social life, the dwindling of the middle class and the coercion of the culture of mobilization through the pervasive medium of TV. All before the decline that began in the 1980s.

They flocked, those who could still remember the Italian political cinema of the 1970s, the films of the generation before the Soviet thaw, the French New Wave, and stellar Italian auteur cinema. They came with their sons to watch the film by the filmmaker whose country was crushed by war, in a movie theater whose fissured ceiling let slip streams of water. Then they went home, and sought his films on videotape and DVD and they watched them in their homes.

Droplets of water falling on the surface of a swamp become part of it.

Total film production in Syria numbers around one hundred and fifty movies. A third of these films are commercial, produced in the 1960s and 1970s and intended for popular consumption, aping Egyptian productions. A third of that third were produced by the National Film Organization, an arm of the state. Today, this entity is the sole producer of cinema in Syria. In the 1960s, after the establishment of the National Film Organization for Cinema, and continuing into the 1970s, two general thematic motifs guided film production that was by then fully cognizant of cinema as a field of cultural expression. The first motif centered on the representation of national and patriotic issues, particularly the

question of Palestine. The second motif focused on the adaptation of literary works by celebrated contemporary authors (such as the Syrian Hanna Mina, and Palestinian Ghassan Kanafani), and generally produced films of medium quality.

In the 1980s, a generation of filmmakers returning from studies in the Soviet Union, Czeckoslovakia and France emerged. In the span of a quarter century, they elaborated a new cinema that marked a decisive turn in the legacy of Syrian cinema both as an art form and as a cultural representation of the modern history of Syria. This essay examines some principal features of these films.

In one of his most well-known short stories, Zakariya Tamer, a doyen of modern Syrian literature, tells the story of a tiger in a cage whose trainer toiled for ten days to transform him into a citizen. Near the end of the story, Tamer writes:

> And on the ninth day, the trainer came carrying a bunch of grass, tossed it into the tiger's cage and said: "Eat."
>
> The tiger said: "What is this? I am a carnivore."
>
> The trainer said: "From today onwards, you will only eat grass."
>
> And because hunger gnawed at the tiger, he tried to eat the grass. He was shocked by the taste, and walked away repulsed, but he returned a second time, and began to get used to the taste, little by little.

On the tenth day, Tamer writes:

> The trainer disappeared, and so did his pupils, the tiger and the cage; the tiger became a citizen, and the cage, a city.

Syrian filmmakers come close to resembling that tiger on his ninth day. Their cinema, produced by the state, tries to capture Syria and lock it into a moment of confrontation, one that pits the citizen against authority in the entirety of its social, political and patriarchal implications, laying out a terrain that is the exclusive ground of the adversary, who at the same time, is the ruler.

They proclaim their belonging in the face of the unacceptable — it is not frigid and it changes in tandem with the movement of life — but with the passage of time grow accustomed to the taste of grass, just as the tiger did. Their films are no more than a genuine extension of themselves, their ethical commitments, their drive to say everything at once in its totality, and their ongoing anxiety between narrating themselves or the collectivity. Such is the cinema of Mohammad Malas, Oussama Mohammad, Samir Zikra, Nabil Maleh, Riyad Shayya, Rémond Boutros, Abdellatif Abdul-Hamid, Omar Amiralay, Maher Keddo, Nidal el-Dibs. Their films are an interrupted scream voiced in the language of cinema from within a cinema that is not an industry but has remained an artistic practice, a cultural

endeavor pressed by need into a landscape where cultural production has been hostage to a crisis for thirty-five years.

Most of these fifty-something-year old filmmakers have wagered that they are still in their ninth day. Meanwhile, a new generation of filmmakers has come of age at the beginning of the twenty-first century, without movie theaters or a collective memory of Syrian cinema, and with an outlook on the world mediated through the tenuous bias of the media (at the forefront of which are the satellite networks). Cinema appears to them as essentially material for television.

The cinema of the last quarter century in Syria — and it can rightly be called the real Syrian cinema — is essentially an auteur cinema, borne of the particular circumstances of being produced by the state and only barely disseminated through a relatively non-existent network of distribution (given the size of the population). In other words, it has lived without an audience. As such, these films were never expected to generate revenue because the state regarded them as not-for-profit cultural ventures. In comparison with the reality of any living film production, Syrian auteur cinema experienced a dual schism: detachment from an audience at the level of consumption, and detachment from the audience at the level of time. These features accentuated the cultural value of that cinema, such that it has been well received by Arab elites and has traveled the festival circuit garnering acclaim, and often enough, earning awards.

The films produced in the last quarter of the twentieth century earn their distinction as *the* Syrian cinema because of the artistic maturity of their creators, a generation of students repatriated between the mid-1970s and the mid-1980s. After a brief experience with making documentary and short films, filmmakers ventured into fiction features.

This is the path taken by Samir Zikra who made his first fiction film, *Hadithat al-Nusf Metr* (*The Half-Meter Incident*, 1981) early in the 1980s, followed a few years later by his second feature, *Waqae' al-'Am al-Muqbel* (*Chronicles of the Coming Year*, 1985). With Mohammad Malas's *Ahlam al-Madinah* (*Dreams of the City*, 1983), Syrian cinema produced its first thoroughly accomplished artistic film. The film distills all the attributes of Syrian fiction cinema up to now. An auteur film, it chronicles the childhood of the filmmaker as he travels with his mother and younger brother from the town of Quneytra to live in the lodgings of their stingy and narrow-minded grandfather in the city of Damascus, in the 1950s. With this film, Syrians discovered the delights of auteur cinema for the first time, its richness in recording and recounting memory, and particularly the

Rassa'el Shafahiyyah (Verbal Letters) by Abdellatif Abdul-Hamid, 1991.

memory of a society that had acquired independence recently and was in the throws of coming of age and coming into consciousness. We witness the tribulations of Deeb, the hero, who takes leave of the world of childhood to contend with a city of men. A little Syrian Hamlet protecting his mother, in one of the most poignant moments in the film, he bangs his head against the stubbornly locked door, desperate to open it.

The story of Deeb, his mother and brother, and stories like them, become the sites where auteur cinema manufactures its interpretation of and relationship to the modern history of Syria. Fiction auteur cinema at once undertakes the role of documentary cinema in recording and capturing Syria, narrating the personal stories of its authors, all the while forging an artistic form to represent the complex mosaic that makes up the identity of the country.

In their engagement with cinematic form and genre, these filmmakers mastered a universe of references, and deploy them with clarity and intensity. Andreï Tarkovsky, who graduated from the same Muscovite film school as Mohammad Malas, Oussama Mohammad and Riyad Shayya, would have found multiple resonances to his film, *The Mirrors* (1974), in Mohammad Malas's ambitious but uneven second feature, *al-Leyl* (*The Night*, 1992). Similarly, he would have also found echoes in Oussama Mohammad's

persistent use of mirrors in his two features, *Nujum al-Nahar* (*Stars in Broad Daylight*, 1988) and *Sunduq al-Dunya* (*Sacrifices*, 2002). Sergeï Parajdanov is a looming reference — to the point of adaptation — in Riyad Shayya's unique feature, *al-Lajat* (1995), whose events are set in the southern Syrian province of Suweida. The grotesque cast of characters in *Stars in Broad Daylight* (Oussama Mohammad's first film), and their ragged proletarian brutishness recalls Ettore Scola's *Ugly Dirty and Bad* (1976). Finally, Nabil Maleh's piercing *al-Comparss* (*The Extras*, 1993), is the staunchly Syrian version of Scola's *A Special Day* (1977).

Encased in a structure heady with layers, the films' thickness was compounded by the filmmaker's fear that he might not be granted the opportunity to make another film for at least a decade. Syrian filmmakers have been forced into a real test of maturity: would cinema be a means, or would the act of fabrication become an end in itself? This dilemma has illicited different responses from different filmmakers, but together they constitute the corpus of Syrian cinema and speak volumes, with precision and bitterness, about how it constitutes a national cinema.

The experience of Abdellatif Abdul-Hamid stands out as an exception. Very recently (spring 2006), he completed his seventh film in a fourteen year career. His films have plotlines that are usually uncomplicated, set alternately between the coastal rural environment, from which he hails, and the urban environment of Damascus, where he resides. The simplicity in narration and dramatic structure verges on a delightful naïveté, and springs from his understanding of cinema as chiefly an art form with popular appeal, that has to have a comedic and unabashedly local dimension. His films are the only ones to have garnered a real audience in the last twenty-five years. His first two films, *Layali Ibn Awah* (*Nights of the Jackals*, 1989) but especially *Rasa'el Shafahiyyah* (*Verbal Letters*, 1991), generated something not unlike to a phenomenon in the late 1980s and early 1990s. Screening at the state-owned film theaters (the al-Kindi theaters), the films ran for months to audiences who discovered either the coastal lore casting a reproduction of Cyrano de Bergerac, or a comedic film about a man with a large nose from a countryside threatened by extinction.

Abdellatif Abdul-Hamid's real talent is in the way he weaves stories. This stands in stark contrast to Mohammad Malas, Oussama Mohammad and Riyad Shayya who produce a cumbrous and laborious cinematic narrative that demands an effort from the spectator. In his film *The Night*, Mohammad Malas imagines a series of memories that the film's narrative tries to depict as they intersect, combine and clash. In *Sacrifices*, Oussama Mohammad mythologizes a rural coastal realm whose characters seem forged from within

a fantastical *ex-nihilo*, suspended in a timeless unidentifiable landscape. Riyad Shayya also constructed a sealed realm, using visual compositions and a drama that teeters in an undefined and timeless netherworld (even though the film's script was inspired from a novel by Mamdouh 'Azzam, one of Syria's most mature writers today).

The demands of such a high register of artistic process are compounded when filmmakers are impelled to address the political. Many films touch upon turning points in Syria's contemporary history, particularly on unification with Egypt in 1958, which paved the way for the establishment of absolute authority by a single political force, and the consequences and implications of the 1967 defeat in the face of the Israeli army.

There is an interesting pattern worth noting: Malas's first film, *Dreams of the City* is set in Damascus in the 1950's, his second film, *The Night* returns to his native Quneytra in the 1940s. Oussama Mohammad's first film, *Stars in Broad Daylight*, is set in coastal southern Syria, in the 1980s (the time when the film was being made), and his second film is set in the same socio-cultural setting but in the 1950s or 1960s. Rémond Boutros's two films are set in the city of Hama, the filmmaker's hometown. His first film, *al-Tahaleb* (*The Greedy Ones*, 1991) is set in the present, while in the second one, *al-Tirhal* (*Exodus*, 1997), he returns to the time of his childhood in the 1950s. The pattern reveals a movement, where the filmmaker delves farther into his subjectivity in his the second film, to investigate more deeply his relationship to his native socio-cultural milieu.

One film that does not follow this trend is Nabil Maleh's *The Extras*. Maleh had authored three films produced by the National Film Organization for Cinema in the 1970s and 1980s, set in the countryside and in the city. In 1993, he presented a film set in an apartment. A well-drawn exercise in the genre, classically structured, the film is articulated using three elements: time, place, action. This asceticism in the relationship to composition allowed him to penetrate deeply into the landscape of everyday life in Syria over the past few years.

A man and a woman in their thirties meet in an apartment they do not own. For the first time in a six-months-long love story lived strictly in public spaces, the man sees the woman's hair unveiled. The encounter takes place under the constant intimidation of societal indictment and a real threat of authority, embodied in a police officer who, at the end, bursts into the apartment. The film's hero is a man who works as an extra at the national theater outside his hours of employment, and when a police officer attempts to detain his neighbor, a blind 'ud player, the officer strikes him for intervening. That neighbor's music is heard through the walls of the apartments throughout the film, and during the amorous encounter that remains unfulfilled.

There is an economy of basic elements in this sequence, that endows the cinematographic language razor-sharp precision. We see it also in the sequence where a simple country boy disappears like an insect in the spray of pesticide in Oussama Mohammad's *Stars in Broad Daylight.* We see it in Malas's *Dreams of the City*, as the young boy, who is trying to fit into the city of Damascus is forced from childhood to manhood at the instant of the unification between Egypt and Syria. The city that robbed him of his childhood, also tries to rob him of his mother. We see it again in Rémond Boutros's *The Greedy Ones*, when a crime is perpetrated in the middle of the day, in a court of justice. Similarly, the motif of a son's death on the frontlines in the war with Israel is repeated in Abdellatif Abdul-Hamid's two films *Nights of the Jackals*, and *At Our Listeners' Request*, where the son's grieving father remains captive to the alternating pulls of embittering authoritarian grip and disarming tenderness.

Throughout these works, as they tell the story of the film and their own story at the same time, there is a frustration in Syrian cinema that recalls the tiger's frustration with having to eat grass. In a sense, the only tiger to have escaped from the cage is Omar Amiralay, the only documentary filmmaker in Syrian cinema. Alone, he represents the counterpoint to fiction cinema.

© National Film Organization.

Al-Comparss (The Extras) by Nabil Maleh, 1993.

Beginning with his first film *Film-Muhawalah 'an Sadd al-Furat* (*Film-Essay on the Euphrates Dam*, 1970), until his most recent accomplishment, *Tufan Fi Bilad al-Ba'th* (*A Flood in Baath Country*, 2005), he has made some twenty documentary films of varying lengths. As the only filmmaker strictly dedicated to the field of documentary cinema, his relationship with the medium sees a means and not an end. For Amiralay, there is invariably an affiliation with the subject of each film, whether he is presenting an analysis of the social structures of rural life in Syria and its poorest population, as in *al-Hayat al-Yaomiyyah fi Qaryah Suriyyah* (*Everyday Life in a Syrian Village*, 1974) and *al-Dajaj* (*The Chickens*, 1977), creating portraits of important figures who have now passed on, such as the late Syrian author and playwright Sa'adallah Wannus or one of the Syrian film pioneers Nazih Shahbandar, eulogizing French sociologist Michel Seurat or depicting the Lebanese civil war in its most poignant and grotesque moments.

Amiralay's cinema goes beyond the borders of Syria and Lebanon, to Egypt, Yemen, France and Pakistan. By virtue of both genre and conscious choice, direct representation of this filmmaker's self is the least present across the body of Syrian cinema. In their recording and representation of a social milieu, the films are never an occasion for the filmmaker's self-realization. Rather, they represent a coherent discourse on the world by a Syrian artist who studied in France, witnessed the tumult of the student revolution in May 1968, and who has internalized the imprint of these events. They inform his sensibility and drive, most tangibly palpable in the defiant fighting spirit that animates his most recent film, *A Flood in Baath Country*, where he returned to his first film, *Film-Essay on the Euphrates Dam*.

In one of the rare moments where the filmmaker cast himself in a film, it is so that he can explain why he returned to that first work. This is the only instance where his cinema is itself the subject matter and material for another film. Amiralay confesses that he regretted the elegiac music in his first film as he celebrated the Euphrates dam, ultimately an engine for the stumbling development policy of the Syrian state. This painful critique between self and subject is reflected in the contrast between sequences of children brimming with hope as they draw the dam in the first film, and the sequences thirty-five years later. It is also reflected in the coercion of children in an educational system guided by a total ideology that seems to lock in the tragedy of their reality. The singularity of Amiralay's vision and style does not represent the totality of the Syrian reality. In his complete disenchantment he comes close to drawing a totally hopeless representation. The structure of his film is motivated by a detachment, an emotive distance, which he establishes between himself and the subject, and coupled with the desire to provoke, cast a

Sunduq al-Dunya (Sacrifices) by Oussama Mohammad, 2002.

Qabl al-Ikhtifa' (Before Vanishing) by Joude Gorani, 2004.

face to face confrontation. And yet, there is another side to the coin, and perhaps *The Extras* presents that other side, in the imaginary of fiction cinema.

Despite the space afforded by his withdrawal from the outside world, Nabil Maleh's hero, who works as an extra, does not succeed in fulfilling the expectations of a hero. In Amiralay's documentary cinema, individual members of the tribe that effectively governs the everyday life of its members rush to perform the role of the citizen-extra. As Samar Sami, the actress playing the female lead in *The Extras*, turns her gorgeous face to avoid witnessing the humiliation of her beloved at the hands of the police officer, love is presented as the tenuous site where life tries to sustain itself. The motif of love as the transgressive other side of the coin of hopeless despair recurs in the sequence of the love story between two youngsters in Oussama Mohammad's *Sacrifices*. Filmed within a shroud of magic, freckles flow from a young girl's cheeks to imprint on her beloved young boy's shoulder. As children walk to school in the thick mud, we see life enduring, drawing force from love.

The image of children going to school in packs is another familiar motif; it appears in *Dreams of the City* and *Exodus*, in Oussama Mohammad's first ever film, *Khutwa Khutwa* (*Step by Step*, 1978), and in Amiralay's *Everyday Life in a Syrian Village*. In *Everyday Life*, the camera hones in on a child who limps into the room-sized school. One of those children is the now emerging cinematographer Joude Gorani. She is the first woman who has chosen to specialize in the field in Syria. For her graduation project at the FEMIS (Ecole Nationale Supérieure des Métiers de l'Image et du Son), she directed a documentary on the Barada river, the river that cuts through Damascus and is now nearly extinct. The young filmmaker tracks the Barada from its source to its end, where it is supposed to flow into a small lake. That small lake is nothing more than a desiccated crater of desert-like earth now.

The movement in space of her short film rehearses the reverse path taken by Amiralay in his latest film. He returns to the "source" of his film career, and she to the river. In twelve minutes, she cuts through Damascus with the same incisive thrust that Amiralay's filmography has cut through Syrian cinema for thirty-five years. Between the artificial Lake Assad behind the Euphrates dam and the desiccated crater where the Barada expires, the destiny of Syrian cinema waits suspended in its ninth day. Despite all the calamities and difficulties it refuses to reach that tenth day, when "the tiger became a citizen, and the city a cage."

CÉCILE BOËX

ORGANIC POETICS IN SYRIAN CINEMA: SUBLIMATION AND DISTORTION OF THE BODY

T he body is amongst the plastic, shifting elements that constitute the raw matter with which filmmakers manufacture the seventh art. To tell a story and represent a vision of the world, implies a staging of the transformation and movement of bodies. Under the filmmaker's direction they are rendered seductive or monstrous, frozen or bouncing. While the theater stage brings the spectator into a concrete physical proximity with the bodies of actors and beckons the totality of their bodies, with cinema, representation of the body is piecemeal, its expressive potential multiplied with the tools of the craft, like various fields of focus, framing, editing, and montage. This text will examine recurring motifs in representations of the body in Syrian cinema with the aim of specifically interrogating the process of transformation or alteration that bodies are made to endure in the narrative of film. What are the schemes in the mise-en-scène that filmmakers use to make actors' bodies seem different, attractive, disturbing? And what is the significance of these metamorphoses, considering Syrian cinema is an expressive form borne in an environment where expression is coerced into compliance with normative paradigms? And finally, can the cinematic body be regarded as a vessel for the communication of controversial speech? In Syria, all forms of expression aimed at the public sphere are subjected to the monitor of censorship that exercises its authority in a more or less straightforward manner, and influences creative expression. The feat of Syrian filmmakers is having carved out, each in a deeply personal style, an unabashedly individual gaze on their society, in spite of the environment in which they live and work. Syrian auteur cinema is well-known for its familiar recourse to metaphor, which has earned it the attribute of being a difficult, not very accessible cinema. By pushing back boundaries that constrain expression and clearing a new space, filmmakers have resorted to what can be described as "the art of circumlocution," which consists of suggesting rather than divulging. In the particular attention vested in the bodies of actors, their gesticulations and alterations, an attempt to convey meanings too controversial for conventional expression can be discerned. Making bodies convey meaning presumes a singular mise-en-scène (*mise-en-forme, mise-en-espace, mise-en-mouvement* –staging of form, staging in space and choreography of movement) where the body becomes extra-ordinary. The unconventional character of the cinematic body is what I propose to investigate and interpret. More

79

Al-Massyeda (The Trap) by Wadih Youssef, 1980.

precisely, I will focus on two approaches in the mise-en-scène salient in the corpus of Syrian auteur cinema: the idealization of the female body as it emerges in amorous relationships, and the estrangement of the body in the casting of atypical, unfamiliar characters.

The Utopic Dimension of the Desired Body

In Syrian cinema, the time of adolescence and first loves corresponds to a golden age where everything is still possible, where protagonists are still under the impression they have control over their destiny. The feminine element acquires value gradually, in the guise of discovery and enchantment, which eventually inspires all sorts of transgressions of social convention. Heroes have to be audacious and ingenious to engineer an encounter alone with their love interest, removed from the disapproval of the family, neighborhood or village. The locations of these encounters are invariably atypical, their time span furtive or at least limited, accentuating the intensity of the exceptional nature of the experience. More often than not, the camera conveys the point of view of a masculine protagonist, whose gaze is subjugated, smitten by a femininity presented as natural, spontaneous, and essentialized. The camera scrutinizes, lingers on a nape, tracks the details of a gait, marvels at the exposure of a naked half-leg. The genre of feminine beauty is accessible, shed of all artifice, and the figure of womanhood is associated with the purity of a love that is obvious, natural. Female protagonists are staged to enact a specific posture and attitude; they pull

away a headscarf to reveal a magnificent head of hair, the ring of their laughter is sharp and confident, and they have a special delicate way of sipping coffee or deterring an insistent stare.

Actress Samar Sami incarnated this type of character in the films *al-Massyeda* by Wadih Youssef (*The Trap*, 1980), *Hobb Lil Hayat* by Bashir Safiye (*Love of Life*, 1981) and *al-Comparss* (*The Extras*, 1994) by Nabil Maleh. In these films, she played a young woman from a modest urban milieu who lives a love affair in secret that will eventually remain unfulfilled because of extraneous elements and events. The young romantic heroines in *Rassa'el Shafahiyyah* (*Verbal Letters*, 1991) by Abdellatif Abdul-Hamid and *Sunduq al-Dunya* (*Sacrifices*, 2002) by Oussama Mohammad were more enterprising. The rural environment of these films provides a variety of options to stage one-on-one encounters. In the countryside, the beauty of the heroine echoes the beauty of the natural landscape. In these films, the young women are the initiators, as if they actively provoke the passage from childhood to adolescence, a passage made almost magical in *Sacrifices*. Their beauty is at once enchantment and enchanting, it evokes joie de vivre, insouciance and imaginary worlds. The gestures of grace, confounded with intimacy and stolen freedom, are fragile

Sahil al-Jihat (*The Journey*) by Maher Keddo, 1993.

and ephemeral, and in the end, their promise turns out to be illusory. With subtle staging of composition in space, *The Extras* shows the impossibility of this kind of individual happiness or fulfillment of a desire that springs from individualism. The apartment that serves as a haven for an amorous encounter between the two protagonists confines their bodies in a constrained space that is supposed to be protective. Intrusions of all sorts from the outside world tirelessly recall the precariousness of that space. Throughout the narrative, the space becomes gradually reduced, physically as well as symbolically, until it collapses with the police charging in.

At once refuge and realm of transgression, the amorous relationship reveals the constraints of social reality. The idealized form of femininity speaks to the passion, the romantic drive and imaginary that emboldens protagonists to extract themselves momentarily from their reality and forge their experience of individuality in the intimacy of that relationship. It also speaks to the filmmakers' nostalgia for that period of discovery, when all was possible but now is definitively concluded. Thus the feminine figure is construed from within a romantic pessimism, a notion developed by Norbert Elias in *The Court Society* (1983). The book explored in an entirely different context, how individuals subsumed by the constraints of their environment express disempowerement by idealizing the past. The idealized figure of woman charged with nostalgia, in Syrian cinema, reveals perhaps the profound disenchantment of the filmmakers with the idealism of their youth, whether personal or collective. Mostly, it attests to the difficulty individuals face in constituting themselves as subjects on the margins of established authority, whether in the purview of family, religion or the body politic.

Staging Estrangement of the Bodies: Loss of Signification

The second approach in mise-en-scène consists of presenting characters and the bodies that incarnate them as strange, disturbing. Omar Amiralay's documentary *al-Dajaj* (*The Chickens*, 1977) is particularly illustrative of this approach. The film traces the mutations villagers endure after venturing into the intensive farming of chickens with support from government grants. The filmmaker carefully exposes the alienating rapport that develops between the farmer and his labor, as well as the inhuman character of this type of capitalist production. With complex montage, using wide angle and sound, he draws a parallel between the chickens and the farmers, who find themselves on the verge of collapse when prices drop in the official market. Subjects appear deformed, anamorphosed by extreme close-ups. In the last sequence, the farmers' testimonials are entirely drowned out by the clucking of chickens. Distortions in the presentation of farmers might suggest

the filmmaker's antipathy to them, but it might also convey his denunciation of the dehumanizing nature of this mode of economic production. The effect, or approach, akin to zoomorphism, is also used in *Sacrifices* and *Verbal Letters*, where protagonists take on animal-like physical features. The mother of the young tyrant in *Sacrifices*, played by Hala 'Omran, is a surreal character. She is convulsive, almost repugnant, with nervous tics, and she squeals and speaks in hiccuped panting. In *Verbal Letters*, the character of Ismaïl, played by Fayez Qazaq is also unusual but more compelling and endearing. He is the village idiot who lives with his widowed mother. His oversized nose resembles a beak. His posture and gait, the upper body leaning forward, the neck tall and clear, underscore a resemblance to birds. These characters are completely foreign to familiar social convention, their behavior seems to be chiefly guided by instinct and they are more or less disconnected from reality, which sometimes affords the space for humor and comedy.

The estrangement of the body is particularly elaborate in *Sacrifices*. The film begins with the agony of a patriarch who seems entirely disconnected from civilization. He dies without endowing his name to his descendants. The film follows the ensuing competition between family members over the appropriation of the name, which would bequeath to its beholder the grandfather's power and authority over the clan. The first sequences of the film show the expiring body of the grandfather, at the same time that two sisters-in-law are giving birth. The villagers are bound in sobs and incantations. The sequence is striking and the spectator is awed by malaise and anxiety, sentiments further accentuated by the use of feeble light, a recurring motif in the film. Oussama Mohammad's camera is vested in fragmenting the bodies of his characters with close-ups on eyes, hands, faces, and feet. In a recurring sequence we see a hand that gropes to move forward, yet we never find out whose hand it is. The filmmaker also frequently plays on the reversed reflections of characters in mirrors.

The same approach is used in *Sahil al-Jihat* (*The Journey*, 1993), by Maher Keddo, a film that traces the quest of a young woman looking for the brigands who raped her after they destroyed her home and killed her parents. The presence of the young woman in improbable places astonishes those who cross her path, to the extent that some think she is a supernatural creature. Her quest seems nonsensical. She also seems to have severed ties with humanity; contacts with fellow human beings are reduced to a minimum. Sometimes, she is welcomed by people who show compassion for her grief and encourage her aim to get justice. Her identity is undetermined, suspended: throughout the film, she remains *bint al-nas* (somebody's daughter), literally meaning respectable young woman. Gradually on her journey, she grows weary and her belly begins to protrude; she is carrying a child from

the rape. Dispossessed of all that constituted her identity by the murder of her parents, she is also dispossessed of her own body. In some frames, her body seems to dissolve in the landscape. The film's narrative is structured around the loss of identitarian bearings and the confusion of spatial and temporal coordinates. Similarly, in *al-Lajat* (1995), Riyad Shayya's highly aesthetic treatment of the image, with the fixed camera and slow movement of bodies and narrative, characters appear as if they have been imprinted in the austere mineral landscape of the basaltic plain of southern Syria, as in a still life painting. The protagonists are stiffened with the weight of identity, in an ancestral mode of life and a stifling, plethoric belief system.

The "estranging effects" applied to the cinematic body decenter the gaze and allow a distance, creating the space where critique can be voiced. In this eschewed and alarmed manner of apprehending society, these films interrogate postulates, modes of identification and representation taut with conventional perception and coercive norms. The bodies, twisted, dissolving and petrified, express without words a real loss of bearings and a genuine alienation. They seem to ask the terrible question: is that distance still possible? As such the poetics of the body in Syrian auteur cinema, which sometimes resorts to sublimation and other times to disfigurement, can be read as an image that speaks the disenchantment of filmmakers with their society, a critical point of view they cannot voice with the plain conspicuousness of words.

This text was presented at a conference on the theme: *Body and Identity, Representations of the Body in Arab Culture*, organized by the Institut Français au Proche Orient (IFPO) in Damascus, held January 21-22, 2006.

THE FILMMAKERS

Al-Makhdu'un (The Dupes) by Tawfeeq Saleh, 1972.

SCENES FROM LIFE AND CINEMA

I was eight years old when a solider slapped me for refusing to give up my turn on a swing at a public playground. "No!" I said, and he hit me. In my place, he put the son of his superior officer. I didn't cry and I didn't complain to anyone. I found a small rock, tossed it at him, and ran away. That "no" became my lifetime companion, and that uniform, my eternal enemy. As for the small rock and the silence that comes with wounded pride and coercion, they became the only weapons that would accompany me for a long time.

At nine years old, I went to my first protest for Palestine; many other protests would follow, along with beatings from policemen and short-term detentions. At ten, I began drawing and writing after I was told that the rule of justice and human dignity could be achieved. Since then, I have remained loyal to those ideas. At fourteen I published my first poem, in the Lebanese newspaper *al-Sarkha,* and at fifteen, I became one of the first political cartoonists, the editor of a newspaper, and the writer of a weekly poetry column. And so, in those days of innocence and reverie, the dream was complete, perfect, my own dream merged with the collective utopia. We were dedicated to changing the world.

At seventeen, I went to study nuclear physics in Czechoslovakia, then switched to film directing; it was an adventure. I was the first to seek that specialization in a socialist country at his own expense — a subject without foundations or industry in my country. There, I learned two things: how to acquire the professional and artistic means to express individuality — this was extremely rewarding — and how to resist the draw of following the pack. For that, most of my life, I have paid a heavy price.

That perennial "no" held me back from joining a political party or organization, and I could never accept commands from anyone. Thus, I could never become a civil servant.[1] My adversarial relationship with authority grew and acquired a weight that imprinted on my journey. I came to believe that art, because of its kinetic power, its drive for discovery and rebellion against the prevailing and the familiar, would always be in opposition to official art, to the values and aesthetics sanctioned by a regime in power, regardless of its political identity, because authority is always conservative, even in its most progressive forms. This conviction lodged me invariably in a position of conflict with the authorities at rule. I am forever indicted by the regime because I was deemed a leftist and

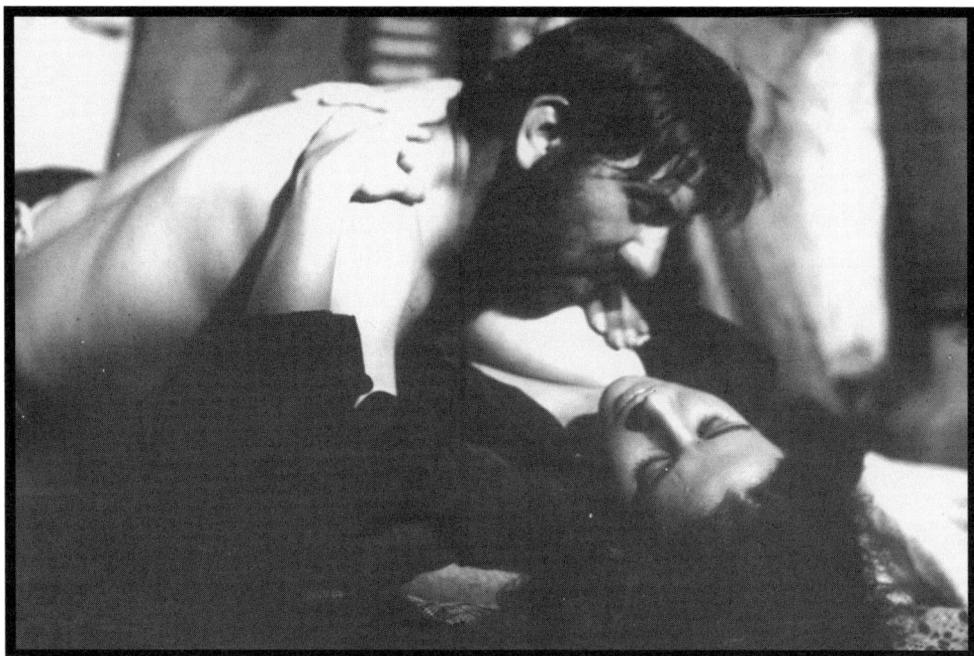

Al-Fahd (*The Leopard*) by Nabil Maleh, 1972.

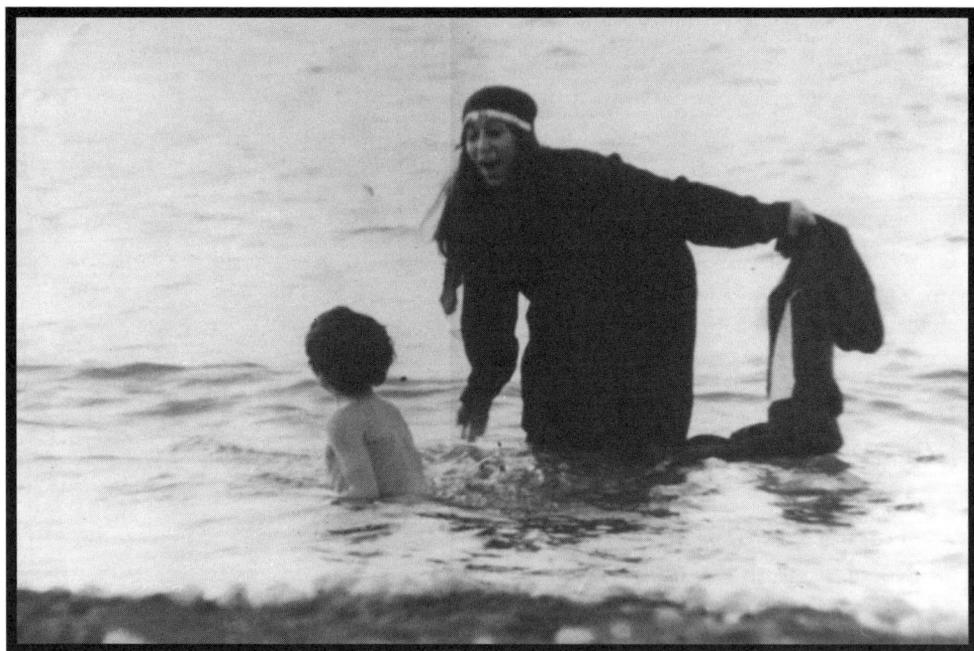

Baqaya Suwar (*Fragments*) by Nabil Maleh, 1979.

had to wage a battle on a daily basis just to exist. At the same time, I was indicted by the leftists because I was never affiliated with their groups. I stayed on that path that did not please anyone.

Al-Fahd (*The Leopard*, 1972) fulfilled a number of goals at once. In truth, it was the first full-length Syrian feature film for the National Film Organization, just as much as it was the first film to earn a worldwide audience and global distribution as well as numerous awards from different festivals. Its most meaningful reward was that it generated a phenomenon without precedent in Arab cinema. From 1972 until now, it continues to be shown in theaters. Syrian cinema waited more than twenty years to witness similar popular success with the film *Rassa 'el Shafahiyyah* (*Verbal Letters*, 1991). With *The Leopard*, I was able to innovate with language, dramatic construction and cinematographic vocabulary vis-à-vis Arab cinema. It was especially illustrated in the contradictory relationship between the external world and the internal world, the individual "no" and the collective "no." In the film, my hero loses the battle against backwardness, stupidity, the absence of collective consciousness, the fragmentation of the social order, individual opportunism and shortsighted selfishness. He loses that battle, but on a moral and human register, he is victorious. As I write this text, I realize that all the heroes in my films share a similar fate — in *al-Sayyed al-Taqaddumi* (*The Progessive Man*, 1975), *Sakhr* (*Rocks*, 1977), *Baqaya Suwar* (*Fragments*, 1979), and *al-Comparss* (*The Extras*, 1993). I can't help but wonder if I was foreseeing the potentiality of my own personal defeat?

The beginning of the seventies held a lot of promise and many dreams: we endeavored to build a culture of cinema, we sank foundations for competent and analytical interrogation of film, we brought to life the Cinema Club and turned it into a platform for bold thinking, and turned its modest publication *Film*, into a platform for insightful critique. More importantly, we were able to set standards for film production at the National Film Organization for Cinema. Back then, working in film was not only about making films, it was about laying the foundations for a national cinema. In 1972, we organized the first Damascus Film Festival and made its slogan "alternative Arab cinema" to herald a different cinema in the Arab world. There were many filmmakers whose films had roused attention. At that time, the National Film Organization seemed a uniquely promising institution in the Arab world. It was inevitable that the illusion would collapse, stifled by an inept and constraining administration. As to the promising Arab filmmakers at the festival, for the most part they disappeared and only memories of their orphaned films linger on.

Until the mid-1970s, the outreach aspect of the Organization had been restricted to sending bureaucrats to attend international film festivals without sending any Syrian films to participate. Bureaucrats and opportunists managed to paralyze the organization entirely. In the 1970s, I was barred from working for about four years, and yet I managed to make three feature films: *The Leopard, The Progressive Man,* and *Fragments* — in addition to a number of short films that I, as well as many critics, consider unique in the production of short films in the Arab world.

Every film I made has its own special character, I was always searching for new expression and no two films I directed are alike, but there is a unity in style. These short films that I am proud of have won many international prizes, like *Ikleel al-Shawk* (*Wreath of Thorns,* 1969), *Napalm* (1970), *Iqaʻ Dimashqi* (*Rhythm,* 1970), *al-Loʻbah al-Azaliyyah* (*The Eternal Game,* 1973), *al-Nafithah* (*The Window,* 1974), *al-Hajara* (*The Stone,* 1976), *al-Daʼirah* (*The Circle,* 1977), and *al-Madrasah* (*The School,* 1978), but some were not rescued from crucifixion. Besides the censorship applied to *The Progressive Man, The School* and *The Circle* were banned.

By the mid-1970s there were signs that the dreams borne in the founding of the National Film Organization would collapse in the hands of bureaucrats. Meanwhile intellectuals had fallen into the trap of petty ideological conflicts. After calling for democratic practices, they began to pursue the most malicious kinds of tyranny against one another. Distracted, they did not pay attention to the alliance between radical reactionary political tendencies and salafism[2], which planned to pursue terrorism around the beginning of the 1980s. The regime was able to thwart them at that time and rescued the country from what other Arab countries endure now. The intellectuals lost their credibility for one reason or other, and failed to form a tightly knit block, bound by basic principles.

At that time, I emigrated again. I was granted a Fullbright scholarship and taught as a visiting professor at the University of Texas in Austin, then at UCLA. I later moved to Geneva, Switzerland, and after a year there, I found myself with my small family wandering like gypsies in Europe, searching for a temporary homeland. Finally, I arrived in Athens, where my temporary but stable residency lasted for more than nine years. During this new period I created television programs and a feature length documentary titled *The History of a Dream,* in which I examined the unfolding of the concept of freedom across cultures, from ancient times to today.

During the last three years in Greece, I tried to work on establishing an Arabic satellite channel based in Athens. I hoped it would become a center for Arab creativity to counter the backwardness, salafism, fundamentalism, and fragmentation that reigned over

Al-Comparss (*The Extras*) by Nabil Maleh, 1993.

the Arab world. The project consumed three years of my life and career, but it was doomed to become one of many martyrs in the battle with the petrodollar and everything else represented in backwardness, fragmentation, and retreat.

In 1992 my forced emigration ended, and I repatriated home to direct *The Extras*. The film was successful; it won five awards internationally and played for a good while in movie theaters in Damascus. During my exile from the homeland, a few important Syrian films had been produced, their number is laughable — five or six films in ten years. Their authors had found opportunities to manipulate Syrian film production to suit their own interests. The films, in my opinion, were good, but none was groundbreaking; they lacked the boldness, and courage of the films made in the 1970s. I remember the description for the role of the "artist" given by a Czech writer (whose name escapes me now), where he likens him/her to the bird that miners carry with them into the depths of the mines. He is their living warning system, if the levels of poisonous gas reach dangerous heights, the bird is the first to suffocate. The filmmaker in Syria should not be different from a prophet for his society; he ought to shoulder the weight of responsibility for the fate of his nation no matter what the circumstances. Like the bird in the mine, whose mission is fulfilled only when he dies, I wonder what my project as a filmmaker was, and where it has gone?

What has driven my filmmaking is a search for a new cinematic language, which I feel I have barely begun to discover even after so many years working in the craft. As a

Syrian filmmaker, after a thirty-year long career I am still fighting for a life with dignity without having to become a civil servant. Thirty long years where one never knows if another opportunity for work will be granted. As filmmakers, we have all become scattered islands, without a shared history or collective concern. The decay that has been gnawing at the Arab world has caused us to drift apart, separating us from one another. I doubt that any filmmaker has come close to achieving his or her cinematic ambitions. The quest for an identity, an individuality, a language or dream has been impeded with the search and begging and pleading for funding from outside the country or the struggle for opportunity from inside. My filmography includes nine long films, ten short films and several television programs. On my shelves sit dozens of prizes, stacks of articles and a mirror that tells me I have the strength to create for another forty years. Yet, the films, the prizes, and the articles all appear to adorn the coffin of a dream, because the dreams of justice and equality have been defeated and the darker forces have won in the Arab world. Backwardness and the law of the jungle seem to prevail with legitimacy now. The aesthetics we defended have lapsed and in their place now the aesthetics of the market rule. Our own spinal cords have failed us, and we have become like gelatinous animals that fit into the mold of anything. The thrill of the quest, discovery, debate, questioning have lapsed and the culture of subservience prevails. Petrified values of profiteering and salafism have claimed control. True, I am one of many who continue working and I remain optimistic. I draw my strength from the drive to save my soul and not to change the world. Pablo Neruda comes to mind:

Like every passing life
Perhaps my life has mingled with an illusion
The blood shedders, they killed my dream
Like a legacy, I leave behind my wounds

In this country, it is pointless to speak of a "cultural scene." Culture is like politics: it suffers from lack of vision and a program, and has stood still on the sidewalk of the world, participating only like an outsider would, by applauding, crying, wailing, protesting, reactive, never with any initiative and prospect. We are the underdeveloped passive receiver, with nothing to say to a world that seems to have done away with this region and forged a new world order with new cultural, economic and political maps. It is we who have placed ourselves at the margins, not the West. I am reminded of the familiar stories of how when someone is taken as suspect in Europe or America the immediate assumption is that he is an Arab. The significance of the attribute, in its cultural and political connotations, as well as the geographical realm it alludes to, is totalizing. The Arab world is a collection of jagged

states caught in inertia. And filmmakers are but gangs and islands that are culturally impaired because they live in states ruled by regimes that have enforced their monopoly over a cultural production that no longer carries the political aspirations of ordinary people. This is the reason political and cultural life has reached the state of decay we endure at present. Culture has to reclaim its visionary power, even if it threatens to break the status quo. Before we speak, look, suggest and point fingers, we need to understand the basic structure that shapes cultural life in this country. Thirty years ago, cultural life thrived with activity: seminars, lectures, poetry readings, books, film screenings, and so on. True, these activities were available only to an elite, but they were not subsumed to the values of the market. Rather, they were the organic output of artists and intellectuals and expressed the yearnings of people. Furthermore, they were plural and diverse in the political visions or trends they represented. The overall circumstances changed, and the tools for dissemination of culture and art also changed. New rituals of reception have emerged, as well as greater apathy in the general public, an apathy fostered by and to the benefit of the regime. The media, which strictly disseminates the credos of authority, propagates a representation of the world that bears no relationship to the reality of life in this country. Its slogan: "Sit. Relax. We'll provide your entertainment and thinking for you." There is profound concord between the satellite television stations and Arab regimes on the values they inculcate, the apathy they promote. Moreover, Arab governments maintain a perpetually reactive state with regard to the international community; I have not heard of an Arab action that has provoked a reaction since the October War of 1973. Intellectuals and the means afforded to them are completely marginalized, and the entire Arab world now waits in anticipation of some outside event to react to.

Amongst the many reasons there cannot be an intellectual and cultural renaissance in the Arab world is the absence of a political vision to support it. The future of Arab societies is managed in small, shortsighted steps, in answer to petty and immediate needs, without a real plan or vision. The simplest component of democratic life, civil society, is fragile and marginal because regimes hold the monopoly over public debate and political engagement. The satellite television station that I once hoped to establish was intended to be an oasis for democracy, a platform for an Arab intelligentsia to find refuge. It predated the profusion of satellite television stations today and it aimed to fight against all that plagues the Arab world today.

I am often asked about my position vis-à-vis the peace process between Palestinians and Israelis. I remember how in the 1950s and 1960s we were bound in our dreams of unity and the intellectual was regarded as the guardian and herald of political

projects. Today, the intellectual seems suspended in a vacuum. In my opinion, if intellectuals are to reclaim their role, they have to be bound in a common project, divorced from the current predicament of Arab states. With regards to peace with Israel, intellectuals have generally been excluded from participating in and shaping the debate. Personally, I think peace is necessary, but I believe that the war has not ended, and the Zionist project is still actively pursuing its ends. Peace is now a mere continuation of the state of war. We cannot blame Israel for the state in which the Arab world is right now; Arab regimes have to be held responsible for denying the rights of citizenship to their people and robbing them of their political agency. In that, Arab regimes have helped the advancement of the Zionist project.

The complicity between the media and Arab regimes and the dominance of market values have silenced true intellectuals and artists, while others have transformed into civil servants and contractors. There are no alternatives, and none seem permitted. Intellectual, moral, artistic and aesthetic pollution drowns the landscapes of cities and countryside. I believe that something — an explosion — will happen, because it is not possible for human beings to accept these living conditions for much longer. At least these have been the lessons of history. A light will emerge from beneath the clutter, the pollution. My dreams have not changed despite the fact that I witnessed the collapse of shared illusions. Syria is the only country I can call my own, and I am stubborn to the furthest extent. There is a lot I would still like to accomplish, and I know there are many like me in the Arab world. We draw our strength merely by virtue of knowing that we are out there, alive.

The Arabic original version of this text, titled "Mashahed min al-Hayat wa al-Sinama," was published in 'Alam al-Fikr, a publication of the Kuwaiti National Council for Culture, Arts and Literature (Volume 26, Issue 1, July-September 1997, pp. 194–201).

Notes

1 Translator's note: By civil servant, Nabil Maleh implies official enrollment to the General Organization for Cinema and enlisting to the corpus of employees of that government administration.

2 *Salafism* is a fundamentalist ideology amongst modern political Sunni Islamist movements that advocates a return to the "pure" practice and dogma of the three first founding generations in the emergence and rise of Islam (known as "the Righteous Predecessors"). *Salafis* insist they are a movement not a sect and are sometimes identified as *Wahhabis*. The etymology of the word is from the Arabic *salaf*, which literally means predecessor or early generation. One of the basic tenets of *salafsim* is that Islam was perfect and complete at the days of the Prophet and his companions, but that undesirable "innovation" was added to Islam afterwards, the movement seeks to revive that original practice of Islam.

WERE IT NOT FOR CINEMA

I am of Ottoman origin, a brew peppered with Circassian, Georgian, Turkish and Arab ethnicity. I was born in Damascus in 1944, a stone's throw from the mausoleum of our great sheikh, Muhieddin Ibn 'Arabi, engraved with his spiritual yearnings, graced by his cosmopolitan disposition. Since I became a filmmaker, I have cultivated a ritual; I proffer two slaughtered sheep to his pure soul, every time I am blessed with a film. Today, my equity nears twenty films, accomplished over thirty five-years of labor in the métier of cinema.

My childhood was spent in the Sha'lan neighborhood, a few paces from the historic building where the Ba'th Party was headquartered and where today a boutique selling ready-to-wear fashions has settled in its place. In our modest Arab-styled home, the largest windows opened onto the main thoroughfare, always busy with movement and people. To distract me from asking for my mother, who was always away at work, my brother pinned me to these windows, where I grew up curious, observant, captivated with watching people and life, noting details of our neighborhood and our neighbors' everyday

Tufan fi Bilad al-Ba'th (A Flood in Baath Country) by Omar Amiralay, 2003.

95

UN FILM DE
OMAR AMIRALAY

LA VIE QUOTIDIENNE DANS UN VILLAGE SYRIEN

SCENARIO
SADALA WANNOUS
OMAR AMIRALAY
IMAGE:
ABDO HAMZE
HAZEM BAYAA
MONTAGE:
KAIS AL-ZOUBAIDY

Production-Distribution: L'Organisme National du Cinema Syrien-Damas 1972

Al-Hayat al-Yaomiyyah fi Qarya Suriyyah (Everyday Life in a Syrian Village) by Omar Amiralay, 1974.

life. In particular, I watched the owner of the *Inqilab Pharmacy* (Coup-d'Etat Pharmacy), whose restlessness with the stability in the country became rabid after the putsch and rule of the Correctionist Movement.

A serene childhood unfolded, with ample space for avocation in the lives of others, engrossed with the facts and stories of their lives, proving what little truth there is the silly popular adage that claims: "Those who observe the lives of others, die of worry!"

My father was a police officer with integrity; his life was abruptly cut short on the Douma Road in 1950, as he chased the notorious one-eyed smuggler, Lawrence Sha'lan. My father — may he rest in peace — bequeathed to me nothing but the whistle he used on the job, and profound contempt for authority and the band of politicians, military and clerics who pursue its exercise, adepts of absolute power who minister the life of the nation and believers with might.

Speaking of the nation and its upheavals, it pains me to inform you that I live in a country steadfastly marching on its hooves to its own demise, after it was betrayed by its rulers, deserted by its brainpower and abandoned by its intellectuals, thinkers and artists! A country captive for more than a half century to a conflict with Israel. The first half of that half century was endured in political tumult, suspended and waiting for the struggle over power to settle out and for the engagement in conflict with Israel to commence. The second half of that half was politically stable and suspended in waiting for the conflict with Israel to resolve, for just rule to establish itself.

This predicament, I believe, harmed me and many others like me. It dictated imperatives and informed choices we made in our artistic practice as well as in our lives which we never wished for ourselves. One such choice has been my proclivity for documentary film from the beginning of my engagement with cinema. Eventually, contact and exchange with people as well as engagement with reality transformed this choice into a deep conviction, and I have come to believe, that a mere mortal such as myself could not imagine a fiction with characters and a plot more enchanting and powerful than that which happens in the crucible of the everyday. All my films were conceived out of a desire for a dialogue with life and people, wherein questions and doubts were raised, and characters and events reclaimed their history, resurrected from obsolescence, forgetting, or denial.

My engagement with cinema has also been animated by a different creative impetus, namely, a search for understanding guided foremost by doubt and skepticism. That skepticism I deem to be one of my virtues, not a coin for sin, like those who have relegated their quest for understanding to absolute truth-values laid out in books. The truth in every fact or postulate is suspicious, ambivalent, relative, and ought to be subjected

to the test of investigation, history, and accountability. This is one of the reasons my films lie in the liminal space betwixt documentary and fiction; they are crafted with the compulsion to coax ambivalence and titillate doubt.

In short, my cinema is essentially no more than a mischievous jest at life; an exploration in human nature, which never ceases to mesmerize me with its mystery and complexity. An album of photographs, a ledger of testimonials, a record of emotional outbursts, that hoard a bitterness veiled by an upright haul of dignity and courage. I never gave in to compromise. Irony was the ruse I used to confound despair with vanity, the stratagem I schemed to rise above my wounds, deny failure, impotence, refuse to surrender in the anguish of life, and rebel against the predicament of reality around me. My cinema, in other words, is no more than my expression of scorn at the despair and tyranny that governs life around me, and the role of man in compounding it with more hopelessness and abuse.

Lastly however, I must confess that were it not for cinema, I would not have trudged in the muddy terrain of my reality. I would not have known human nature and loved humanity. I would not have learned the simple truth that I am part of life, and not the reverse. Cinema tamed my natural penchant for impetuousness and existential despair, and broke the untoward self-centeredness of my gaze. Were it not for cinema, I would not have let myself, for all these years, drift with abandon in the illusion that it has the ability to bring change or make a difference in art and in life around us.

OMAR AMIRALAY,
THE CIRCASSIAN, SYRIAN, LEBANESE

Caustic. Omar Amiralay uses sarcasm to thwart bitterness so deep it can subdue expression. He almost never smokes, and his appetite for food and drink is barely perceptible. In the company of others his sartorial disposition suggests asceticism, a youthful, muted felicity veils his real age. He travels from one place to the next seemingly with the weightless agility of a runner, but it's just the way he is, the way he carries himself. In his tireless excursions between the Syrian, French and Lebanese capitals, his films have drawn him to cross more borders. He is unencumbered with considerations of exile and memory. Of Circassian origin, carrying Lebanese and Syrian passports, he stands amongst the vanguard of Arab documentary filmmakers. The films he has directed since the start of the 1970s have imparted to Arab documentary cinema an idiom of constant renewal and courage, animated by the desire to provoke, interrogate, probe and galvanize.

After he completed *al-Hayat al-Yaomiyyah fi Qaryah Suriyyah* (*Everyday Life in a Syrian Village*, 1974), *al-Dajaj* (*The Chickens*, 1977), and the script for *al-Qaramitah* (*The Qarmatians*), Amiralay settled in Paris. There, he worked with French television stations and the scope of his work widened to include a number of pressing issues in several Arab countries. His approach to poignant subjects like the contemporary social conditions of women in Egypt in *al-Hubb al-Maow'ud* (*The Sarcophagus of Love*, 1984) and the rise of radical Islamic fundamentalism amongst immigrants of Arab origin in France, in *al-'Aduu al-Hamim* or *L'Enemi intime* (*The Intimate Enemy*, 1985) raised much controversy. Uncontroversial, however was *Masa'ibu Qawm 'inda Qawm Fouad* (*The Misfortunes of Some Are the Fortunes of Others*, 1982), his film on the Lebanese civil war, which remains one of the most compelling documentary films on the subject.

In 1990, he completed his documentary on Pakistan, during the rule of Benazir Bhutto titled, *A l'attention de Madame le Premier Ministre Bénazir Bhutto* (*To the Attention of Madame the Prime Minister Benazir Bhutto*) and then he became involved with helping his friend Mohammad Malas in the production of *al-Leyl* (*The Night*, 1992) through his company, Maram CTV. At the time of this interview, he was in the throws of preparing for his first fiction feature, inspired by the biography of the legendary Arab singer, Asmahan. At the same time, he was planning to start shooting a documentary on the slain French sociologist, Michel Seurat. This is where our conversation was supposed to start from, and

yet, we found ourselves going much further back.

We begin with childhood. What is the first scene you return to now?
It is almost a fantastical image, not in its chronology, but in its location. I saw a touring bear trainer in Jounieh.[1]

His identity?
I think he was a *Metwellite*.[2] Or maybe he was a Gypsy.

On what grounds?
We were told that *Metwellites* showcased animal acts and roped their goats with bells.

Did you insist on calling Shi'ites Metwellites?
It was common practice then. The referent *Metwellite* did not have a religious connotation in a sectarian mindset. In popular parlance, it referred to people who lived in misery. Before the emergence of Moussa el-Sadr,[3] I did not know there were Shi'ites in Lebanon. In fact, for a long time, I did not even know there were Sunnis and Shi'ites in Islam.

Why did you choose the scene with the bear-trainer?
It came spontaneously. I did not choose it. I am not bent on nit-picking through the details of my recollections. I don't really pay them a great deal of attention. I firmly believe that what lapsed, has died. Memory conserves things. Consecration threatens truth-value.

Do you believe the scene with the bear-trainer has the currency to signify a particular meaning?
It implies two elements: spectacle, and recording time and place through the bias of what I see.

You identified Jounieh as the location of that scene in your childhood. What was its image then?
I am suspicious of the documentary accuracy of the image. I fear it may be a compositional montage. I can recall it now as the setting for the *Frères* school, overlooking the sea. Its buildings were covered with red-tiled roofs, in the old French style. In the courtyard of the school, my friends and I are watching the slaughter of a pig.

Is that all?

This is what seems anchored in my imaginary. More than that, I can only recall that I was dressed in a French sailor outfit. On my head, I wore a white hat with a red tassel.

Were you very fond of the sea?

Not at all. To me, the sea was never more than space. Not something sensate.

And the sailor outfit?

It was the fashion then, a legacy of the Second World War. I believe parents have dressed their children in sailor outfits since the turn of the century.

Were you born during the Second World War?

I was born in Damascus, in 1944.

You spent your childhood in Jounieh, why?

That is another story. I will spare you the details, but the gist of it is that my father is Circassian and my mother Lebanese. My maternal grandmother lived in Jounieh, isolated from her family and society. To entertain her, they dispatched me to spend time with her. For four years, I lived in her company.

Why was she isolated?

I was a child, and I do not bother keeping up with too many elements in my memory.

Why?

I was used to perform a role I did not choose: to be my grandmother's entertainment. My mother offered me to her.

Did your grandmother have particular traits?

I don't remember a single feature. I only came to understand her personality recently. I learned to value discovering the person she was with candor and purity, unhindered by the bias of memory or accumulation of images. It was more like a revival of her personality.

Was she beautiful?

Yes. The only feature I can remember of her beauty is her white skin.

Your account of that bracket in your childhood does not include reference to your parents.
I was five years old when my father died. I did not know him. He was a detective, killed in a car accident chasing smugglers on the Douma road. He and five of his colleagues died when their anti-smuggling squad pick-up truck overturned. A tramway conductor witnessed the accident. He reported that he was just outside his house when he saw a man in the far distance, a bayonet gun hanging on his shoulder, stagger four or five paces and then collapse onto the ground. The conductor did not realize the man had lived the last breaths of his life. Moments later, he discovered that the gun was not slung over the man's shoulder, but rather that its bayonet had perforated the man's neck. That man was my father. He died young, he was thirty years old.

Do you know more about your father?
He was a strange man. I regard him more as my mother's husband than my father. I am in awe of the image he left behind. I am told he was eccentric, loved to drink and liked to live large. He regarded work with contempt, despised authority and responsibility. These are the attributes that explain my affection for him. Had he been a tender father and model employee who wanted to own a car, I would have surely despised him.

You said he was Circassian. What is the extraction of your family name and how did he end up with his family in Damascus?
"Amiralay" was the military rank of my grandfather, and it became our family name. By the way, my grandfather, my father and I share the experience of having lost our fathers early. I don't know when my grandfather's story began. I know it started in the Caucasus. He was ten years old when his uncle accompanied him to Istanbul and placed him in the guardianship of his aunt who was one of the sultan's wives. He was enrolled in the military academy, at a precocious age in his adolescence. His record is rich in the service of the sultanate and he was promoted to high posts. He was appointed military commander of the Ottoman army contingent in Yemen for the period of eight years. During his tenure there, a truce between the Yemeni resistance and the Ottoman army was signed and the province experienced stability. Prior to the collapse of the empire, he traveled to Damascus, where he met and married my grandmother. I was always surprised by that love story. She was moderately beautiful, but his passion for her blinded his heart, and because of her, he was stripped of his title as *pasha*.[4] When the sultan's court received news of his betrothal, a missive was issued demanding his return to Istanbul. His reply was to send his military suit to the Sublime Porte[5] and stay in Damascus.

From your grandfather to your father, your family bequeathed service in the military?
There is no tradition of attachment to the military in our family. My grandfather relinquished his military glories for the love of a woman. My father took after my grandfather. Military service was the employment venue for minorities. In the old days, minorities were recruited into the security forces based on the assumption that, by virtue of cultural or ethnic difference, they would not harbor bonds of solidarity with Arabs and would be more amenable to mobilize against the native population.

And how did your mother and father come to meet?
It was my mother who eyed my father first. Their first encounter happened by coincidence, during a family visit to the *Muhajereen*[6] neighborhood of Damascus. She had accompanied her parents and sat next to a friend of hers. As she prepared to take leave, she caught glimpse of a young man with a tall, straight gait, wearing an English coat climbing the stairs in their direction. When my mother asked her friend who the young man was, she was surprised to learn he was her brother. After that, the conventional procedures were undertaken to consecrate the marriage.

What was it about him that attracted her?
His shoes. They were white and black shoes; he was a pioneer in wearing colored shoes. That pair of shoes would later become the source of much anxiety in our household. Because of them, my father was fired four times because he refused to leave the house before he made sure they were clean and shiny. I have inherited this quirk from him. Strange. In my mother's opinion, people inherit personality traits and character. I did not know my father, but he imprinted on me his obsession for clean shoes.

Before she was married to your father, what did your mother do?
She was schooled at the Italian nuns' school in Beirut, but she had to interrupt her schooling when she had to take her mother's place in their household. To this day, she is frustrated because she was prevented from completing her education.

She was beautiful?
People say she was attractive and her femininity caught men's attention. Her dramatic family experience caused by the explosive blossoming of her mother's own femininity, induced her to regard that attribute as an ill. I think she repressed her femininity. The sacrifices she endured to raise her children and her attachment to the image of the giving

mother are embodiments of that repression.

After the passing of your father, she decided to remain in Damascus.
She did not think about Beirut. Damascus was an exile for her. She came to belong in the milieu of minorities, she had to learn Turkish and meld into my father's family.

How many children did she carry?
Two. I have a brother who is six years older than me.

In the absence of a father figure, was she harsher in your upbringing?
My mother is a woman of principle. She inculcated in my brother and I the notion that there are principles in life that don't acquire their full meaning unless they are coupled with equal endorsement of selflessness. She was not Circassian but she passed on to us the intransigent rectitude of Circassians, an ethnical typing widely regarded as lore. Of course, as with any education that follows prevailing societal norms, there was repression in a traditional sense. My brother's rebellion as well as my own, has led our mother to understand in these last few years, that different value systems don't necessarily detach human beings from a commitment to fundamental morality in life.

How was your relationship with your brother?
Ideal. I owe a great deal to him. To some extent, he is the one who corrected my choice of what I wanted to do with my life. If it weren't for him, I would have joined the army.

The army?
Yes. I was smitten with commando operations. With challenge. I was attracted to heroism. Also risk-taking. Surely, if I had gone down that path, I would have either died younger than my father, or participated in the first military coup!

Where does your sarcasm come from?
From a blissful childhood, where I did not experience anxiety, and where I was given the space to become involved with others and observing people. This was the window from which I engaged with life.

By looking?
I spied. I was a peeping Tom. I mean I was always curious about truth in how human beings

related to their self. Despite the superficiality of that vista, it is a visual medium that was useful in teaching me to read reality and people, and later, in making films where the ability to read characters from their mannerisms and outer expressions is tested. I suspect that my eye was born before my heart; that my eye came to life from my mother's belly, before my head. The eye needs distance to see accurately. That is why there is always something that detaches me from people and things.

How does that affect your relationship to women?
Women, in general, or woman, were basically bewildering. Prior to the last ten years, my knowledge of women was superficial. For 38 years of my life, my interest in women was invariably secondary.

Did your mother's image prevail?
I was like someone watching an Olympic contest in strength: women competing in a race. None could break the record my mother had established years earlier. If I continue with this analogy, nothing can sever the primordial and epidermal hold of a man's relationship with women, until he faces his first failure with a woman who has pushed him to ask himself profound questions. Questions that reflect on the failure of the relationship with her, not necessarily anchored in the shortcomings of what women bring to bear, but rather because you are unable to understand her and unable to define an open relationship, deep, equal, and free from the hold of the prevailing prejudice and social codification embodied in the relationship with the mother and its ideal-type lure. The emblem of the mother hides a bitterness that transcends the noble values associated with motherhood.

When did you begin to discover women?
Suddenly. And only in the past ten years, I discovered without being aware of it that I was more keen on choosing women as a subject in the films I have completed during that period. I owe my discovery of women to cinema. If cinema were a woman, I would have married her.

For years now you have been working on a feature-length film on Asmahan. I have the feeling that your heart has fallen captive to her.
True. She is the first woman with whom I have fallen in love. Since I brought up the motif of record figures, all that draws me to a woman now are virtues associated with Asmahan's persona, from near and far. Asmahan's principal feature lay in her being essentially

shrouded in paradox, even her physical beauty was riddled with contradiction. She is the embodiment of ambivalence in the transition from women's conservative disposition and an idealized figure of motherhood; the woman versus the ideal. Without a doubt, she was a mother, but she was also able to embody a full-hearted engagement with life.

Your words exclude references to her body.
This is the only thing I have not succeeded in forging for myself, namely extracting a view independent from prevailing norms. I feel I am laggard on that level, I am like other men.

A popular adage amongst filmmakers is that making cinema is like making love.
When I hear these things, I hate cinema.

What seduces you in cinema?
I came to it by coincidence. It was not something that fascinated me during my childhood. Then, all cinema to me was cowboys and lone figures, western films. My life is a humble stream that flowed in the river named cinema.

When did you decide to study cinema?
I studied with reluctance. I had applied to study journalism, but was rejected. I had to study something. And because I was a visual artist, I chose cinema and enrolled at the IDHEC[7] in Paris.

That was in spite of your will?
I don't like to be taught anything. At the IDHEC I developed a reputation, I would rarely sit through a class until its end, I would sit in the last chair. My class peers can attest that for seven months I never took off my coat.

If that was the case, how did you manage to finish your studies?
My tenure at the IDHEC ended a year after I enrolled. The events of May 1968 forced the closing of the IDHEC. With that, and despite the restlessness that gripped me, I left the IDHEC convinced that I would work in cinema. The problem was vanity. But the decision to pursue filmmaking as a career came by accident. At the end of the school year, our teacher in film direction was well-known French filmmaker Jean-Pierre Melville. For the exam assignment we were asked to produce a treatment for *Le Cercle Rouge*. The treatment

involved transforming the text into a script with detailed specifications on the technical requirements of camera angle, set design and costumes. Melville carried away our dossiers and returned fifteen days later. As was his custom, he looked like a character in a detective film, and I remember distinctly that he came in wearing a trench coat, hat and dark sunglasses. That day, he took off his coat, folded it as if he were rehearsing Humphrey Bogart in noir films, and tossed it away from him. He removed his glasses and his hat, and tossed them on top of the coat. After he went through the dossiers of a number of students, my turn came. I was surprised to hear him say that if he had to do the assignment himself he could not present a better treatment than the one I proposed, and he ended the class by lecturing about the element of suspense in film directing.

After that exam, you stopped studying cinema.
Soon after, I purchased a camera. I was galvanized by the actions of students in the streets of Paris in May 1968. My first film captured the first stone that protestors extracted from the Latin Quarter. I presented it to the office of student protest set up in the Sorbonne. The second time I took my camera, on my way to meet protests, I caught a mob making its way from the Luxembourg (gardens) and I began to film, sequence after sequence, the destruction, the extraction of trees, and the confrontations with the police. The strangest thing about the story is that I was filming without a roll of film in my camera! Imagine! I was aware of it, but it was my way of asserting my presence. I chose the position of the documentarian and was taken with that role. This accident led me to realize the pointlessness of art and cinema in overwhelming moments like the events of May 1968.

Your motivation for filming the student protests was a political imperative?
My contact with the political occurred in the street. I understood the notion of the political through the student movement in the street. Either I would join them or begin to engage in politics, but all of this was the beginning of the reckoning that life was the wellspring of art and knowledge.

Did your political engagement begin with the film Everyday Life in a Syrian Village, *or was it the reason for your return to Syria and to make films there?*
Everyday Life in a Syrian Village was my own political redemption from prior sins, because I had not paid attention to the tragedy of people. Or that was my thinking then. Before *Everyday Life,* I directed a film on the Euphrates river dam. After that film, and even at some point in 1968, I had met Sa'adallah Wannus[8] in Paris and he would soon become a great

Al-Dajaj (The Chickens) by Omar Amiralay, 1977.

friend. We decided to work together, as soon as he returned to Damascus, on the communities that were more representative of our society and its weaker link, namely, the peasants. Our choice was more ideological than artistic, and this is how *Everyday Life* was born in 1970.

Until when did the ideological choice no longer prevail?
Until I completed the film *The Chickens*. With this film, vanity overpowered ideology.

It was a vanity that clearly announced the return of sarcasm.
My sense of irony never faded. Sarcasm became itself the ideological framework. I no longer viewed people and life from the purview of philosophy. I used the cast of irony to represent symbols of authority, religion and backwardness. I quickly became aware of what I was doing and reclaimed the philosophical essence of irony, never sparing anyone, neither authority nor people.

How do you regard your early work?
A few years ago, I watched *Everyday Life*. I noted its shortcomings and recorded them; I criticized it as if I were seeing it for the first time, or as if I were not its filmmaker. With the passage of time I have become more a spectator than a filmmaker.

Do you think that you made your films as you wanted to in Syria?
Absolutely, and as if there was no censorship.

But you left and settled in Paris to make films.
I discovered that our regime was not very keen on temperament. The joke has to be aimed.

Who are the filmmakers you are most fond of?
Pasolini, Eisenstein, Orson Wells.

And the writers?
Tennessee Williams.

You have not mentioned an Arab name.
The human experience and philosophical depth of Tennessee Williams is, in my opinion, the distillation of the lived experience of writers in our part of the world. However there is not a single Arab writer who has been able to match the charge of even a short story's dialogue in any of Williams's works.

Why have you not directed a fiction film yet?
Perhaps you should ask me why I have not made a film, and which film? I have escaped the trap that has caught other filmmakers who suffer from the complex of the popular appeal of fiction cinema. I don't deny that fiction films earn greater recognition, fame and critical interest, and as such allow the self to grow and grow. But the cinema I have chosen is a controversial cinema, and I expect my films to be received negatively. Personally, I don't see that the emaciated audience of documentary cinema has an emaciating impact on the film-maker's ego. To me, making films is more important than ego and audience.

You persist with irony to the point of hostility.
Let's go back to irony. I use the sarcastic form on myself to alleviate the toll of pain, revolt, and rejection that the subjects we are discussing rouse. I am not an aggressive person. I would rather describe myself as caustic in the sense that irony is the salve against aggressivity.

How do you explain audiences' rejection, particularly Arab audiences?

Those who hate my films, profoundly, hate themselves. And if I expect that at some point this reaction will change, then I know I have receded from the essence of my vision of reality and my relationship to it.

Do you like to provoke your audience?

My intention is not to provoke the Arab spectator. All that I try to do is slit openings in dead skin. Only then are people able to verify if that skin is natural and if there is some life breathing behind it.

You carry two nationalities, Lebanese and Syrian, but you use your Lebanese passport when you travel. Why?

It accommodates my personality a lot more.

Do you feel your personality is less Syrian and more Lebanese?

It becomes less Syrian when I confront the conservative, retrograde mindset of Damascene society. I am closer to the Lebanese in their open-mindedness and their ability to absorb whatever is useful from the cultures and aesthetics of others.

What has a greater pull, your belonging to your Circassian identity or your Arab identity?

My mother represents my Arab constitutional element, but I am repelled when I feel that I belong to our era. I was never able to succeed as a basketball player, as an individual in a group. That too is one of the reasons I have never joined a political party.

Since you travel back and forth between Beirut and Damascus, how do you describe the way the Lebanese and the Syrians regard each other?

I see first an essential complementarity. As for the sarcasm, and grudge, they are the consequence of geographical, political and cultural cohabitation accumulated and acquired over the years. I mean there are no essential differences between them. And this is not an ideological claim. Personally, I don't find that there are any fundamental differences which draw the features of Arabs throughout the diversity of Arab societies.

Do you think that the presence of Syrian forces in Lebanon through the span of the civil war was enough to elaborate a collective memory... at least a collective memory of war?

Any remembrance animated by deprivation and envy is not memory.

Michel Seurat was your friend and now you are preparing a film on him. What do you have to say about the film and Michel?

The film is a letter to a friend after his passing. The title is *Michel, You Who Has Stolen My Love.* I will use a 16mm camera. It is produced by the European television station Arte. My friendship with Michel Seurat goes back years. He helped me with the translation of two films, *The Chickens* and *The Qaramatians.* Some time ago, a friend who is an artist, brought me a series of photographs of Michel taken in one of the gardens of the Ghuta.[9] You ask me what I have to say about Michel? Well. I stared at these pictures and concluded that his eyes were the most gorgeous I have seen in my life. And I will make this film for the love of his eyes.

This interview was first published in *Mulhaq al-Nahar,* the cultural supplement of the Lebanese daily *al-Nahar,* on April 10, 1993.

Notes

1 Translator's note: Jounieh is a small port in the eastern outer-suburbs of Beirut.

2 Translator's note: *Metwellite* is an old Arabic epithet for Shi'ite. Its contemporary usage is generally deemed derogatory, particularly in the Lebanese vernacular.

3 Translator's note: Moussa el-Sadr is a Lebanese Shi'ite imam who was a pivotal political protagonist in the 1960s and 1970s, a foundational voice for the Shi'ite community's political consciousness and empowerement on egalitarian grounds and inclusion in the Lebanese polity. He disappeared during a trip to Libya and remains missing.

4 An honorific title in the hierarchy of Ottoman society that granted significant privilege to its beholder.

5 The official apellation for the Ottoman government then.

6 *Muhajereen* is Arabic for immigrant. Late Ottoman Damascus had a rich diversity of ethnic residents, migrants from the Ottoman empire who settled in the city. Non-Arab residents were known as muhajereen and lived in clusters of neighborhoods, the largest concentration of which was in that particular one.

7 IDHEC is the acronym for Institut des Hautes Etudes Cinématographiques in Paris. The institution is now known as the FEMIS.

8 Sa'adallah Wannus is one of Syria's most renowned playrights and essayists. He succumbed to cancer in the late 1990s.

9 The Ghuta is an area at the boundary of Damascus and the Barada river. It was known for the beauty and luxuriance of its gardens because of the nearness to water and is a popular spot for outings.

INTERVIEW WITH OMAR AMIRALAY

Where does the idea for a film usually come from, your exterior or interior world?
We ought to recognize that when a filmmaker has acquired some currency in the profession, and her or his name has become familiar to the "establishment" of television production, then some of the freedom in choosing subjects has to be ceded if she or he wishes to pursue collaborations with these entities. In other words, she or he has to acquiesce for their ideas to sprout in a garden selected by others. That garden, in general, is the framework for the themes and subjects that are set in the annual production planning ledgers of television stations. This is the reality, and indeed true for some of the films I have directed during my humble career. But that has never implied that I agreed to renounce any of my artistic and intellectual principles and convictions, or that I have not succeeded in leaving my personal imprint on these films. Without a doubt, the ideal situation — more often than not the result is a singular and unique film — is when the theme beckons for the intertwining of the personal with the collective, and the film is borne from a moment whose chemistry is not the substrate of any consideration except for the filmmaker's pressing organic, visceral need to be released from its pressure. In all honesty, these are very rare moments in the career of any filmmaker.

How does the idea first take shape and grow? Do you have a familiar process you follow every time, or does every theme impose its own rules?
It is difficult for me to assert that I have a single rule that works for every situation, but surely every filmmaker has a pattern, particularly after years of experience. That pattern guides the initial and fundamental approach to engaging with any idea. For me, particularly considering my proclivity for questioning and inability to see things in anything other than relative terms — the furthest possible position from the folly of certitude — any idea is invariably subjected to tireless interrogation, testing, doubt and reconsideration before I settle on any conclusive judgment. Experience has taught me that the first solutions that come to mind, at the outset of any project, are those I return to after a long journey. The journey has to be undertaken precisely to rid one's mind of immature wanders that do more to hurt a project than enrich it.

Film-Muhawalah 'an Sadd al-Furat (Film-Essay on the Euphrates Dam) by Omar Amiralay, 1970.

After a film is finished, how do you evaluate the drift of the idea behind the project from its inception to its completion?

I can assert categorically that after completing a film, invariably, I have found myself, to be at a great distance from the initial conceptualization which instigated the film. In fact, I find myself confronted with a new idea, always without any connection to the initial one. When a documentary filmmaker abandons him or herself to the drift of the unexpected, this bears not only on a particular understanding of documentary cinema, but rather more importantly, it implies a philosophy of life based on a deep affinity for critique, a dialectical understanding of human nature, of the relationship to oneself, others and the living environment. It is a way of apprehending reality. It may seem antagonistic, defiant, but that is only on the surface. It is founded on a faith in the constant ability of reality to change, to tirelessly create stories, tales, mindsets, and surprises.

Do you need a special place to work and cohabitate with your themes in order to articulate them?

Usually, nothing except a film project has the power to extract me from the shell of my well-entrenched daily routine. Through the bias of working on a film, I reclaim a real and organic engagement with reality and people. I delve deeper with investigation and conceptualization. The demon of curiosity and observation suddenly awakens, and I plunge further and further to the point of obsession. I become part of it. That feeling does not leave me until the last moments of post-production.

Do you feel a special affiliation or sense of belonging to a particular place or region, and is there a link between that bond and your choice of themes?

The specific locale and historical moment of our birth is purely coincidental and by virtue of that, it is imbecilic to think oneself more fortunate to have been born in a particular place rather than anywhere else in the world and for the experience of that belonging to be construed as an exclusive privilege not afforded to others. In fact, tragedy occurs when that purely coincidental instance is transformed into a sacred cause, for which many are driven to their deaths, and nations are forced into awesome sacrifices. The question speaks to the primordial and instinctive, and is universal to the human experience.

The problem lies in the nature of our understanding of belonging. It is a philosophical, existential notion that deserves debate just like as any other that shapes our consciousness, but need never be a matter of life and death. Belonging is an act of will, not the product of instinct; some of us spend a lifetime without a conclusive determining of the concept. And here I would like to raise an important question: can an artist represent a specific place and its people that she or he has no cultural, historical or any other affiliation with? My experience in such situations is very limited, restricted to a single work I directed on a reality entirely foreign to me, namely Pakistan, for the film *For the Attention of Madame Prime Minister Benazir Bhutto… (A l'attention de Madame le Premier Ministre Bénazir Bhutto (For the Attention of Madame the Prime Minister Benazir Bhutto…,* 1989-1994). That experience taught me that an artist guided by prudence can bring forth an expression on any reality, as long as his engagement with the theme is impelled by an act of free will, humane and conscious.

Was your decision to return to Syria, after that lengthy residence in France, prompted by emotional considerations or a desire for intellectual regeneration?

The decision to return to Syria was motivated by two reasons: a love story with a Damascene, and a profound political and professional disenchantment that acutely questioned the purpose of pursuing life and work in France. Let's leave the first reason aside. The second reason raises many questions for me, not without a great deal of sorrow, on the significance and raison d'être of being an Arab filmmaker living in exile in a European country, working specifically for French television stations. My disillusionment occurred during the invasion of Kuwait and the second Gulf War, as I watched the French media's short-sighted coverage in general, but also the television stations' paucity of vision in their compulsively shallow pursuit of each day's events. I had been under the illusion for years that my work added to the body of work by other Arab filmmakers that would have accumulated to provide an alternative body of representations and meanings of our countries. I had hoped that in the medium or long term, they would serve to anchor the foundation for a more accurate and intimate understanding of what really goes on inside our countries.

When you complete a work, do you think about what the future holds for it?
One of my peers likes to deride the fate of my films and my relationship with the audience,

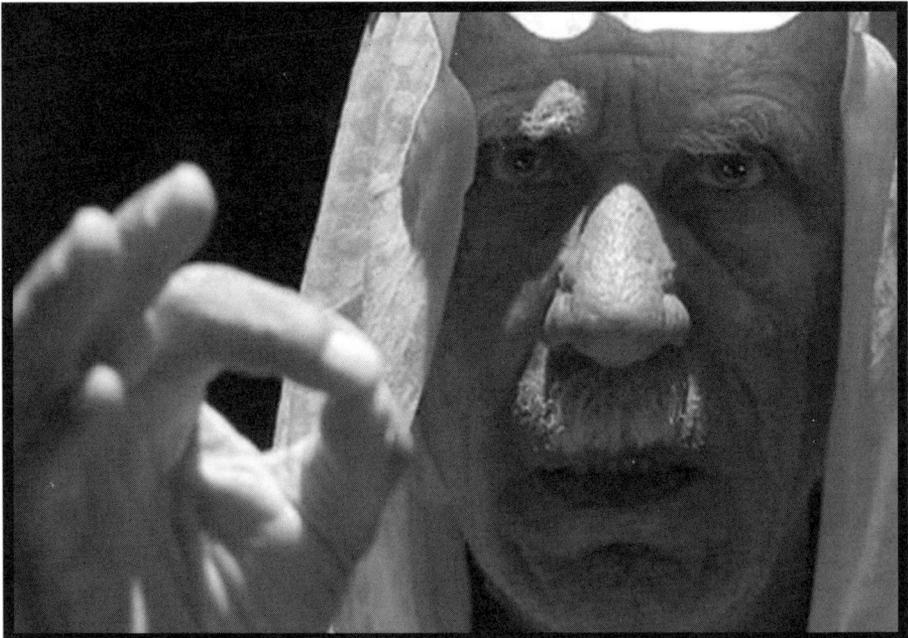

Tufan fi Bilad al-Ba'th (A Flood in Baath Country) by Omar Amiralay, 2003.

claiming that the predicament of my films is closer to those works attributed to gods than human beings, because only gods neglect their creations, while human beings care for them until they die. It is a correct observation — absolutely not indicative of membership in the club of gods — but reflective of my estrangement and divestment from finished projects. It is almost as if the adventure of conceiving the film completes its trimesters of gestation before the film is born. I am unable to experience concern for any of my works after they have been voided from my interior. I experience them like burdens on my shoulders.

Do you allow the concept to devise its own form, or do you design form to fit the concept, even if it is inspired from extraneous elements?
Form is the key to unlocking meaning or content, and not the reverse. Form is usually inspired by an image, a visual detail, a movement of camera, an element of sound, and sometimes even from the title of the film itself, which emerges even before another step is taken in a project.

What keeps the significance of a film alive with the passage of time? How do you explain people's appreciation for the two films Everyday Life in a Syrian Village *and* The Chickens *up until today, three decades after their completion?*
I live in a country where time has been stifled since its sun reached noon, and the sun dial in people's eyes arrested by the rule of a regime that came from the wilderness. And yet *The Chickens* has been granted a new lease on life, contrary to the wisdom of the laws of nature. Only in countries that deny endings and believe in the eternal life of convictions and leadership, is the life span of chickens lengthened, in reality, as is widely known, it is brief.

This interview was conducted by Hala al Abdalla Yakoub in October 2005, on the occasion of the 2006 edition of the Cinéma du Réel's special program in tribute to Syrian documentary cinema and the work of Omar Amiralay. The interview was published in the catalogue of Cinéma du Réel 2006 (Bibliothèque publique d'information and Centre Pompidou, Paris, France).

BETWEEN IMAGING AND IMAGINING, WOMEN IN FILM

In the attempts to sketch representations of women between image and imagination in the body of my literary and cinematic work, I have relied on the cinematographic texts from which my films were borne. These texts, effectively film scripts, have a literary value in themselves that I cherish. They hold within them preliminary sketches for ideas, events and characters and allow the reader to engage with a realm detached from theory or philosphizing, regardless of whether the films are familiar to her or him. It is also my conviction that the cinematographic text, or the literary film script ought to be regarded as a legitimate creative and literary expression in itself. The film is a distinct creative endeavor that may or may not follow the text.

From three literary and cinematographic texts, I tried to sketch a cinematic triptych that unveils a cinematic portrait of Syria, from the middle of the 1930s, the date of the Great Revolt of Palestine in 1936, until the beginning of the 1990s, the date of the second Gulf War.

In the wholeness of the triptych, as well as in each of its windows, I was looking for something fundamental that I felt has been lost in my quotidian life in this country.

In the first window of the triptych, with the film *al-Leyl* (*The Night,* 1992), I was looking for a lost place, namely, Quneytra, the village destroyed by Israel. I reconstructed it and recovered its life, cinematically. In the film, I chose to locate its biography in two time periods. The first period extends from 1936, the date of the popular insurgency in Palestine, and ends in 1949, the date of the first military coup d'état in Syria, the marker for the beginning of the disintegration of civil life. The second time period wavers between a memory desired, yearned for and a memory imagined, between the occupation of the city in 1967, its destruction in 1974, and today.

In the second window, with the film *Ahlam al-Madinah* (*Dreams of the City,* 1983), I was looking for a time lost. It is bracketed in the middle of the 1950s, when the first democratic elections took place in Syria. In the film, the search for that time is cast in a popular neighborhood in the city of Damascus. The film opens with the beginning of the end of the military dictatorship in 1952, and the intensification of the popular political movements that broke the back of this dictatorship and made elections possible. I end the film with the proclamation of the unification between Syria and Egypt in 1958.

In the third window, with the film *Sinama al-Dunya* (*Cinema al-Dunya*), a film that has yet to be realized, I was looking for a lost self through the vestiges of the memory of a brain in recovery from an affliction and the remains of an expired love story. I chose to locate that search for the lost self in cinema, the realm for creativity, imagination and love. The time frame was set during the Desert Storm operation.

In the triptych, the country was the imagined, and the figure of woman was the image. Both are imbued with the social and political reality of everyday life. The woman that I tried to draw and mold was inspired from female characters personal to my own private life, in each instance she is embedded in the time and locality specific to the film. Invariably these fictional women had the power to transcend the social milieu and locale in which they were inscribed, they belonged to my own existential, interior world and to my personal affection for women...

... At the beginning was Quneytra.

We never choose where we are born, or the markers that imprint our childhood. I was born in the city of Quneytra, it is the place where I inhaled and exhaled my first breath of air. The city is forever etched in my memory. In the universe of my memory, where the air is forever branded, the walls are burnt with images of the city, and its labyrinths haunted by the tragedy of its fate. Lingering as the gaping wound in the body of our country's imbrication with the tragedy of Palestine, images of Quneytra's living past and its collective memory merge with images stored in my own memory. In that photo album, the last image is of my father's grave. After my father's death and the city's demise, the etchings in my memory became mirrors, surfaces reflecting other images. My mother — the woman —, shrouded in the black of mourning, framed the flow of images and imbued them with scents.

After Quneytra was Damascus.

The first image of Damascus was framed by my mother's gait. Her body, her voice mediated my experience of Damascus in the 1950s, of that popular neighborhood in the city. In those days, life was brimming with infinite potentiality, everything intertwines in my memory, the hopeful dreams of a nation, backwardness, religion, political ambition, desire, love, decadence, and the colorful diversity of religious communities. Packed in that humble neighborhood, they grow more intense, embattled, gnawing at the body of the country and the labyrinths of my consciousness, my memory.

How did the image of woman take shape in the universe of my self? Who was she? Which of the lenses in my interiors captured her on film? With which colors, which light? Did her voice have an image?

In all my literary and cinematographic texts, I have always sensed that images in film and words in texts have a voice, muted and secret, woven in their fabric. I could even sense their touch, taste and scent, which I associated with my perception of women.

The Night

In the cinematographic text for *The Night* the woman is not merely one of the characters in the story, the story is her own, and she is the storyteller. When events have a narrator, the narration becomes also self-portrait.

A woman and a city from that time

Addressing her son, Wisal says:

"… Quneytra?"

"What was Quneytra like in that time?"

There were no more than five or six houses… and the French constabulary, the jail, the police station, the mechanical repairs garage and a handful of small shops. When my father boarded us on the bus and brought us to Quneytra, I was six years old. We all lived together, my mother, father, brothers and sisters in the mezzanine of the shop. A few years later he bought Abu 'Ajjaj's house. In that house there was neither water nor electricity. The house was all dust and darkness and mosquitoes and rats… We slept under mosquito nets on the floor.

Soon people started settling in Quneytra, they built houses! Why did they come? I don't know. What I do know is that we cooked meals for the prisoners, the constable, the translator, the appointed clerk, and the lieutenant… After we cooked the food, we covered ourselves with the mesh veil, and carried plates filled with food back and forth. I woke up to this world only hearing:

"Take the food to the jail!

Prepare the plates for the constable and the translator!

Chop the chick peas!

Pick the fava beans! Peel garlic! Fill the olive oil jars! Press the pickles! Wash the dishes!

And when I could steal a glance outside the shop, all I saw was my father, seated on a makeshift chair, the radio set next to him, his water pipe in front of him, listening to *al-Balad al-Mahbub Waddini* (*Oh Beloved Country, Take Me*).

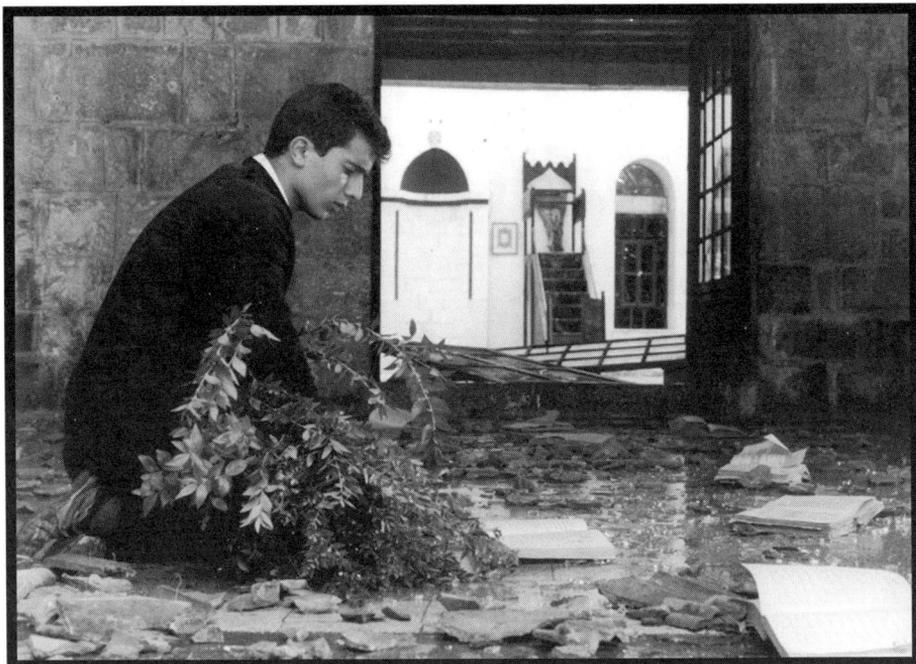

Al-Leyl (*The Night*) by Mohammad Malas, 1992.

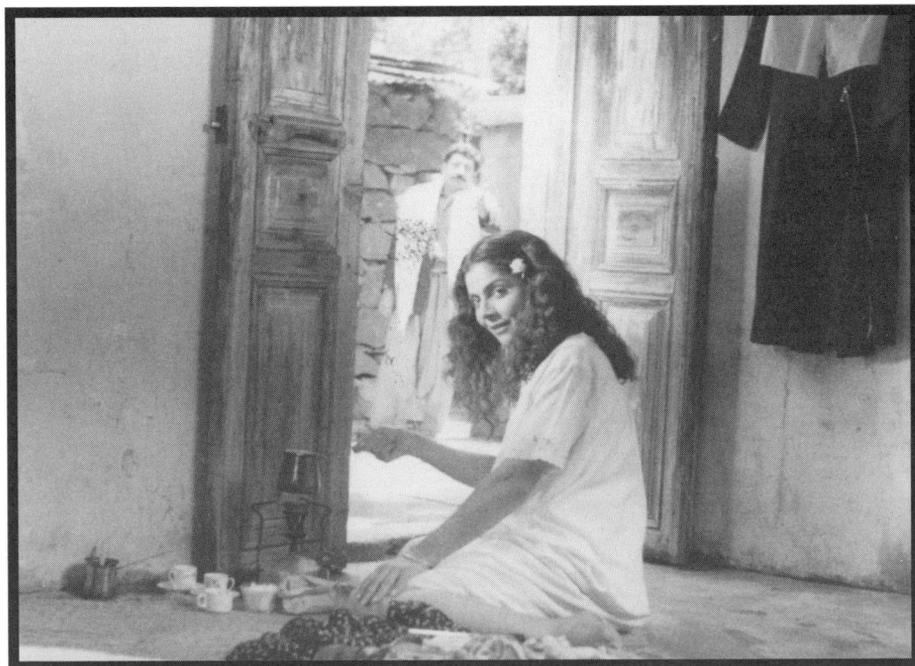

Al-Leyl (*The Night*) by Mohammad Malas, 1992.

One time, my father walked into the shop, turned around looking for me and called:

"Wisal!"

I rose from between the coal ovens, pulled the drape a little, to see what my father asked for… And I saw him…

There was my father and yours!

My father whispered something in his ear, and your father was staring at the drape where I stood.

That day he stared at the drape intently, maybe he noticed my bare feet, my joints felt weak and I almost fainted on the floor, and all I felt was the glass in my grip slipping and crashing to smithereens on the ground around my feet.

My father pulled the drape completely and said in the imperative:

"Gather up your sisters and tell your mother to take you all to the *hamam*. Tell her my father is coming home after sunset with guests."

"Go home!" So we went home.

On the way home, we saw the French confiscating radios from the shops.

"Go to the *hamam*!" So we went to the *hamam*.

On the way home from the *hamam* in the souk, we were carrying our clothes in bundles, the sun had not yet set, next to the walls of the Ashmar's house in our neighborhood, a French patrol of Senegalese soldiers appeared suddenly in front of us. When they realized we were all women, just bathed and clean they accosted us. They repeated, laughing:

"Fatima… Fatima… Beautiful Fatima! You Islam?"

In the beginning we could not help laughing. We ran away from them, and they took off running after us, they encircled us, tried to grab us and we ran from one corner to the next, like chickens. Our knees were trembling with fear! We cursed and spat and they continued hassling us saying:

"Fatima… Fatima!" And they laughed.

My mother, God have mercy on her soul, collapsed on the floor and started screaming from fear, and peed on the floor. The bath bowl dropped from her grip, and the bundled up towels and clothes. The neighbors finally came out, and the Senegalese fled away.

The Nuptials

Wisal said:

The instant when guests entered our house, I was busy dousing the window panes with blue dye. When my father called for me, I was on the ladder, painting the upper windows. He said:

"Wisal, come down, my daughter."

Oh God, how my heart was warmed at hearing "my daughter!"

I came down the ladder, and as soon as my foot touched the ground, I felt the clutch of anxiety…

He said to me:

"Leave the blue dye and follow me!"

He turned to my mother and as he stepped out of the kitchen he said:

"And you, woman, when the boys from the pastry shop come to the guest room, you and your daughters should begin ululating from behind the kitchen door."

I remember that my mother's body stiffened instantly. In a trembling voice she asked my father:

"Goodness gracious, my man, is the war over? Are the French leaving?"

My father looked at her with contempt and replied:

"God damn you, you're such an imbecile! You have to ululate because I found a groom for that eldest one! And now we have to finalize the engagement."

My mother was taken aback and became confused as to what she ought to say or do. She suddenly lept to my father's hand, grabbed it, kissed it and pleaded begging:

"Have mercy, my man, just let us see him first once! One glance from behind the door."

I sprang to my mother's side and knelt at his hands:

"We kiss your hands! We kiss your feet! One glance and that's all!"

My father softened and said:

"Fine. I will see what I can do. If he has his identity card, I will bring it back to show you the photograph. But I swear to God, if any of you stick your neck from behind that door, I will cut it."

Before I had a chance to wash my hands from the blue dye, my father's voice reached me, ordering me to come nearer and hold his hand.

I ran to him, standing by the door of the guest room, waiting. From behind the door, I could discern my father's voice saying to me:

"Come on, extend your right hand, girl!"

I swear I did not understand what he was saying… Suddenly, a hand emerged from behind the door, and a slap landed on my face.

I fell mute.

When I extended him my hand, I noticed it was all dowsed in blue dye. I said: "Father, my hand is painted with the blue dye!"

He did not reply. He grabbed my thumb, spat on it, and pressed it on a book. My mother and her daughters started ululating from behind the kitchen door.

A Woman and a Moment Worth a Lifetime

…Sometimes I feel that perhaps all a human being claims from a lifetime is a moment… a moment lived. That's all. Nothing before it and nothing after. And the living that precedes this moment is like waiting for it, and the living afterwards is all trying to recapture it. That moment has a scent, an aroma that comes from I don't know where.

That day, it was nighttime, there was moonlight, and the Quneytra breeze, that you know so well my son, was blowing gently.

I had heated water to wash his feet…

I poured the water and drew close to him. I placed his feet in the hot water, and washed away his exhaustion. He said to me:

"Wisal, tell me what you saw in your dream today."

He was staring at me, his eyes were wet, there was something in his gaze like a hot wind that enflamed my whole body…

I was embarrassed, timid, but I drew courage from recalling the first time I ever saw him… How strong was my desire to cook for him, feed him, clothe him, and put him to sleep… I said:

"Wish for good things. In my dream, I saw you imprisoned in the Circassians' mosque, the French and the British had put you there. You were banging on the door and screaming."

I was about to tell him what he was screaming in my dream, but suddenly I found myself intimidated again, my face reddened and I could not say anything.

And he said, "Tell me."

And I replied, "I am shy."

He held my face between his palms, wrapped my hair around his hand, came closer, very, very close… and said:

"Tell me. Tell me."

My neck was wet with sweat, my head fell into his grip… I wiped the tears that flowed from my eyes and gathered around the protruding veins of his hands, he pulled a strain from my hair and affixed a long stare.

After that, I melted…

Whenever I Ask Her to Tell Me Stories About You, She Says:

She has almost forgotten your features, and all she remembers from your photograph has become foggy, obscure. After a long silence, as if she were trying to recall something more, she says:

"Palestine! 36! I swear to God, I no longer remember. He used to talk to me about Palestine and 36. And I was either distracted, or listening to him but also worried that the milk heating on the fire will boil and spill over, or the food cooking will get burnt. Other times he would be talking and I was so weary and tired all I wanted was to sleep."

In that "portrait," the intention was not to discover when the woman becomes an image and the city a sound, when sound seeped into the fabric of the image, and the image into the frequencies of sound. In that text, I delved into a personal interior word, the memory of fragrant moments, forgotten, misty or barely discernible, that the passage of time has rendered to a representation of lips moving without a sound.

Dreams of the City

In the cinematographic text for the film *Dreams of the City*, two distinct phrases that depict fleeting moments in the representation of woman, seemed to be keys to the musicality or sketch in that text-film.

The first phrase: "…The woman was cloaked in black, when she saw us, she dropped the veil on her face, and the fabric became moist with sweat."

In that image I wanted light to beam from the woman onto us rather than light unto her, so it reveals us.

The second phrase: "…The boy heard a knock on the door, he looked towards the house and saw the woman's hand emerge from behind the door, extending to knock, and

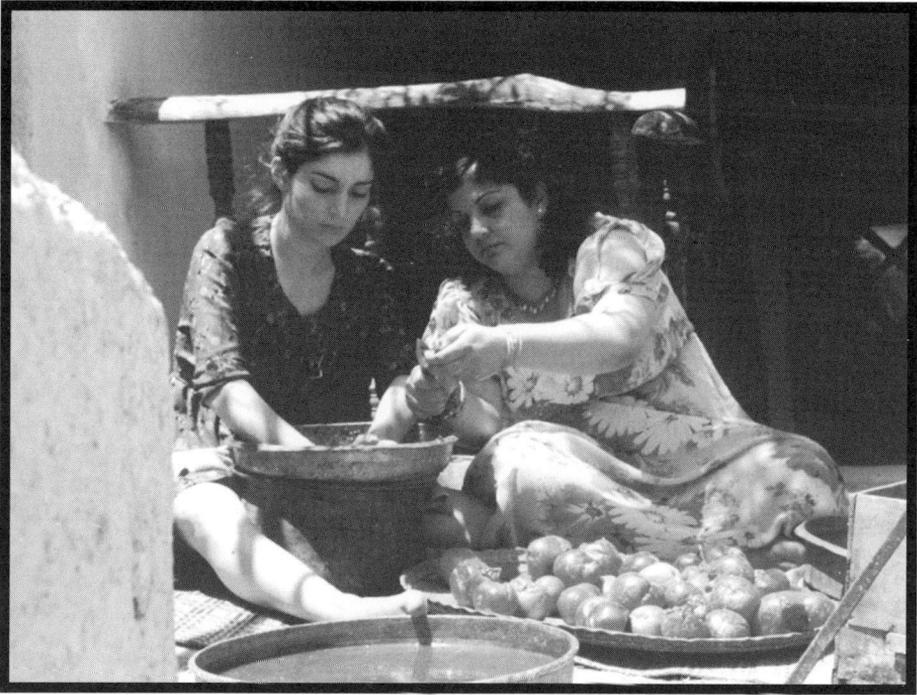

Ahlam al-Madinah (Dreams of the City) by Mohammad Malass, 1983.

then disappearing behind the door again…"

In that image I wanted to show how the voice of woman is "forbidden," and yet her hand, with all its femininity appears to us in the open. The magic in that moment lies in how the sound of the knock rises above other sounds from the street. It rises above the sound of the tramway's wheels rolling, songs and political speeches blaring from radio sets in storefront shops.

In that film, the woman-mother retreats from the story, behind the walls of a Damascene dwelling. The setting is a popular neighborhood, where Muslims and Christians, the educated and the illiterate, decadence, hashish, political ambition, traditional leadership, nationalists, secularists, fascists live side by side.

Woman, in this film, is not embodied in a single character, rather a whole panoply of characters, both visible and invisible but perceptible to the viewer from accounts in conversations of male characters, gazes and overtly sexual overtures men throw around as women walk by. In these stories, women are only represented through the image of desire and coveting.

The representation of the woman-mother takes full shape only in the last third of the film. She appears like a character who would have been scripted in a short story, by a

female author. A short story narrated by another woman where the female character stabs the film and its cast of other characters, leaving them wounded and defeated, in synchrony with the general circumstances of the country then.

Women, Imagined by Men

The text reads:

…Abou el-Nour was a vibrant university student, impassioned with the patriotic questions that pressed the country. He was jovial, confident, walked around the neighborhood humming the national anthem.

From behind the glass window of the shop, Abou el-Nour notices a female university student walking by, carrying her books. He rushes to the door of the shop to stand and stare at her. When she passes him, he accosts her in seduction: "I swear to God, when we seize power, we will drag you with us to the military service!"

A male resident of the neighborhood who endorses another political movement, passing by on a bicycle, sees him and remarks teasing:

"Aren't you ashamed of yourself? You literally ate the girl with your eyes!"

Abou el-Nour retorts:

"By God, you would eat the egg with its shell!"

(The use of "egg" here references the allegorical meaning of the expression, but also its sensual and political connotations).

Abdo, another character in the neighborhood who runs the mechanic repair shop, is standing at the front of his shop, undressing from his work overalls to put on his pristine daywear. He is humming a love ballad, *Ya Wardat el-Hobb el-Safi* (*The Rose of Pure Love*). Every passage in the song is rendered at the precise moment when a woman walks by on the street, every word in the ballad's lyrics, he intends for these female passers-by. *"Oh rose of pure love"* seems intended for Madame Marie-Rose; *"grace the hands that have brought you here"* is intended for a passer-by who scuttles along intimidated by his presistent stare; *"could it be, perhaps?"* is aimed at Antoinette who walks by when Abdo's hands are buttoning the front of his pants and Antoinette's face draws a smile.

In the clothes pressing shop, the steaming coal seems to heat everything up. Tahsin, who owns the shop is clad in an undershirt, and when his male friend Wihab relays his adventures, his body relaxes from pressing the hot iron. Wihab recounts:

"Yesterday, after my work was done at the slaughterhouse, I took a bath and spent the entire day at Najah Sabah's (a bordello). As usual, I brought with me some fresh liver, and Najah sent me to Durriyeh. Durriyeh protested that she did not like that kind of meat. I was upset. So I took the liver and went to see your blonde friend Afaf. The liver and I were her happy lot."

Sipping a drink of water, and spraying the dress he was ironing, Tahsin replies:

"God knows that Afaf does not deserve that liver!"

Tahsin presses hard and leans over and steam wafts from the iron, and continues:

"God is my witness, the Thursday when I don't visit Durriyeh should not be subtracted from my life."

Wihab replies:

"If you were not a jackass, you would not run after that cow! Anyway, the only women you deserve are those who come from 'between the two rivers.'"

In these sketches of the popular neighborhood in Damascus, I wanted to show that the image of women in men's conversations then was almost always tied to sex, and because of that, stories are centered on prostitutes. As for the female residents of the neighborhood, they fell under the guardianship of the tribe (so to speak), they were only stared and gazed at, desired and coveted.

Stolen Images

Stolen images of women's private lives in intimacy are mediated through the young boy's gaze. He is the central protagonist in the film, and captures scenes of women's lives inside homes.

They are vignettes of femininity, overtly physical and exhuding a carnal desire that women defined and suggested. In that era the vocabulary of suggestion prevailed, it fit the code of social norms but also expressed a playful lack of inhibition amongst women.

In the text, the boy says:

...When Hind grabbed the clothes from me, she touched me. She dumped the bundle in a bin with water, and stood on top of the pile and stomped it with her feet, quick-paced, her thin dress flew with her jumps. Her legs stepped with force, splashing water on her breasts, her dress became wet and stuck to her figure, she lifted the skirt slightly, to prevent it from getting more wet.

She looked at me, smiling and said to her uncle:

"Yes, uncle, why don't you continue the story of the *Jaysh al-Inqath* (the volunteer army of Arab soldiers that fought with Palestinians in 1948)?"

And she said to me:

"Listen to the story."

I was seeing the "image", and hearing the "sound".

I opened the door of Marie-Rose's house, and stared at the open space inside, the fountain flowed with strings of water, splashing droplets on the beds of flowers all around. I stared at the painted icon of the Virgin giving her breast to her baby.

I climbed the stairs, knocked on the door, and Antoinette's voice rose:

"Who is it?"

I pushed the door open, and saw Antoinette in front of the mirror drying her body with a white towel… I saw her naked back, her hair unraveled in all its length, I saw her breasts shining with beams of light refracting on the surface of the mirror. Spontaneously, Antoinette turned around, and the towel slipped, her naked body revealed. I stepped back and closed the door.

Standing on the door step, I was captivated by the beautiful magic of that moment, mystified, embarrassed.

A parrot perched beside the door suddenly screamed:

"Marie-Rose! Marie-Rose!"

Antoinette stepped out of the room, clad in a lemon-colored nightgown. She carried Easter eggs painted in red:

"How many are you at home?"

I walked home carrying red-painted eggs, the taste of a beautiful moment of magic, mystifying and embarrassing, lingered in my mouth.

Short Story

At the height of the frenzy of preparations for the democratic elections, on the eve of the elections, a new protagonist appears in the film, without prelude or prefatory explanation, and disappears afterwards. That protagonist is a woman.

This is how she is depicted in the text and the film:

Carrying her ample bosom and a large bundle of robes, she came to the young mother and recent widow, for her to embroider them and make a little money. As she climbs the stairs leading the young widow's room, Um Adnan says:

"My arms are broken from the weight of this bundle, this is the last time I carry them for you, you should deliver them back to me. And he told me to tell you that you will not be paid your fee unless you went by him yourself and showed him your face.

Oh God, what's this heat today! I am burning!"

Um Adnan removed her black coat, revealing her sleeveless dress, and its plunging *décolleté*. She sat down and extended her legs, opened wide. She grabbed the seam of her dress, and waved it to relieve herself from a heat that seemed to affect her only. She continued:

"It's actually not that hot, but I am on fire."

She looked at the young widow's face, staring intently and with desire, she continued:

"You look beautiful today! What have you done to your face? Good for you. After you meet the master, your work will improve.

I wanted to ask you, what is this cacophony in the streets? And what are these elections? Things seem different this time… and everyone is talking about them. He was in our neighborhood today and they gave him an boisterous reception… I swear to God, I forgot his name. Al-Assaly? Isn't al-Assaly that old man? No… It was a young man. What was his name? The one with blue eyes and curly hair, what's his name?

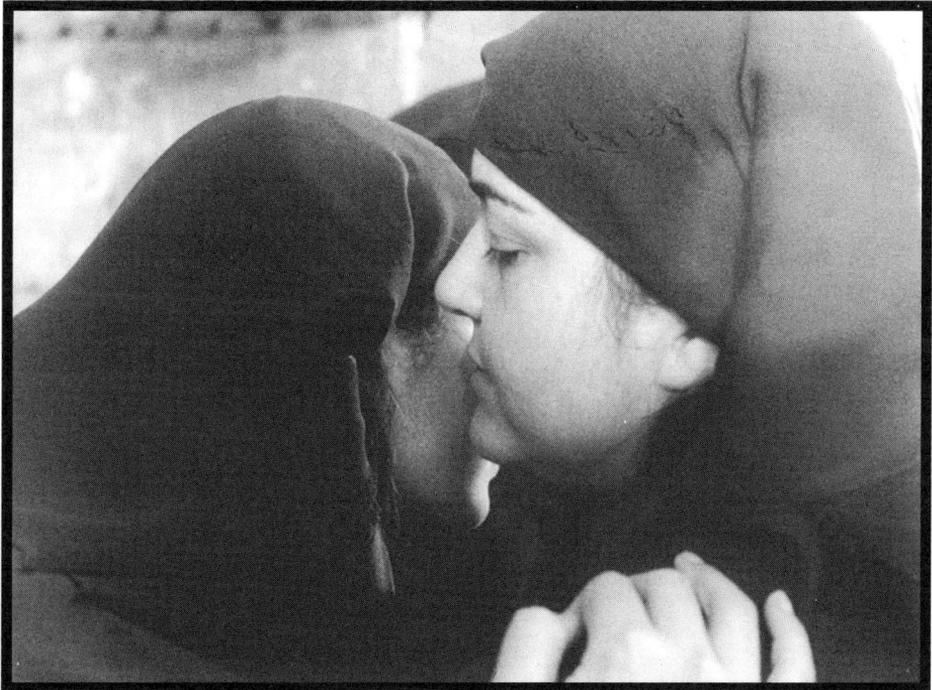

Ahlam al-Madinah (Dreams of the City) by Mohammad Malass, 1983.

He stood in the middle of our neighborhood and delivered a speech surrounded by young men. When I passed by there, he did not move his stare from me for a second, and the men around him could not believe their eyes when they saw me!" Um Adnan talked, words shooting from her mouth like rounds of ammunition. She drew to the young woman's ear whispering words, then her hands felt the woman's breasts and said:

"Look at your breasts! They are wilting and shrinking."

Her hands wandered into the young woman's hair, and said:

"Show me. Look, I can see white hairs. Stop. I will pluck the white hairs."

Um Adnan started plucking the white hairs and said:

"I swear, tomorrow, I will come and henna your hair with my own hands."

Then, she started showing off the golden bracelets that adorned her wrists and said:

"And tomorrow, he will fill your arms with gold!"

I swear I wish that my husband dies so I can marry him instead of you. But what can I do? My husband refuses to either divorce me or die.

You know, he is harvesting gold from that factory of robes, he has six or seven employees and they can barely meet the demand. This trade brings treasures. And if you only saw the clients who come to the shop, they are all so princely, all from the Hijaz, and Mecca and al-Medina… Beware of losing this opportunity. Human beings only get one chance in this lifetime. You're scared of his first wife? Don't be scared of her! He is dying to marry another. She can go to hell, were it not for her kids, he would have divorced her already. Seven or eight kids, he cannot just throw them on the street.

You will see, slowly, slowly you will control the situation with him. Now, in a few days… a few months, I will rent you a room in my house, and then he will rent an entire house only for you.

My room is fully furnished and it's all yours, my bed is wide, the closet and its contents are all at your disposal, and they are filled with underwear. I will also make a new robe for you, and what more would you need?

You will see, in a day, or two, I will throw a party for you, and then you'll get engaged. Until the papers are sorted, you can have a "special arrangement" with him, it's all legitimate and according to the Prophet's teachings. I swear to you, three fourths of the women in this country are married in special arrangements. Just nod with your head that you agree, and I will fly to get you a dowry. By God,

if a woman does not enjoy herself when she is young, when will she?
Get up! Move, move a little!"
The woman drew close to the young widow's ear and whispered something.

In this sequence, the representation of woman echoes the demonic pull in moments of temptation. The character of Um Adnan circles around the young widow, drawing near and far, whispering and shouting, condescending, admonishing, cajoling, all with the objective to cause her downfall. She does not stop yammering, sometimes repeating herself several times... while the young widow remains silent. She listens, ponders, sensing that parts of the woman's diatribe echo her own internal monologue.

Cinema al-Duniya

In this cinematographic text (the film was never realized), the author extracts himself from the story to become its narrator. He draws three portraits of three different women.

Woman, Dream

In the text, the narrator says:

...And when I turned to her, I saw she had fallen into a deep sleep, her chestnut hair had covered the face she had turned away from me.

The green blanket that we covered ourselves with revealed part of her beautiful back and one of her knees.

I stared at her, two drops of sweat lodged in the ridge between two ribs on her back seemed like two drops of a faith that relieved the lonesomeness that gripped me, and when my eyes settled on the small brown mole — like a coffee bean — that the hand of God had etched on her back, a profound tranquility began to sink within me.

I descended the stairs to leave, she stood at the doorstep of the room, one hand held the door, and the other the green blanket that covered her chaste nudity...

In that darkness, she seemed like a shadow onto which my gaze projected any image I wanted, foremost amongst images stored in my mind, was my mother's...

She said:

"God be with you!"

The timber of her voice had a taste, the kind that no shadows or images could alter.

Woman, World

…And when she lay in bed, her face turned towards the wall, I smelled disaster, my nostrils filled with the scent of damage.

She raised her head slightly, looked at me, then placed her head down again and closed her eyes. Muttering, she said:

"Nothing is more important to you than cinema?"

I thought the weight of habit and routine had probably caused the damage to settle inside me as well.

She interrupted my stream of thought, turned her body and said:

"So for you there is nothing in this world that concerns you besides films?!"

She turned her body again, her back was facing me, her soft, regular breathing filled the muted silence.

I felt this woman sucked the air from my breath. I realized that when human beings lose everything, they behave as if they own everything. And this woman, to whom my back was turned, and whose regular breathing I listened to, was living in a dead-ended realm of pain and self-inflicted torture.

She had lost hope in restoring that image of yearning that she had cast for our relationship, all she could resort to now was to destroy the images reflected in her interior private mirrors.

All either of us could do now was close our eyes and dialogue with the other as if talking to ourselves. We were like frogs staring in a box of mirrors, dreaming, waiting.

The scene had the cadence of a bolero, our bodies turning to the other, the copper frame of the bed shaking, we darted at one another with interjections, then turned again, each in their turn, as if firing rounds in the obscure winding labyrinths of our communication then recoiling back.

That silence was the lull, the elusive truce, the time for the bed to stop shaking, until we were at it again.

I rebelled and left that box of mirrors. She extended her arm and pulled the blanket all to herself. She expelled me from the box of mirrors, I was now the frog whose time had come for dissection.

She felt my body, bit by bit, examining every detail, as if searching for a trace, an

imprint, a taste, a scent… She confounded questions with answers, silence with words, words spoken today with words spoken years ago, dialogues from films with dialogues from life. She wandered in circles, mourned the past, cursed the present, regretted moments here and there, pledged and threatened to impose the image she had constructed herself…

I was smothered, short of air, I sweated profusely…

I began to suspect what was happening was a conflict between images searching for their victims, or spectators. Images of dramatic characters, subsumed in impotence and confusion, whose last resort is to become naked and expose their wounds and failings.

As she performed that role, I felt as if the sound inside me was the only hinge holding the image, like the director holds his actress backstage waiting for the moment to thrust her onto the stage.

Woman, Cinema

Mariam says:

…When the narrator lapsed and fell into a coma, I felt a strong compulsion to take his place and tell his story.

When my own feelings and opinions began to slip into the story… I sensed the story began to seem as if it were my own, and at several moments I was impelled to construct my own mise-en-scène, so that events unraveled with their own coherence. All this started when I reckoned he had lapsed for good, as if his head had been left out in the open, displayed on a plate, precarious.

He was suspended between life and death, and in the fog of that precariousness I began to contemplate how the harnesses of control he had fastened onto himself had come undone, one after the other. That the image seemed more beautiful and free, despite its tragic tones. The film I had been so inhibited from realizing, never once possessing enough courage dwelled inside, I was now inhabited by an eerie drive to rescue him from death, and a conviction that his should become my own film.

At that moment, I looked at him and felt a peculiar relationship had been sown inside me. It was different, maybe it resembled the kind that he harbored for the actress he cast for each his films.

And why not? Was he not the "actor" in my film now?

I cannot remember where I learned that when human beings fall into a coma, they should never be left unattended and that everything must be done to try to awaken them. When I

was told there was an imminent risk he might die, I used every means possible to eliminate that risk. I feared that nothing inside him was safe, yet all I could do was talk to him. I called out his name, spoke to him, in the street, in the car, in the hospital, in the corridors, in the elevator, when he was far in the intensive care unit, and when he was behind the glass window of the operating room. I talked to him, whispered…in front of him, behind him, above his head.

I was scared the pulse would stop, so I talked to the heart; scared the irregular breathing would stop, so I talked to the lungs; scared of hemorraging in his brain, so I talked to the veins and arteries; scared of the coma, so I talked to the brain. I talked and talked.

Slowly, the harnesses of my own control came undone, and I slipped into a state of detachment, a different kind of coma.

Talking to him seemed like talking to myself. Talking to him, about him, became talking to myself, about myself.

As desire transformed into life and the imagined became tangible, I found myself for the first time talking out loud, and in the presence of another, about myself, my experience, things intimate. I succumbed to the force of that moment, it was more overpowering than the torture I endured in prison and to which I had not surrendered.

Perhaps it was all that talking that made me feel that I was writing my own film…

I hovered around him, at times like a mother, at times like a lover, and at times like an assistant getting the location ready for a shoot.

I talked to him about cinema, how my relationship with the art began, how when all the screen available to me was the wall of my jail cell and I imagined films, edited them. How I waited for my cellmates to go to sleep to screen my films at the end of the night and lived through them.

I held his fingers when I talked to him, I massaged his feet, I rubbed his temples, caressed his head. I remembered I was told the scent of basil was useful, so I pulled a bottle out of my purse and doused his body with basil essence. I placed a tape recorder and played Fairouz's song, *"I will see you at the awakening, I will see you at the awakening, come to me from awakening, lost in the leaves of the almond trees…"*

I read to him the letters I had written on cigarette papers to my beloved when I was in jail. For the first time in my life, I was reading them aloud.

As if a meteor was released from my grip.

I felt as if all of us, him included, had had our nails clipped, and we were going on with our lives as long as it was going on with us. I realized that all of us, him included, lived in mysterious labyrinths, half of which were lit and the other half darkly. And today, our

bodies contained nothing other than mirrors. The lost image, held captive deep within, was corroding while it waited for release.

I sprang to the bathroom, looked at the reflection of my face in the mirror a little… I coiffed my hair, put on some make-up, sprayed perfume, and for him, I changed into the clothes of an actress for one of the scenes. I stepped out to perform a scene for him from one of his films, to imitate her voice, recite her lines and sing her song."

Ahlam al-Madinah (*Dreams of the City*) by Mohammad Malas, 1983.

Al-Leyl (The Night) by Mohammad Malas, 1992.

A CONVERSATION WITH MOHAMMAD MALAS

How were you introduced to the world of cinema?

I was drawn by a deep feeling of solitude and exile. The movie theater was a refuge in which I could break this solitude. As for my approach to cinema professionally, I must say, I was introduced to it by pure chance. During my childhood, I believed, I felt, I wanted to become a writer or a man of letters. I had a deep desire to travel and see the world, but I didn't have the means to do so. I was told that the only way to leave was to apply for studies abroad and that I should apply to programs. That year, 1968, the only scholarships abroad that were offered were for film directing. I applied, I was accepted, and I was sent to study cinema. At the end of the program, I returned home as film director. The year was 1974.

Have you been influenced by a particular trend or director?

As I said, to me cinema was an existential refuge. The films I was able to see before I left Syria had nothing to do with knowledge of cinema. In those years, the only films I could see were the ones screened in the cinemas of Damascus, where I lived. There weren't many movie theaters and most of the movies showcased were Egyptian. Leaving Syria was the first true step in order to become acquainted with the world and with cinema. I think I was lucky to have studied at the school in Moscow. I was tutored by a young art film director, Igor Talankin. The most important thing he taught me during the five year course was to listen to my interior voice, to look inside myself, to take possession of myself. This lesson has protected me from mechanical influence, but did not harness me from being drawn to and harboring affection for the films which have filtered into my interior world and have never left me. During my studies I had endless opportunities to become acquainted with the works of the great directors. I would choose those that helped me discover how others turned their attention to themselves and how they expressed themselves. When I loved a film, I felt that love enticing me to be myself. In order to nurture and protect that love, I did everything possible not to become its slave. A few films had and continue to have, an influence and perhaps film critics will have to decide if my love for them has helped me maintain my interior voice or lose it. The films I have made owe what they are to cinema, to the films and the directors you can't help but love, to the ones you cannot but let yourself be influenced by. Films like Kurosawa's *Barbarossa*, Tarkovsky's *The Mirrors*, Bergman's *Wild Strawberries* and other films of that scale. It's difficult not to be influenced by them.

I find it significant that you have a privileged relationship with literature, as is evidenced by the place literary screenplays hold in your work.

The literary dimension in my films springs from both a need for expression and a penchant for literature. I chose to make films that forge and develop a language in contrast with commercial production and prevailing convention in Syria and in the Arab world. I have tried to bring a literary sensibility to visual expression. The fact that I have chosen art house cinema to express my interior world and the memory of contemporary imagery in the reality of my country has been a great help to the dominance of literary trends in cinematographic writing. My literary vision of the world and my vision of the world through literature are subjective choices. I love watching that kind of cinema; they are the genre of films I want to make. In parallel, I consciously imbue my literary texts with a visual sensibility. I am very sorry to note that there is no legible cinematographic screenwriting in the Arab world. The screenplay is still considered an intermediary, instrumental medium. The majority of screenplays that are published were written after the film was completed, like a ledger of the elements that have been edited. I consider screenwriting a literary genre in itself, that can be read by all, a form of artistic expression that guides the author's vision. Once it is turned into a film, it guides the director in his reading and interpretation of his vision. This is how I write my scenarios. It is the first writing of the film, where the word is the vehicle for expression. I have published screenplays in books or literary magazines because they can be read.

Narration, in the literal sense of the term, has an important place in your works, giving them an interior, romantic dimension that is rare in Arab cinema. It is as though the word can't bear the absence of the image, or perhaps, that it isn't fulfilled without an image.

I use expression in order to describe my discomfort with my society and my country. To release this pain I decided to narrate it, search for the "lost image," and find out what it is, in order to stop the compulsion to narrate it. This is the key to narration. I felt it was necessary to ask a number of questions with sincerity. What is it that has been "lost," for this interior pain to end? What has to be lost so that the nostalgia can cease? What has been lost and what can we do, to substitute death with love? If I am worried about these questions it's because I have no other images than the ones within me, in my memory; images charged with feelings that moan as they wait for me to exhume them and articulate them into a cinematographic language, coupled with wider questions about nation, society, history and politics. I don't know how the images hiding within me transform from images I experienced to images that are stowed, dormant, speaking with a voice, a taste, a color. They

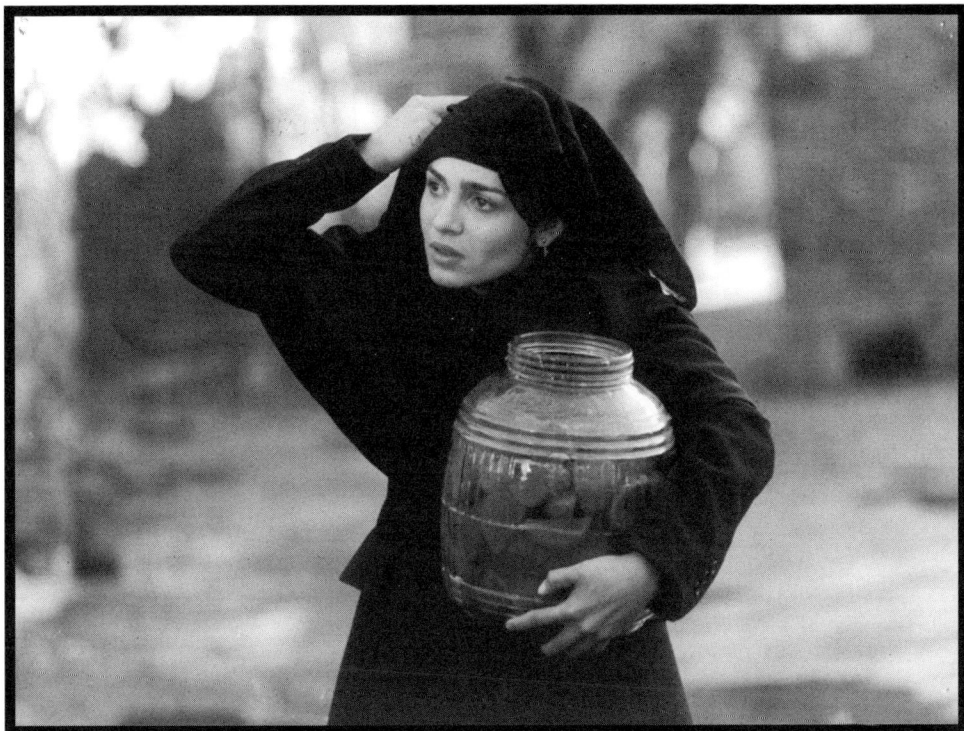

Al-Leyl (The Night) by Mohammad Malas, 1992.

revolve around themselves, captive, so intricately imbricated in their literary meanings and their visual charge that I don't know if their literary presence can be separated from their visual presence.

Why are documentaries so important in your work?

I use fiction to express myself and make direct use of reality to articulate expression… both allow me discover that cinema is cinema! I make no distinction between one genre and another in my compulsion for expression. The documentaries I made belong just as much to art house cinema; they are entrenched in my subjectivity as a director. In that regard, I belong to the trend of documentary cinema that emerged in Syria during the mid-1970s. That purview allowed documentary cinema, in Syria and the Arab world, to engage with important trends in world cinema. This trend paved the way for the generation of filmmakers that followed (to which I belong), and inspired a cinematographic rebirth widely evidenced in films produced in the subsequent decade.

If we examine your development so far, we have to acknowledge the importance of memory, and in particular, of memory as it confronts the Middle East, and the fact that this memory doesn't limit itself to historical memory, but, on the contrary, is profoundly subjective.

From the very first film I made during my studies I used stories I carried within myself... The lesson and the first exercise was, in fact, listening to our interior voice... Memory became the reference point for the event and not the means to remember that event... That first film and the decision to turn inwardly and lean on my memory helped me discover this wellspring. Otherwise, I would have been wandering aimlessly. I understood the richness, the value and the strength that memory had for me... It has provided me with a stock of stories and concealed events, but also with a visual presence, a presence full of feeling, rhythm, light and color. I had to combine this personal memory with the collective memory of people and unite these two memories with facts and historical documents... Personal memory was no longer made of private pain and the lost image I needed made clear how I was to give a shape to the instruments necessary to narrate the instant, the time and the space of the subject I wanted to express.

It is not difficult to acknowledge the weight of ideology in Arab cinema and the ugliness of the outcome it can bring to bear. How were you able to avoid this trap? What did you do to achieve this high level of aesthetic elaboration? Can we say that your refined aesthetics are, somehow, a reaction to the ugliness of dominant ideology?

In the beginning there was Egyptian cinema. In Egypt, cinema began early and transformed itself into an industry, a market that easily permeated film theaters across the Arab world, to the point that it became dominant... It was able to establish its own commercial conventions that became the yardstick for success and failure for film production in the entire Arab world. But different political circumstances in some countries — the rise of nationalist regimes and the strengthening of state institutions — enabled the development of new trends. In the midst of abundant commercial production, a different cinema expressing new outlooks was suddenly possible, as with the trend of realist and experimental cinema that was politically engaged and proposed a different cinematographic language. The emergence of these new trends, coupled with new critical writing on cinema, helped diffuse and strengthen this new conception of cinema. The realist cinema of Salah Abou Seif and the experimental cinema of Shadi Abdel Salam are now considered reference points for these trends, as well as for critical writing on cinema, in Egypt and in the wider Arab world. Our generation was raised on these films and on the

enthusiastic study of the ideas and cultural worldview they embodied. In the same way, the political changes in Syria and the public sector's decision to invest in film production helped disrupt the trend in commercial production. This coincided with the return of the first generation of filmmakers who studied in Europe. The prevailing mindset in that period played a significant role in the directors' refusal to be subsumed by the values and conventions of commercial production; they were invested in making a different cinema. The public sector's fear of filmmakers' criticism of the established order combined with nationalist concerns about representation of history, social and political injustice in the past and present, as well as the concern about the tragic predicament of the Arab nation particularly with regards to the question of Palestine, promoted the production of films that did not deal with present day Syria, and cautioned filmmakers against addressing these themes. The situation was the same in Syria as in other Arab countries, and the generation of filmmakers working then, who wanted to reach out and touch their Arab audience, felt caged. The generation that followed, and began working in the early 1980s, had returned home to a society and a memory; it was less compelled by prevailing ideology and more in touch with the contemporary preoccupations of Syrian society. It could imagine a cinema without running the risk of censorship from the governmental institutions producing films. The return to memory, just like the desire to describe with sincerity the yearnings of society, was without doubt the appropriate reaction to the ideological ugliness of the films produced by the public sector by preceding generations. One could perhaps say that *Ahlam al-Madinah* (*Dreams of the City*, 1983), which I made in 1983, was a beginning, the first step that allowed new directors to discover a way to avoid that trap and the weight of ideology… The generation which suffered greatly because of the public sector's diktat, of its dominion over every branch of the industry, only on rare occasions was able to escape its clutches and make a new cinema.

This interview was conducted in 2004 on the occasion of a tribute to the filmmaker organized by the Infiniti Festival in Rimini Italy, and published in the festival's catalogue.

A CINEMA OF DREAMS AND... BEQUEST

Barely had we set out when we found ourselves inching close to the end. And when the awareness of that nearing end overpowered us, we felt as if we had not even begun. In a blink, in an instant, everything unraveled in a film or two, or... as in a dream.

Everything?!... And thousands of other things — the falling stars, the worlds that lay buried within us — that had not yet been unshackled from the binds of our minds to be organized into the structure of the fiction of a film. Will we carry them with us when we are released from the fetter of our earthly being — our bodies — into the eternal drift of the soul? Or will we bequeath them to others?

Nothing ever goes extinct, and nothing ever comes from nothingness, but every birth generates its own cells that hold memories and dreams particular to it only. Never has a generation relived the experience of another. The paradox or problem for our generation is that we have not realized our dreams and we don't know to whom our still-born dreams should be passed. Are dreams inherited in testaments?

Hadithat al-Nusf Metr (The Half-Meter Incident) by Samir Zikra, 1981.

© National Film Organization.

It was our conviction in the beginning and now — as the end nears — we are riddled with doubt. We never freed ourselves from the burden of expectations bequeathed to us by generations before us. We packed them in with our own and we now apprehend the end of our world, the testaments and expectations.

This is the blade that slits the pupil of the soul, failure. Thus we return to one of the first films we ever studied at film school, after all the films — our reveries — we realized, and just as we venture in drafting our testament, that indeed we are all "Andalusian dogs" pulling carcasses of dead mules in a world, obscure and eerie... and stale. Who has the courage to labor still, and bequeath dreams, and to whom?

My intention had been to write in the first person singular, but I have not been able to liberate myself from the collectivity of "we," the clemency in that being not what "I" have accomplished on my own by myself, but what others have accomplished as well, on their own or in collaboration with each other. All of us, our collective "we," have together dreamed to protect and foster the only means by which we could pack our aspirations into films, namely, Syrian cinema. Together, we now participate in the draft of our testament, namely, Syrian cinema. We gaze far behind us into the past and we find humble traces of the film production that preceded our time. We gaze far forward, into the future, and we find a mirage of illusions... is it a mirage or reality?

The films we were able to make, no matter how humble their lot, remain the bridge between illusion and reality. We shouldered the responsibility of mediating narrative, meaning, and representation in a society whose roots strike into the history of human civilization more deeply than the Stone Age, contending in the present with the New World Order, a social realm that embraces a mosaic of cultures, ethnicities, tribes, religions, social classes... and antagonisms. And we were impelled to encapsulate all of this in a single film that signaled a new world, like a memory chip embedded in the cells of newborns.

A world condensed in a film, a film summoning engagement with the world.

The tools at our disposal, our lot of handed-down cameras, manual primitive crane and chariot purchased by the National Film Organization in the 1960s from an Italian crew that came to Syria to shoot a fiction feature; everything worn with time. Our lives exhausted every single piece of the equipment, passed from each one of our films to the next until they expired. None was ever replaced.

They were, nonetheless, the machinery that manufactured Syrian cinema; a cinema youthful in its reveries, grey-haired in its tools, modern in its soul and genres, backwards in its technical and bureaucratic production. We were promised a "city for cinema," a claim that remains suspended between illusion and dream; neither was it built, nor have

Waqae' al-'Am al-Muqbel (*Chronicles of the Coming Year*), Samir Zikra, 1985.

they stopped making the promise. Just like our dreams, our films.

We continued working, with the technology of the 1920s and the expectation of making a cinema for the twenty-first century: with broken-down movie theaters, a local market carved according to the Sykes-Picot Agreement, a standard of living for a people captive to a single social class pegged by a sinister gauge to the rising value of the dollar, and rampant illiteracy spreading faster than pollution in the living and thinking environments or the rate of cancer afflictions.

Shriveling means, shriveling freedoms, shriveling artistic and intellectual benevolence: in contrast, a generous flow of empty promises, enchanting words and our determination and imaginative abilities.

We dispatched our reveries-films to participate in Arab and international film festivals and compete with the achievements of the most technically advanced and generously funded productions. Sometimes they won awards, and other times they learned lessons, but they invariably represented our country, whose love… has also become a reverie. And yet, there are those in Syria who charge that "we make films for festivals." That is no other than the painful tax of poverty and backwardness. If you try to be conciliatory

to these voices, they despise you, and if you disregard them, they chide you.

For all this, I urge you to be diligent with the noteworthy length of our films, their perplexity and burden of detail, for every single film was either the first, or second... and even possibly the last. They were made breathless from running after our compulsive desire to have them made, every time, every film was made to say everything.

Everyone in the world refers to the industry as the "film industry." Only in our country is it more the "dream industry." I cannot recall anyone in the film industry in Syria who has died. Most are still breathing, but some have stopped making dreams... and as such, they have expired.

Are we all lingering in expectation of a similar fate? Will we lapse into a world that cannot remember, or has no time for remembering? This world of ours makes artists feel as if they were afflicted with a defect from birth; this is the world-nightmare. And here I am giving my testament to another generation: Take pleasure from dreaming as the best way to confront the bitterness of our nightmare world. Dream to the span of your lifetime.

Am I doubtful that dreams will endure?

Last but not least, my final request is that our tombstones be engraved with: "Whoever amongst you was without a dream shall be stoned."

OUSSAMA MOHAMMAD

TEA IS COFFEE, COFFEE IS TEA: FREEDOM IN A CLOSED ROOM

Prologue

I stood on a street in Paris, dialing Syria from a public phone to share the happy news with my family that my first film, Nujum al-Nahar (Stars in Broad Daylight) *was accepted at the Cannes Film Festival. They sobbed, laughed and cheered and announced the birth of Leila, a daughter to my sister Amal. The year was 1988. Until now, I have not made a second film[1], but one night, when she was eight years old, before turning the lights out and going to sleep, Leila babbled: "As long as the veto is in effect, what is this democracy are you talking about?"[2]*

Everything resembles everything else, coffee is tea and tea is coffee. The television is there, facing you; the television set, your entire universe. Your least bitter choice from betwixt bitter predicaments, the showcase duel between a sword and a Tomahawk cruise missile, the herald of the decadence of our century.

I pledge not to do unto you as you have done unto us (for too long now), in your American crime and detective films, where the identity of the murderer remains a secret until the last minute. Neither will I follow the rules of the noir of real life, where the identity of the murderer is clear from the first moment, and you spend your life waiting, as one waits for destiny, judgement, tyranny, or globalization, for him or her to fall into the trap. Instead, I will allow myself to propose an arithmetic riddle so we embark as equals on this collective journey –be it Noah's Arc or the Titanic– and so as to level the ground for communication so we would not require subtitles. And by the way, you ought to be informed that whoever solves the riddle will be awarded with marrying the princess.

In a faraway, beautiful, somnolent country called Syria, early one morning, in the year 1963, a messenger (blowing a horn) announced the enactment of "Legislative Decree Number 258 of the Year 1963" (please imagine a musical interlude here). He blew his horn twice (in fact) and proclaimed: "A public institution has been established, it shall be known as the National Film Organization; it shall be bound to the Ministry of Culture and National Guidance but shall have its own operational, administrative and financial sovereignty; its seat shall be in the city of Damascus. Its objectives are: firstly, to develop the

Khutwa Khutwa (*Step by Step*) by Oussama Mohammad, 1978.

Nujum al-Nahar (*Stars in Broad Daylight*) by Oussama Mohammad, 1988.

film industry in Syria; secondly, to support healthy production in the private sector; thirdly, to foster documentary and fiction films that will raise the standards of cultural and artistic appreciation amongst the people."

And here we are on this Wednesday, morning or evening, of the year 1999, gathered to discuss cinema in Syria, in a country known as the United States of America that preaches its own new gospel and punishes the unbelieving heathens that don't endorse it.

To this day, the single agency producing cinema exclusively in Syria is the National Film Organization. Everything mirrors itself and what surrounds it: the single pole, the single party, the single producer, the single film. This is the endgame: the single film production agency produces the equivalent of a single film every single year. Ventures in the private sector evaporated soon enough, their evanescent vapors wafted to the sector of television production. They are all giddy over there now, peeping at strip-tease and lap-dances, smitten with the pretenses of television, purportedly enraptured.

The private sector seems to have expired its last sigh, without sorrow over its years of youth, or its intellectual and artistic contributions. It spent stubborn years waddling to produce bad copies of commercial Egyptian films, which in their turn, were bad copies of American commercial films. Before the angel of death misunderstands me, and for the angel on my right shoulder not to misquote my words, I hasten to correct the record. I am a staunch believer in freedom and plurality, and regardless of their artistic worth, I am absolutely not an advocate of the annihilation of the private sector, nor did I rejoice when it ended. Plurality, diversity, remain until this fine hour, sacred values I endorse whole-heartedly.

But let's go back to the single film produced in a single year, and a thirty-six year old National Film Organization, pacing slowly, step after step (a single step every year), as if afflicted with plegia from childhood. Our (mother) state granted itself the guardianship of cinema under its mercy, without mercy. It drew cinema into the realm of public administration, and informed by deep lack of experience and foresight it pushed the National Film Organization to fend for itself on its own, and decreed it ought to generate its own financial resources. Thus were the very precepts proclaimed in the infamous decree that marked the birth of the organization and ignored entirely. The National Film Organization and the cultural value of film production eerily transformed to a commodity, subservient to the market and the whims of supply and demand. This happened under the aegis of state boastful of its socialist creed that admonished the demons of capitalism and the evils of the market.

From its birth, the National Film Organization was bound by labyrinthine laws and codes of the Ministry of Finance and the Commission for Censorship and Inspection that regulate inbound and outbound blood flow for all public institutions, the General Establishment for Meat, the General Establishment for Fruits and Vegetables, and the National Film Organization. The sequence of this previous sentence, draws the full tableau, a still life, or *nature morte:* meat, fruits, vegetables, cinema. An agreeable ornament to enliven the walls of a living room. In Arabic, *nature morte* is usually translated as mute nature. Youssef Abdelké, the Syrian printmaker, preferred to call it "nature in waiting". I am more keen on "nature in somnolence".

Nature morte has all the evocations of death, murder and crime, and reminds of the riddle I promised to deliver in the preface. The page-long exposé of fact and information that deferred its delivery was unavoidable. I am not a Cartesian, but for the sake of making sense now, ladies and gentlemen, here is the riddle!

(I mentioned the reward earlier, but I need to specify that according to the rule, whoever fails to marry the princess will be decapitated. The rule is the same, everywhere and under the rule of every democracy, everyday until today, in some place in this world, a head is decapitated. In some place or other, like Iraq or Palestine.)

And here, Ladies and Gentlemen, is the arithmetic riddle: If the single film producing establishment in Syria produces no more than a single film per year, and if the number of film directors in the employ of this organization is no less than thirty, then, according to the principle of equal opportunities, how many films can one director make in his lifetime? Well, the answer is: one film every thirty years. If given an early chance, the filmmaker would be thirty years old when making his first film, and for the second, he would be sixty years old, obviously, ninety for the third.

Simple enough. Now take me for example (a specimen from Syria who, for reasons of grave importance, does not wish to enlist to an American think tank), and suppose that I wanted to wait until my seventh film to transcribe my autobiography, like Frederico Fellini in *Eight and the Half,* or Elia Kazan in *The Arrangement.* A fair estimate to assume that by my seventh film I would have achieved the required maturity of emotional intelligence and depth of insight to tell my story. According to the arithmetic equation just laid out before you, I would have to be 242 years old.

And thus, you will see now, how Syrian cinema holds within itself the essential ingredients of science fiction and fantasy, because 242 is also the number of the UN Security Council resolution that has yet to be implemented. From the lack of

implementation of resolution 242, follows the implementation of the Emergency Laws. (There is no riddle. Life itself is the riddle.)

Is Israel alone to be held responsible for the Emergency Laws?

The Emergency Laws don't recognize the full meaning of freedom because we are in a moment of confrontation, and our land is occupied. They also don't recognize the primacy of cinema, nor its importance, because we are in a state of emergency. And land comes first. If Israel were to pull out of the Golan in 242 days and demand compensations for dismantling the settlements, we, the filmmakers of Syria would squarely demand compensation from Israel in our turn for the three hundred films that were never produced because their funding had to be diverted to the country's defense. At least the first third of that total amount. The second third of the figure was absorbed by the Emergency Laws themselves, at a speed faster than a Mercedes 242. As for the third third of that figure (or the equivalent of the cost of a hundred Syrian films), it can only be accounted for by the American veto on the implementation of UN resolution 242, which only served to prolong the life of the riddle.

Obviously, I did not come here to challenge you with a riddle, knowing all too well it has no resolution. Most of the thirty filmmakers have long deserted the camera and eloped, looking to fend for a living elsewhere. Some work as carpenters, others as marketing consultants, advertising film directors, and others have been granted a "green card" to dwell in the land of television where job opportunities multiply at a rate faster than population growth. Only a few of us stayed where we are, doing what we do, like a band of quixotic musketeers at the service of Her Majesty, Queen Cinema.

And everything resembles everything else. We have become the legacy of cinema, with our films, our sounds, our images. We are like the song that the prisoner in Cell Number Six sings, "Oh Hassan! I brought you up when you were a child, why do you deny me?"

Everything resembles everything else, tea is coffee and coffee is tea in this long nightmare (it will become clearer to you after this brief commercial break).

I once ventured into one of the al-Kindi movie theaters (they are owned and managed by the National Film Organization) to see for myself how Syrians experience Syrian cinema, how they read the signs, the meanings. I walked into the theater, and in the space between the front door and the screening room, Abou Walid greeted me. He sat behind a counter, where he had placed a small television set. Despite the fact that it had earned some golden European award, the film did not attract more than ten spectators. They were lost in the room. When the film sequences that I cherished most (and considered

vanguard) unfurled and I began to unwind in the darkness, I suddenly took notice of the sound. It was not the sound of the film, nor was it the voices of the actors. It was the sound of the television set near the front door, the sound of the serial. It occurred to me that the physical presence of the sound of the television serial was at par with the physical manifestation of image and sound on the large film screen. Unencumbered from allegorical significance (or not), the sound from the television serial had latched itself onto the large screen, merged with the sound of the film, supplanted it, dubbed it, garbled it.

Sound and image are distinct, but everything resembles everything else; the room resembled a screening room and yet it was not that, the dialogue resembled a dialogue and yet it was not that. I confess that for a few minutes I was mystified by the eeriness, but soon I realized I was enjoying an aberration and betraying a principle, so I sprang up from my seat in the direction of the entrance hall where Abu Walid was absorbed watching the television serial. From behind the glass window of the box office, the television beamed images, whose hybrid aesthetics were intended for fast digestion, and a sound whose reach prevailed over the film inside the screening room. I coughed to get the man's attention and with one intent stare I held him responsible for marginalizing culture. Out of my keen commitment to pluralism and democracy, I urged him to lower the volume on his television set.

The following day I found myself mulling over the incident and its significance. The day after, I was given more reasons to ponder. Pasted on the wall, at the entrance to the al-Kindi theater, as well as at the entrance to the National Film Organization, a notice of death announced the passing of Abu Walid after a sudden heart attack. He was forty-three years old, exactly my age then. Abu Walid had first worked at the National Film Organization as the coffee server, but after he was deemed to have failed the expectations of that function, he was dismissed and assigned with the lesser task of tearing filmgoers' tickets at the door of the state-run al-Kindi theater. Because spectators were scarce and ticket holders even fewer, he had installed the black and white television set in the entrance hall to assuage his loneliness.

As spectators were individuals, he disregarded their rights and took license to raise the volume of the sound.

Abu Walid had failed as the coffee server because he attempted to embody the persona of the late coffee server Abu Badr, the jovial elderly man who was loved by all. Abu Badr noted down everyone's orders, from the bottom of the hierarchy to its top, nodding his head knowingly and invariably returned with tea instead of coffee. If anyone protested, he retorted first with an affectionate smile that grew into a childlike giggle. He placed the tea down and demured ever so sweetly(even to the director): "Tea is better."

He said: "Everything is the same", and continued laughing, "the only difference between an Arab and a foreigner is coffee." He said it knowing all too well it would be the occasion to choose tea over coffee, television over cinema, habit over love.

Abu Walid tried to resurrect Abu Badr's voice, he cracked jokes but flopped. The sound did not conform to the image, so… he died. Should there be a causal relationship? He died, and after I read the notice and climbed the stairs of the building, a voice whispered in my ears that donations for his family were being collected, that some had given money and others not.

(Here I am reminded of a Russian joke I heard during my schooldays in Moscow. One day, Ivan (then a Soviet) took his television set for repair to another Ivan.

The second Ivan asked: "What is wrong with it?"

"The sound does not conform to the image, " answered the first Ivan.

"And you expect me to repair the whole of the Soviet Union?!" the second Ivan replied.)

Neither does our own image conform with our sounds-voices, we, the handful of Syrian filmmakers. We were quelled by the routine of everyday life. When questions press us in the media we are jolted into awakening and answer in our idiom of allegories and metaphors. In reality however, we are absent from the screen. And there is no longer a screen, in fact not in allegory, there is no longer a large white screen, no image, no sound, no comfortable seats and no toilets. In the nation's capital, Damascus, there are only eight movie theaters serving six million citizens, in the city of Homs, there are three, two of which have been under renovation for decades, in Lattakia four movie theaters are still operational as compared to the total eleven, when I was eleven years old.

In 1969, the horn-blowing messenger that announced the establishment of the National Film Organization manifested himself once again. He read a new decree that bestowed the role of import and distribution of films in the country exclusively to the state through its expert appendage, the National Film Organization. As recently as this past March, on the occasion of the celebration of the anniversary of the revolution, the daily al-Thawra reminded us of the wisdom behind these edicts, namely, that many films conveyed ideas antithetical and hostile to the principles of our revolution.

Even if such actions were animated by good intentions, and regardless of the fact that coerced guidance underlines an implicit mistrust of people's ability to draw judgements on their own and without mentorship, the National Film Organization's good intentions did not save it from endemic and sustained poverty. It was never afforded the means to import the best or the most contemporary of world cinema, nor was it able to

foster a culture of appreciation of cinema. Its monopoly over access was dwarfed by television and the informal traffic of video cassettes. They invaded the "well-guarded" homes and consciousness of people with seamless efficiency. The cherished tenets of our revolution's ideology were thus defeated by poverty, and the bright image of the Tomahawk, centered in frames unfolding on television sets, beamed into our people's households. Nor was the National Film Organization able to rival Beirut, only a shy few kilometers away, where film releases are apace with the rest of the world, movie theaters multiply steadily and people don agreeable attire to watch films. It is almost as if the messenger who proclaimed the state's decrees had blown nefarious winds of a looming tempest from his horn, rather than the National Film Organization's good intentions, and inspired spectators and films to forsake movie theaters. And we woke up one day to find deserted movie theaters void of lifeblood, rotting in decay, hollowed of their guts. This is not an allegorical image, movie theaters had to dismantle and discard half their seats to lighten the burden of taxation because they are tabulated according to the number of seats, not spectators in attendance. The eight surviving movie theaters in Damascus are now in deep comatose slumber. No radical surgery, heart or spinal transplant can save them, they have been declared clinically dead, at least for the time being.

We are absent from the screen. We are absent from consciousness, from the social consciousness that hungers for freedom, from people's collective memory, distant or near. The word "film" is never hinged with the attribute Syrian in collective awareness, there is no place for Syrian cinema in people's collective memory. The notion of a living, breathing, contemporary Syrian cinema registers so much like an aberration that it is perceived to elude the laws that regulate the nation's everyday life, like the succession of seasons, increasing cost of living, spread of corruption and suffusion of fear. All the things that comprise the cadence of people's consciousness of living in this country.

The single film produced every year, once released, is allotted a peculiar space, almost apart. Like a drop of serum injected in the veins of a solitude old by a hundred years, it stirs sentiments, sometimes it stings and sometimes it elates, in a worn-out body that has long grown habituated to living without its presence.

Back in the day when socialism still wielded magic and held the promise to bring bliss to nations and peoples, the Syrian regime purported to borrow the Soviet mode of organizing cultural production, in parts or in whole. To the contrary of their Soviet authenticators, however, the Syrian regime did not populate its cities and villages with movie theaters, playgrounds, parks, nor was the production output sustained. As early as its beginnings, the public sector drifted from these foundational premises, seceding to forge its

own experience. Encumbered with the good intentions of their producer, our films come to life, step by step, drop by drop.

And yet, in spite of our poverty and of all the implications that a third world state-sponsored film production entail, the National Film Organization has produced thirty-six films in thirty-seven years, all of a distinguished artistic and intellectual standing, that have earned a total of seventy-two awards, internationally and in the Arab world. There is a real paradox between the historical conditions in which films are produced and the final outcome of the films themselves.

The paradox can be traced to the inner workings of film production, the kitchen of the institution so to speak, where films are made. There, a counter-intuitive redress of the injustice of the paucity of material resources takes place, and at times with rare generosity. As such, Syria might very well be the last place in this world where a filmmaker is given license to re-shoot a sequence until it is deemed right, where time and space for editing or sound mixing of an entire film can be redone, without a reconfiguration the film's overall budget. Furthermore, Syria is perhaps the only place in this world where a young filmmaker without significant prior experience is provided the opportunity to make a feature-length film, regardless of the viability of the film once it is released. This generosity, which runs against the grain of the prevailing mores of our century, comes at a high cost. The tremendous burdens of producing a single film, or a film and a half every year is shouldered at the expense of an output that would sustain a dialogue with spectators, with our society. Syrian cinema is trapped in a conversation with itself, an eerie monologue that the National Film Organization (despite its hard labor) has failed at bridging into a dialogue with society at large, year after year.

And time knows no mercy. Generosity not withstanding, we all pay the wages of backwardness and poverty, and there are most likely, hundreds of talents craving for air to breathe, and for opportunities to find expression; they lie in waiting, time slowly extinguishing their flame. In this third world of ours, creative innovation and genial ideas dwell in gestation, in their largest share, hostage to poverty and backwardness. I have always lived with the belief that Fellini's groundbreaking approach, for example, must have long been dreamed in the imagination of a captive soul in our part of the world.

Its generosity not withstanding, the National Film Organization has turned its back on venturing into creative solutions to alleviate the weight of its mission.

At a time when we are unanimously convinced that only works of art and the language of creativity are able to obliterate, through dialogue and communication, the sinister thick of backwardness, the tyranny of globalization and the insuperable

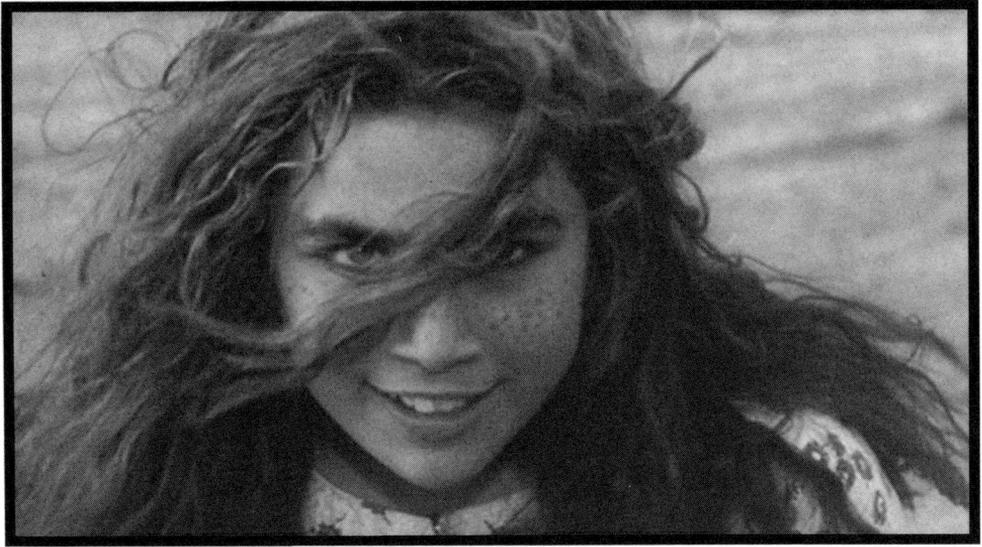

Sunduq al-Dunya (*Sacrifices*) by Oussama Mohammad, 2002.

polarization that pulls geographies apart, the National Film Organization has turned its back on every opportunity at co-production and cooperation that has frayed its passage to Syria. Under the guise of protecting the self-styled "purity" of its mission, it has cowered in its destitution, hostage to fear and suspicion. And so we too remain, suspended in that atrophied space; with our hopes and dreams we struggle for air.

The National Film Organization regards collaboration with European counterparts as the road map for colonization. The argument goes like this: How could countries that once colonized us, or coveted our riches with colonial designs be attributed good intentions. Europe does not really recognize Israel's occupation of our territory as a crime, and they have absolved Zionism from the occupation of Palestine, the expulsion of its people from their homes. Europe does not see Zionism as an ideology of terrorism. How can we collaborate hand in hand with countries that defend all these crimes?

These facts are true, and I would go further and deepen the notion of terrorism, it should not be restricted to opening fire, setting up checkpoints or administering violence. Terrorism is also the violent death that comes packaged in a hamburger and vetoes the implementation of UN Security Council resolutions. The flaw in the argument is not in the veracity of the evidence it lists, but in the question it asks. Firstly, it presumes that European countries, their governments, their civil society, their intelligentsia and their cultural actors are all one and the same block. As such, it imputes the same agency and intentions to all these distinct and independent entities. Secondly, it presumes that the mandate of cinema

and film production is to oversee (or lobby) for the implementation of UN Security Council resolutions. It does not regard cinema as the sovereign site for existential interrogation by individuals and collectivities, for forging freedom and unveiling life's small secrets, lived and imagined.

A conversation with the world is the only (and most effective) strategy afforded to the quixotic musketeers of the Third World. The absence or failure of that dialogue is a loss to the entire world, east and west, it compounds the toll of global poverty because the riches of culture cannot be plundered, usurped, or seized like oil or diamonds. Our countries may be stunted in abject poverty, but we claim novels, poems, music and films unsuspected by the western world, marvels that bring so much wonder they lengthen a human being's short life by at least a few years.

Amongst their accomplishments, Americans and Europeans claim airplanes that break the sound barrier, state of the art technologies of extermination and stealth industries of well-being and leisure. This does not imply that their poetry is superior, their imaginary more sophisticated and their commitment to life, dignity and justice more legitimate than ours. I am aware of the hard reality and that with the resources at her or his disposal, the American and European artist is able to chase her or his flights of fancy, while our wings are clipped by the weight of historical contingency, and our dreams or flights of fancy remain folded in our shirts. However, at the risk of sounding like a missionary for culture and the arts — and I don't consider myself an intellectual —, it is my unshakable belief that art and culture are the realms where humanity finds freedom, justice and equality.

Before you are allowed into the American Cultural Center in Damascus, before you can grab a seat to listen to Richard Peña, the director of the New York Film Festival who has traveled all the way to Damascus to deliver a lecture, you have to pass through the metal-detector at the gate of the building and endure a security search. In a single stroke, all the curses against imperialism dormant in the back of your head, awaken suddenly and growl. In one fell swoop, you find yourself emboldened anew in solidarity with Che Guevara, the massacred victims of Maï Laï (the Vietnamese village) and slain Iraqi singer Nazem al-Ghazali.

Richard Peña, or Richard the First as we re-christened him that day, began with boasting his Spanish and Latin extraction, but he made an observation on Syrian cinema that struck us all. He postulated that the common denominator to all Syrian films, regardless of artistic accomplishment, was their independence and individualism, and the absence of opportunism. In the whole lot of Syrian films, he could not find a single propaganda film. This, he added, was a unique virtue.

"Not a single film, Mr. Richard?" you find yourself asking.

"No," he replies to you in English.

That Richardian assertion led me to reflect on the conversation that binds us all, we Syrian filmmakers, that lonely monologue I deplored earlier. How could we have missed seeing that common denominator? My perception of our collectivity until then was that we were generally divided in two camps. The camp that despises a colleague's film because it does not fulfill the standard of what is considered to be art, and the camp that does not care and dispatches film and filmmaker to hell. In reality, and for the sake of precision, we are divided into at least seventy camps, the camp of those of who tell the truth fearlessly versus the camp of the hypocrites, the camp of the honest versus the camp of the dishonest, the camp of those adept at grabbing opportunities, the camp of those who know how to bluff... We are indeed the cultural vanguard of our society, and its backwardness finds expression in our collectivity in many ways. We manipulate, philosophize, theorize, each single-handedly scheming in the pursuit of self-interest. And thus we divide and multiply to form seventy camps, seventy voices each singing its own tune.

Standing on the field of the final battle that defeated Spartacus, the Roman general asked the captured black slaves: "Which one of you is Spartacus?" The noble freedom fighter rose and said: "I am Spartacus." I remember weeping in the movie theater, compelled with his courage and nobility. But then, one after the other, the black slaves stood up and said: "I am Spartacus!" "I am Spartacus!" I wept more and more. They were all executed. Would you consider me a Spartacus, me the Syrian filmmaker (now also philosopher), if I were to make a confession? That everytime the National Film Organization prepares to consider a new (single) production, and each one of us knows it could be the one and only chance to make a film, I begin daydreaming the appropriate scenario for my colleague, whose name is on the same list and has been waiting for that one and only chance as eagerly as I, to perish in a noble yet untimely death. (The very same colleague I embraced just a moment ago, and who embraced me back.) Martyred after a savage air-raid shelling by the American-Israeli F-16 or F-17 planes (despite the fact that he had nothing to do with the Nazi crematorium or European anti-semitism)? Crushed under the brand new tires of a speeding luxury vehicle driven by the precious progeny of a *nouveau riche* patriarch (the very cast of *nouveaux riches* created by the veto on the UN Security Council resolution)? Of course I would be the first to deliver the compelling eulogy, a poem in classical sonnets. I would do more, I would dedicate that one and only film of my career to him. I am not the only protagonist in this real-life noir, and I am certainly not the most evil.

Sunduq al-Dunya (*Sacrifices*) by Oussama Mohammad, 2002.

This is why Richard the First's observation was striking. He did not see our opportunism. He saw us as honest filmmakers. Had we developed a singular strain of Machiavellianism, I wondered, were we sinister opportunists to whom the end justified all means, but the moment our hand grabs hold of the camera, we become honest and conscientious filmmakers? In truth, our circumstances are dire and the stakes are very high, because we don't apprehend opportunities as merely the occasion to make another film, but to articulate our subjective vision of the world, to speak and innovate our individual cinematic language. This hunger for expression is the key to unlocking the paradox that mystifies all those who stumble on the productions of our National Film Organization. We are fierce about speaking our minds, it is our right, our *raison d'être*.

Our right as filmmakers to innovate and explore, to craft our art according to our vision, to reconfigure our society and national aspirations according to our own pulse and sensibility, is what animates our cinema. We understand the very personal to be very humanist, and to be the other face that coins the very patriotic, and very universal. This is the confession in its totality, it is what has allowed Syrian cinema to cast the national anthem in the most forbidden, impenetrable and unsuspected places, to the surprise of all.

It is premature to distill attributes of an identity to Syrian cinema, in the way Italian, French or American cinema have carved identities for themselves. The identity of Syrian cinema is yet in its embryonic stages, growing slowly, alone, at the rate of one film per year. The common feature thus far palpable, is the motivation of its filmmakers for a tireless search, in the self, the social, the political, the aesthetic. That search has been its salvation from mediocrity, from aping other cinemas and pandering to a calling lesser than art. The National Film Organization is unfortunately the only haven for making films that

meet the ambitions of cinema as art. It would be a mistake to regard it as the contingency itself, rather, it is the result of the overarching contingency that shapes the fate of our country. It is not right that it should hold monopoly over film production, but this is the reality today. And today too, it seems worn out from exhaustion, like a tire churning to come unstuck from mud, or a film reel beaming into emptiness: at once tangible and ephemeral, not unlike mercy.

The National Film Organization is the progeniture of our regime, its cadres are the sons of our state, and so are we, the filmmakers, sons of this nation. In the circus showcase of life we chose the tightrope, despite the dangers, because we wanted to make sure the rope would be stretched, that thin rope hinging between reality and imagination, freedom of expression and artistic creation.

Our cinema is free, but its freedom is like a whisper in a closed room. We too are free, but locked in an enclosure, the historic contingency that weighs over our sky. It is as if we sneaked into that closed room from the keyhole, and we grew inside it. In its turn, it sneaked inside us and grew. And we are stuck in this locked embrace.

On the outside of that enclosed room, the invitation to jump ship and join television production lurks with insistence. It is like the call to surrender and negotiate a truce: "Come to television, your voice will be heard, instead of your metaphors and allegories and that art, you will be seen, you will have a presence, you will make a difference."

The city of Homs, which grew irritated with its football team's lot of continuous defeats against its arch-rival team from the city of Hama, tells a popular Syrian joke. The residents of the city raised millions of pounds to sign the star player, Maradona. The Homs team was defeated once again, this time, by the humiliating score of 10 to 0. "What about Maradona?" someone asked. "The coach kept him on the sidelines" came the answer. And one morning, Pushkin, the Russian poet, went to meet his fate at a duel. Revolver to revolver, not poetry against Tomahawk. But poetry was still in the man's heart. And coffee is coffee, not tea.

Epilogue

I will conclude with an anecdote, also popular in Syria. In a world competition amongst cats in the world, the expert-trained American cat was defeating every cat he fought with. The last confrontation had him duel the Somali cat. To everyone's surprise, the Somali defeated the American. There was much alarm in America. The White House issued orders to increase training of their contender and a second match was called. The American cat was defeated a second time. After much consternation,

president Clinton invited the Somali cat for a closed-door meeting. "How were you able to defeat the cleverest, smartest and best-trained cat in the world?" he asked. "Look at me, Mr. President" said the Somali cat, "look deep into my eyes. I am not a cat, I have never been one. I am a tiger, but hunger and poverty made me look like this."

The text was presented by Oussama Mohammad at a conference organized by Georgetown University in 1999.

Notes

1 Since that year, Oussama Mohammad has directed a film titled *Sunduq al-Dunya* (*Sacrifices*), released in 2002.
2 The reference is to the US-enforced veto on the implementation of UN Security Council resolution 242 that demands the Israeli state to pull out of the occupied Syrian territories in the Golan Heights.

MOTHER'S MILK

For nine months I was initiated into life's alphabet, from my father's A, to my mother's B, C and up to her Z, in her womb, and then I came out to life. It was a stormy night… Rain, snow and wind. Excruciating pain heralded my coming into this world… Intense hemorrhaging, as well. Before my arrival, three hours minus five minutes passed into the beginning of the year known as 1954. This is how my mother tells the story… And my identity card corroborates it. I came out to share in people's celebrations for the New Year, but they had succumbed to sleep. Meanwhile I shrieked and shrieked, protesting the departure from the warmth of my mother's womb into the cold of life. My shrieking would not stop. The pain and suffering of my mother made her scream: "Throw him… Throw him to the street. For nine months he would not stop kicking in my belly and now he is killing me with his howling. Please throw him."

I was hurt. Yes hurt… I stopped crying and stared into her eyes with reproach.

Behind the window, snow fell. Warm milk started to drip from my mother's bosom…her breasts were heavy… She tried to feed me; I turned away, still upset with her…

Su'ud al-Matar (Rise of Rain) by Abdellatif Abdul-Hamid, 1995.

© National Film Organization.

She put me on her other tit, and I reject it... I did not nurse... She tried many times, all in vain... I hated milk... Or maybe I was born hating it... Until the very moment I write these lines, I still hate it. I was nursed on creamed wheat and oat, anise, water and sugar.

I did not feed from my mother's milk, and lost my chance to suckle at her breast and hear her heart beat... And as I grew up removed from the warmth of her embrace, there came a distance where cold crept in. Where pain settled...ambivalence. A distance where the answer to the long enduring riddle lay: did she love me?

My mother was intransigent and obstinate to the point that my eyes widened to become magnifying glasses always searching for signs of tenderness in her eyes, in her soul. I strained to catch a glimpse of the longing inside me in her own interior. I used all kinds of magnifying lenses to delve deeply into her gaze and decipher what lay in her soul... To release the stubborn riddle: did she love me, or not?

One day, my mother fell ill. I was working on the preparations for my first film, *Layali Ibn Awah*, when my sister informed me that our mother had lapsed into a deep coma a few days earlier. She said only her heart was beating. I went to bid farewell to my mother-the riddle. She lay in bed in the hospital.

My sister greeted me: "Hello Abdellatif."

My sister barely finished articulating my name when my mother opened her eyes, inside them a joy unequalled. With a smile I had never on her face ever before, she asked: "Where is he?"

I came near her and looked into her eyes. They showed a love thirty-five years thick, released all at once. Then her eyes closed forever. It was as if she were telling me: "Learn filmmaker... Learn how to lock years of deeply buried love in a single instant."

ENTRIES FROM THE DIARY OF A FILM SCRIPT

Confessions to feed the conception of a film
Syrian cinema has delivered me two contradictory realms.
Syrian cinema has delivered me (in)to two contradictory realms.
The first is an open realm, charged with courage and freedom, creativity and imagination, defiance and provocation…
In that realm, I am awakened, enthusiastic, emboldened and desiring.
The second is a closed realm, encumbered with fear and ambivalence, echo and emptiness, confinement and absence.
In that realm, I am flat, wilted, lost… I don't feel myself, I no longer exist…
That realm fills my soul today.
That realm gnaws at me today.
For years, long years, I was convinced that to come alive from within artistic expression, one had to have lived…
To create, you have to have been created…
To unveil a life, a childhood, a memory, a self… they had to have their anchors first in reality.
For years, long years, I was convinced that my Self had yet to be born,
that I had never had a childhood, that my memory was weightless… that I had nothing proper to myself, nothing of my own to express. I did not have interiors.
I had no guts.
The political chapter of my life accompanied my delusive waltzing in illusion, to the music of ravishing harmony…
Struggle with and for others, devotion, the plurality, the party, the group, the troupe… effacement in the face of another, the struggle against the Self, confronting desires of one's own, wishes of one's own, bury the buds of dangers bridging to the Ego.

I have no recollection, not of a sentence, nor of a situation that could explain how I was educated, and how I came to be how I am, and how I have always believed things were, and par excellence, the human being:
who gives way for others to go before him.
Others to be born before him.

Others to express themselves before him.

And everything is done before him… This is the human being par excellence, who exists always behind, at the far end…

I am that.

With great pride, satisfaction and daring, I was this human being par excellence…but I was not.

From Damascus to Paris

In April of 1981, we arrived in Paris… I don't know why, I had no project in my head. Once again, I turned my back on everything, my city, my neighborhood, my family, my comrades, my studies, and landed in Paris, innocent, eyes wide, pockets almost empty, a heart blinded with love and a spirit so light, so white…

My past tucked behind me, I had no future, I did not ponder tomorrow, I homed in on today, as if I were gliding in a boundless space; my only reference, my only reassurance, Youssef's hand that held my own and let me glide, drag behind him…

I remember the weightlessness that love breathed into my being. It transformed the constitution of my body into a warm breath, almost nothing… Youssef held my hand, and I circled in his orbit, without weight, without a center of gravity… my sole path, my sole movement drawn by his hand that held my own.

Very quickly, Youssef needed both his hands to live, to work, to build his present and his future…

My hand was released, and I, without weight, without space for gravity, found myself in the void, disorbited, without references, without bearings, without recollections, I was gliding in the emptiness, in the nothing, in nothingness…

I drew near axes and centers, touched places, locations, but I drifted far… I was unable to settle, anchor myself in a place, make a place of my own, fabricate a project of my own.

I don't throw anything away

Interrogation marks replace the fluid in my brain and cranium.

Now, I grab my right hand, uncap the pen, and force it to write.

This time, I know it, I feel it, these words will escort my film, my beloved film.

What an adventure, what a bizarre procedure, what an eerie process.

I don't throw anything away.

I sift through my thoughts looking for my film, papers, places, discussions, encounters, discoveries, revelations, my dreams and my illusions.

I don't throw anything away.

I probe deep in my guts, in the wrinkles of my brain, to find it, my film... my film is there, I don't have to construct it: I retrieve it.

For my female friends, who like me, will turn fifty in a short while.

For my own fifty years... I decide to make myself a gift of this film.

I am afraid to look behind me.

I am afraid to look into my "yesterday."

This is the reason I resist writing my past, my life, my present.

I hide behind the artistic argument to avoid contact with this dossier, defending the idea, that... I don't know, that what...

I need you... my beloved film

It is 3:00 pm, in one hour, I have a meeting with Jacques to deliver these pages (deliver myself)... these pages I have just drafted...

Half an hour ago, I was in the garden next door, writing. I finished, headed home, just to be home right before my meeting, a very old obsession, to return home as soon as I can, to do nothing.

What energy, what appetite for life, I feel at this instant...

This morning everything was grey, insipid, brooding, my mouth felt dry, my stomach parched and my throat tight, I was drained... I felt my head reverberating like a hollow aluminum box... And here after writing these few pages, without checking them, without reading and without knowing if they have any value or not, only the effect of writing, of trying to exhort some words from my guts... was enough to charge me with renewed energy and renewed strength.

Time

I wanted to toss the table of time, avenge the time lost, resuscitate it, fish it out.

In January 1986, I began to write projects to make my own films, and the moment never came to be, I never came to meet it.

Today, I decided to recreate the time that slipped from my diary over the span of twenty years without leaving traces.

Return to Zero

It's the return to zero, I am blocked, totally, this rupture has dried me up… my draught is back.

I know it only requires a little effort, perhaps a lot, to rekindle contact with my interior, with this timid yearning to exist…

I do it. Maybe, I am a little lost, I lost the thread, I am searching…

The technical question, maybe that's what is blocking me… What do I want to do, a documentary? I don't think so… fiction? Not really… a personal narrative…a personal diary? No…

Time (bis)

Today I am thinking the principal element in this text is time.

Time is the axis that leads to the exit, to deliverance.

That axis boring through the earthen layers of my soul to forge an unhindered passage for the images to be released.

That axis boring to enable the transformation of my dark reflections into a rainbow…

Why time? I want to put it to work, exhaust it, overburden it, burden its head and its back… And to draw wrinkles on its forehead… to make it suffer.

Yes, to make time suffer when it is caught with its own time, when it will be infected by the obsession with time.

Why do I treat it like an enemy? Rather, it's the adversary that has worn me down, and it is time to turn the page…

Dare

To write in French, that is the first temptation, it has been luring me for two weeks. A challenge for me, with nonetheless, a most agreeable tinge.

Today, specifically, it bears a "double effect."

To evoke recollections, a privilege I have rarely indulged. Since I have landed in the world of "cinema" to work, I tell myself: you are a woman without memories, without childhood, without past.

Nothing is inscribed in the folds of my brain!

Today I have the "pleasure" (I mean it) to say:

Nothing is to be decoded in my wrinkles, not yet.

Nothing is to be deciphered, not yet.

In French, I will read the lines of my wrinkles... Here, now, I understand at this instant where the "double effect" cited above comes from:

I am taking the risk of treading in an unlit zone, in the absolute fog, with a tool I do not master, that is not intimate to me... the French language.

Is the verb "to dare" more powerful in French or Arabic?

The Icons

I want to use the idea of the restoration of icons to structure the film.

I want to maintain the link between the blackness of the icon and the present blackness of my own image.

As the film folds, the cleaning of an icon progresses. We discover images from films that have never come to life, and we discover faces and layers of an icon shrouded under the grime of time and dust of place.

How to Resemble a Poetess

As I excavate the profound conviction of my kinship with the poetess Da'ed Haddad, I shall disregard for a moment, my attachment to her poetry. The explanation lies elsewhere. It dwells in the terrain of simple feelings, naïve, original, primary. On that terrain we ought to have met.

Perhaps she was more fragile than I, perhaps less attached to life than I am. We both share, I think, the same reference of pain, borne from the infinite and burdensome search for love and tenderness.

We are both made of the same patina of madness, I think. This patina forged Da'ed into a marvelous poetess, and forged me into nothing.

Me, I am able to control the madness, I buried it deep within.

In the Beginning Was the Verb

These texts, these words, will hold the film (my baby) by the hand and move it, move forward towards life… towards the sea to baptize it.

Da'ed Haddad, the Syrian poetess, who abandoned life too early…(her short life was no more than a quest for love and poetry), her poetry will never abandon me, she will be the poetic guide of my film.

At several moments in the film, her verse will be recited by an actress, before she disappears into the sea.

The testimony of three women, three of my women friends, of my generation, will recount a dream unfulfilled.

They are nearing their fifties, like me. In effect, the number does not scare us, all four of us, but it summons an occasion to bring out the ledgers.

Words in my papers, all I have written around this project when I plumbed the depths of my soul.

Letters from prison I exchanged with Youssef, my beloved at the time, during both our sojourns in jail.

Exchanges with people to orient myself to places and characters of my films…

The path that leads to my path

I set out on my quest, I am searching.

I grab my small camera, I film my friends
I grab my small camera, I film my path
I grab my small camera, I film the people who inspired me

My friends facing me
My path guides my steps
People orient my thoughts

My friends, we: four women
We are not yet fifty, but the moment is nearing
We, and each on her own, will say that an accomplished life does not mean accomplishing one's dream.

My path: my steps are guided by the path
My steps guide me toward the path
The trek draws the face of my film
The trek ends in the locations of my fifteen suspended films
The path composes my scouting for locations
The locations I film to tell the meanders of my life
The locations I film to find my favorite sequences

People: my thoughts oriented toward the films I did not direct
People orient me toward places from where I should embark
People orient me toward persons I should meet
People orient me toward light under which I ought to give birth.

But the Photo Is Still Here
The coup d'état by Hafiz el-Assad in 1970, forced the president of the Republic, Nour-Eddin Atassi into jail for twenty-two years.
Two months after his release into freedom, he left life definitively.

Sequence from a Film that Has Not Been Realized
The three members of the Atassi family, the wife, the son, the daughter, recount one story, the same story…
All three have their backs turned to the camera, a portrait of the president hangs high on the wall… We are in the home of the president.
One after the other, the mother, the son and then the daughter recount for us, each in their way, their version, how they obtained permission for the first visit to papa in jail, after two years and half of waiting. And how the daughter, who was merely months old when her papa was taken to jail went, those few years later, with her mama and brother to visit the president in jail, and there, when mama saw papa, the jailed president, she announced to her children: "there, look at your papa", and the daughter looked all around the bare walls where nothing hung: "I can't see him mama, where is the photo"…
The mother turns, we see her profile. She discloses the meaning of waiting, the meaning of

absence. Her son follows suit, in profile, the daughter as well. All three say the same thing. At that moment, the framed portrait hanging on the wall becomes a screen where black and white photographs of the president unravel. He stares at the camera.

When the mother has spoken the last sentence, she turns completely toward us and does not say a word. Same with the son, and then the daughter, and all three now face us in full frontal stare into the camera, silent. The screen/frame shows colored photographs of the president right before his death.

All three listen with us to the announcement of President Atassi's death. They don't move; they continue staring into the camera, straight into our eyes.

The photograph in the frame changes color, fading more and more to white until whiteness covers it entirely. The eyes of the three personages resist and they remain colored until the end.

BIOGRAPHIES

EDITOR

Rasha Salti is an independent curator and freelance writer, working and living between New York and Beirut. Trained as a printmaker, she earned a master's degree in Liberal Studies from the Graduate Faculty at the New School for Social Research. She has participated in the organization and administration of a number of cultural events, including "For a Critical Culture," a tribute to Edward Said (Beirut, 1997), and a three month-long cultural season for the fiftieth commemoration of the tragedy of Palestine, titled "50, Nakba and Resistance" (Beirut, 1998). She is also director of the CinemaEast Film Festival in New York City, a celebration of cinema from the Middle East, North Africa and their diasporas organized by ArteEast, a non-profit arts organization based in the city. She writes about artistic practice in the Arab world, film, and general social and political commentary.

CONTRIBUTORS

Livia Alexander is executive director of ArteEast, a non-profit organization promoting the arts and cultures of the Middle East in the United States in an effort to foster more complex understandings of the region and encourage artistic excellence. She has curated and consulted on numerous film festivals. She has a PhD in Middle East Studies from New York University, where she completed her dissertation on Israeli and Palestinian cinemas between the two Intifadas.

Cécile Boëx is a doctoral candidate at Paul Cézanne University (Aix Marseille III) and is currently a fellow at the Institut Français au Proche Orient (IFPO/IFEAD), in Damascus. She is writing her dissertation on representations of the political in Syrian cinema.

University professor and journalist **Tahar Chikhaoui** is one of Tunisia's most renowned film critics. He publishes regularly in the francophone Tunisian daily, *Le Temps*, and the periodical, *Cinécrits*. He co-authored *Le cinéma tunisien de l'après-indépendence* with Kmar Kchir-Bendana in 1993.

Hamid Dabashi is the Hagop Kevorkian Professor of Iranian Studies and Comparative Literature at Columbia University, where he teaches world cinema, comparative literature, and the social and intellectual history of Iran, Western Asia ("the Middle East") and North Africa. He has been the Chair of the Department of Middle East and Asian Languages and Cultures (MEALAC), the Associate Director of the Center for Comparative Literature and Society (CCLS). He has authored and edited several books including: *Iran: A People Interrupted* (New York: New Press, 2006); *Masters and Masterpieces of Iranian Cinema* (Washington DC: Mage, 2006); *Once a Rebel, Always a Filmmaker: The Film and Fiction of Mohsen Makhmalbaf*, (London: I.B. Tauris, Forthcoming); *Dreams of a Nation: On Palestinian Cinema*, (New York: Verso, 2006); *Theology of Discontent: The Ideological Foundations of the Islamic Revolution in Iran* (New York: New York University Press, 1993); *Close up: Iranian Cinema, Past, Present, Future* (London and New York: Verso, 2001).

Born in 1975, **Oussama Ghanam** completed his doctoral degree at the Université Paris VIII (Saint-Denis) on the work of Michel Vinaver. His graduate work focused on Edward Bond, Syrian playwright Sa'adallah Wannus, Peter Brook and Antoine Vitez. He is a professor of modern and contemporary theater at the High Institute for the Dramatic Arts at the University of Damascus, and is a critic who has published in a number of Arab dailies and periodicals including, *al-Nahar* (Beirut), *al-Quds al-Arabi* (London) and *Jaridat al-Funun*. He published a novel in the spring of 2003.

Richard Peña has been the Program Director of the Film Society of Lincoln Center and the Director of the New York Film Festival since 1988. At the Film Society, Peña has organized retrospectives of Michelangelo Antonioni, Sacha Guitry, Abbas Kiarostami, Robert Aldrich, Wojciech Has, Youssef Chahine, Yasujiro Ozu, and Amitabh Bachchan, as well as major film series devoted to African, Taiwanese, Polish, Hungarian, Arab, Cuban and Argentine cinema. Since 1996 he has organized, together with Unifrance Film, the annual "Rendez-Vous with French Cinema Today" program. He is an associate professor of Film at Columbia University, where he specializes in film theory and international cinema. In the spring of 2006, he was a visiting professor at Princeton.

Mohammad Soueid began his career writing on cinema for the Lebanese daily *al-Safir* prior to joining the editorial team at the cultural supplement of *Mulhaq al-Nahar*, the *al-Nahar* daily's weekly cultural supplement. He has published numerous books on Lebanese cinema and its collective memory during the war. An accomplished filmmaker, his bold

experimental style has made a distinctive mark on the work of emerging generations. He is also a novelist. His most recent novel *Cabaret Su'ad* was published by Dar el-Adab (Beirut) in 2003.

Lawrence Wright is the author of seven books, including most recently, *The Looming Tower: Al-Qaeda and The Road to 9/11* (Knopf 2006). He is also a screenwriter. His films include *The Siege* (starring Denzel Washington and Annette Bening, 1999), and *Noriega: God's Favorite,* starring Bob Hoskins. He has been a staff writer for *The New Yorker* magazine since 1992.

FILMMAKERS' BIOGRAPHIES

Abdullatif Abdul-Hamid

Born in Lattakia, in 1954, Abdellatif Abdul-Hamid worked as an actor, musician and singer in the theaters of his hometown prior to pursuing studies in film directing. Two years after enrolling in the University of Lattakia to study Arabic literature, he earned a scholarship to study at the Russian State Institute of Cinematography (VGIK), where he graduated in 1981.

He has directed two short documentaries for the National Film Organization in Syria, *Umniyat* (*Wishes*, 1983) and *Aydina* (*Our Hands*, 1982). He worked as an assistant director to Mohammad Malas on *Ahlam al-Madina* (*Dreams of the City*, 1983). He also played the lead role in Oussama Mohammad's *Nujum al-Nahar*, (*Stars in Broad Daylight*, 1988). Among Syrian filmmakers his work has garnered the widest popular appeal in Syria and the Arab world. His filmography includes, *Layali Ibn Awah* (*Nights of the Jackals*, 1989), *Rassa'el Shafahiyyah* (*Verbal Letters*, 1991), *Su'ud el-Matar* (*Rise of Rain*, 1995), *Qamaran wa Zaytouna* (*Two Moons and an Olive*, 1998), *Nassim el-Ruh* (*Soul Breeze*, 2001), *Ma Yatlubuhu al-Musstami'un* (*At Our Listeners' Request*, 2003). He has just completed his seventh fiction feature, due for release in 2006. He has authored the scripts of all his films, as well as the script for a television serial entitled *Usbu'an wa Khamsat Shuhur* (*Two Weeks and Five Months*, 1985).

His films have earned numerous awards in the Arab world, beginning with the Damascus Film Festival, the Journées Cinématographiques de Carthage (Tunisia), and Rabat International Film Festival (Morocco). They have also received critical acclaim worldwide: *Verbal Letters* received the Golden Olive at the Valencia Mediterranean Film Festival in 1992 and *At Our Listeners' Request* received the Special Acknowledgement at the Asiatica Film Mediale in Italy in 2003 "for the lyricism with which he was capable of describing the tricks of fortune and the reality of war."

Omar Amiralay

Born in Damascus in 1944 to the son of a high-ranking officer in the Ottoman military and a Lebanese mother, Omar Amiralay headed to Paris in 1965 to pursue studies in drama and theater at the Théâtre des Nations. Gradually he began to lean towards cinema and enrolled at the Institut des Hautes Etudes Cinématographiques, or IDHEC (now known as FEMIS) in 1967. He was deeply suspicious of fiction cinema, and after a year at the institute he began to question whether film was really his vocation. When the 1968 student revolt erupted, Amiralay joined the hordes of protestors, and began to film. His fate was sealed; he never returned to the IDHEC and instead began to make documentary films.

He returned to Damascus eager to instigate a new documentary cinema. His first film, *Film-Muhawalah 'An Sadd al-Furat* (*Film-Essay on the Euphrates Dam*, 1970) was an enthusiastic documentation of the Ba'thist regime's construction of the Assad dam on the Euphrates river that promised to bring radical improvement to surrounding villages. His second documentary film, conceived with Sa'adallah Wannus, one of Syria's most celebrated modernist playwrights and essayists, was radically different. Titled *al-Hayat al-Yaomiyyah fi Qarya Suriyya* (*Everyday Life in a Syrian Village*, 1974) it was a scathing critique of the government's failure to provide basic amenities to the poor. The film, produced by the National Film Organization, was banned and remains so to this day. His third film, *al-Dajaj* (*The Chickens*, 1977), was produced for Syrian television and continued in the same critical vein, this time documenting the plight of poor peasants suffering as a result of failed ventures in chicken farming promised by the state to bring prosperity.

Amiralay's new approach to documentary filmmaking gradually became recognized in the Arab world and Europe. He was commissioned to direct a documentary on the socialist revolution in *Yemen 'An Thawra* (*About a Revolution*, 1978), and the civil war in Lebanon *Masa 'ibu Qawm 'Inda Qawm Fouad* (*The Misfortunes of Some Are the Fortunes of Others*, 1982). The latter remains one of the most compelling documentary films about that war. A number of films followed, most commissioned by television channels in France, including: *Ra'ihat al-Janna* (*A Scent of Paradise*, 1982) on Palestinian refugees during the Israeli siege of Beirut; *al-Hubb al-Maow'ud* (*The Sarcophagus of Love*, 1984) on contemporary social conditions of women in Egypt; *al-'Aduu al-Hamim or L'Enemi intime* (*The Intimate Enemy*, 1985) on the rise of radical Islamic fundamentalism amongst immigrants of Arab origin in France; *A l'attention de Madame le Premier Ministre Bénazir Bhutto* (*For the Attention of Madame the Prime Minister Benazir Bhutto*, 1989-1994) on the expectations carried by Benazir Bhutto's appointment as prime minister; *Par un jour*

de violence ordinaire, mon ami Michel Seurat, (*On a Day of Ordinary Violence, my Friend Michel Seurat,* 1996), a tribute to the French sociologist, Michel Seurat, kidnapped and slain by Al-Jihad al-Islami in Lebanon; *Hunalika Ashiya' Kathira Kana Yumken an Yatahadath 'Anha al-Mare'* (*There Are So Many Things Still to Say...,* 1997), the last testimony from Sa'adallah Wannus recorded a few months before his passing; *Tabaq al-Sardin* (*A Plate of Sardines — Or The First Time I Heard of Israel,* 1997), a reflection and conversation with filmmaker Mohammad Malas on the subjective recording of the conflict with Israel; *Rajol al-Hitha' al-Thahabi* (*The Man with the Golden Soles,* 2000), a documentary on slain Lebanese Prime Minister Rafiq Hariri; and finally, *Tufan Fi Bilad el-Ba'th* (*A Flood in Baath Country,* 2003), in which the filmmaker returns to the Assad dam on the Euphrates river, filmed in his first documentary to interview the enforcers of the Ba'th regime's dogma, a school master and a parliamentary representative. The film caused uproar and controversy because it presents a damning portrait of the ideological bankruptcy of the Ba'th, and of the regime's annihilation of the basic precepts of citizenship.

Omar Amiralay has been a close friend and collaborator with fellow Syrian filmmakers, including Mohammad Malas and Oussama Mohammad, with whom he co-authored two documentaries on the pioneer of cinema in Syria, Nazih Shahbandar, and the pioneer modernist visual artist and writer, Fateh el-Moudares.

Currently, he is a driving force in the establishment of the Arab Film Institute, a novel venture in the Arab world to establish a an institute for teaching cinema, that involves a number of independent collectives of filmmakers in the region as well as the Danish Film School in Copenhagen.

From very early on, Amiralay's films earned a number of awards worldwide, beginning with Leipzig (1971) for *Film-Essay on the Euphrates Dam.* His cinema has become canon for generations of documentary filmmakers in the Arab world. The most recent edition of the Cinéma du Réel festival at Paris' Centre Pompidou dedicated an hommage to his work in March 2006.

Mohammad Malas

Born in the now destroyed village of Quneytra (in the Israeli-occupied Golan), in 1945, Mohammad Malas first earned a teaching diploma and worked in Damascus for three years as a teacher while enrolled in the Philosophy department at the University of Damascus. In 1968 he earned a scholarship to study film directing at the Russian State Institute of Cinematography (VGIK). He directed three short films while there, *Hulm*

Madinah Saghira (*The Dream of a Small City,* 1972), *The Seventh Day* (*Al-Yaom as-Sabe'eh,* 1973), and *Kullon Fi Makanihi Wa Koll Shay' 'Ala Ma Yuram Sayyed al-Dhabit* (*Everybody is in his Place and Everything is under Control, Sir Officer,* 1974). The latter was his graduation project, exploring the experience of prison in Egypt, in which he collaborated with renowned Egyptian novelist, Sun'allah Ibrahim, who also starred in the film. He returned to Damascus in 1974 to work for the Syrian Television, where he produced short films like *al-Quneitra '74* (1974) and *al-Zhakira* (*The Memory,* 1977). He co-authored the script of his first fiction feature, *Ahlam al-Madina* (*Dreams of the City,* 1983) with Samir Zikra. His second fiction feature, *al-Leyl* (*The Night,* 1992) was co-authored with Oussama Mohammad. In between, he directed a number of documentary films, beginning with *al-Manam* (*The Dream,* 1982), shot in the Shatila Palestinian refugee camp in Beirut, only a few months before the massacre. He co-directed with Omar Amiralay and Oussama Mohammad two documentaries, *Nouron wa Thilal* (*Light and Shadows, the Last of the Pioneers: Nazih Shahbandar,* 1995), a portrait of Syrian cinema pioneer Nazih Shahbandar on the occasion of the Centennial of Cinema in 1995; and *Moudaress,* a portrait of the veteran modern artist, Fateh Moudaress, in 1996. In 1998, he shared scriptwriting and direction duties with Hala al Abdalla Yakoub, on a documentary on political prisoners in Syria, *Tahta al-Raml, Fawqa al-Shams* (*On the Sand, Under the Sun*) on the occasion of the fiftieth anniversary of the United Nations Universal Declaration of Human Rights. His most recent film is a fiction feature, *Bab el-Maqam* (*Passion,* 2005). He has published articles and essays widely, and wrote a novel, *I'lanat 'An Madina Kanat Tai'sh Tahta al-Harb* (*Advertisements about a City that Lived in the War,* Beirut: Dar Ibn Rushd, 1979 and Damascus: Dar al-Ahali, 1990). He has also published a number of screenplays and film diaries including: *Al Manam; Moufakarat film* (*The Dream; a Film Diary,* Beirut: Dar al-Adab, 1990), *The Night* (Damascus: Dar Kanaan, 2003), and the film diary for *Everybody is in his Place and Everything Is under Control, Sir Officer* (Beirut: Dar al-Mada, 2003).

Malas has received numerous awards in the Arab world and around the world. *Dreams of the City* earned eleven awards including the Golden Tanit at the Journées Cinématographiques de Carthage, Tunisia (1984), The Golden Olive at the Valencia Festival of Mediterranean Cinema in Spain (1984). *The Night* earned five awards, including the Golden Tanit in Carthage (1992) and the Silver Olive at Valencia.

Nabil Maleh

A staunchly Damascene native, Nabil Maleh is a filmmaker, poet and painter. He is a pioneer in contemporary Syrian cinema in many respects. First to leave the country to study cinema at the film institute in Prague, Czechoslovakia in the early 1960s, he paved the way for a new cinematographic language and was the first to clash with the National Film Organization, the sole producer in the country.

Maleh graduated in 1964 and returned to Damascus, a year after the establishment of the National Film Organization, emboldened to forge a new cinema in Syria. He also worked for Syrian television where directed three long features, *al-Mufaja'a* (*The Surprise*, 1964), *Ahlam* (*Dreams*, 1965) and *Rajolan wa Imra'* (*Two Men and a Woman*, 1965). At the National Film Organization, he directed a number of short films, documentary and fiction, including, *Ikleel al-Shawk* (*Wreath of Thorns*, 1969), a powerful testament on the tragedy of Palestinians. Maleh was the first to make experimental films under the aegis of the National Film Organization. His 90 second film *Napalm* (1970), a political piece in response to the wars raging in Palestine, Vietnam and the world at that time, had a tremendous impact on audiences in Syria and worldwide. His second experimental film, titled *Sakhr* (*Rocks*, 1970), courageously documented the labor conditions of quarry workers.

Also in the spirit of mobilization for the Palestinian cause, in 1970, Maleh directed one of three chapters of a tryptic titled *Rijal Tahta al-Shams* (*Men Under the Sun*) in which he directed *al-Makhad* (*Parturition*) while Qays al-Zubeydi and Mohammad Shahin co-directed *al-Milad* (*The Birth*) and Marwan al-Mu'athen directed *al-Liqa'* (*The Encounter*). In 1972, inspired by a novel by renowned Syrian author Haydar Haydar, he wrote the script for his first full-length feature to be produced by the National Film Organization, *al-Fahd* (*The Leopard*, 1972). Filming was turbulent, but the film earned wide critical and popular success. Charged with suspense and drama, it gave a realistic account of spontaneous rebellions in the countryside common in the recent history of Syria. The hero of the film, a lone rebel who is willing to be martyred for the cause of redressing injustice, echoed loudly with the figure of the Palestinian combatant. It won the first prize at the Locarno Film Festival that year, the first production of the National Film Organization to receive recognition from a prestigious international festival. In 2005, *The Leopard* was selected by the Pusan International Film Festival to be included on the list of films of the Pantheon of Asian Cinema as one of the greatest masterpieces in Asian cinema history.

His next feature produced by the National Film Organization was titled *al-Sayyed al-Taqqadumi* (*The Progressive*, 1974), and the one following, co-scripted with colleague Samir Zikra, an adaptation of a novel by renowned Syrian auteur Hanna Mina, was titled *Baqaya Suwar* (*Fragments*, 1979).

185

In 1981, as tensions mounted in the politically turbulent confrontation between the state and the Muslim Brotherhood, Maleh took leave of Syria and spent time in the US, teaching in Texas and California, deciding later to settle in Geneva, Switzerland. A year and a half later, he packed up his life and drove to Greece, where spent a little less than a decade.

Early on in his career, Maleh established contacts with television stations and producers outside Syria. His list of achievements includes as many films, of varying lengths and genres, produced for the private sector as for Syrian television and the National Film Organization. During his time in Switzerland and Greece, he worked with Libyan, Saudi, and European entities directing documentaries, television serials and fiction features.

He wrote the script for his most acclaimed film to date, al-Comparss (The Extras, 1993) while in Greece and during a visit to Syria proposed it to the National Film Organization. The film took twenty five days of shooting and was finished just in time to premiere at the Damascus Film Festival. It played for three months in movie theaters in Damascus to wide popular appeal. The film earned Maleh a number of awards at the Cairo International Film Festival, the Biennial of Arab Cinemas at the Institut du Monde Arabe in Paris, and the Rimini International Film Festival in Italy.

For the past few years, Maleh has settled back in his native Damascus and has been working exclusively with producers in the private sector, largely from Europe. He has completed the first British-Syrian coproduction, a fiction feature titled The Hunt Feast (2004) that awaits distribution and release, and is currently working on a number of projects, the most ambitious of which is a dramatic television series based on the life of singing legend Asmahan.

Oussama Mohammad

Born in Lattakia in 1954, Oussama Mohammad graduated from the Russian State Institute of Cinematography (VGIK) in 1979. There, he directed a short documentary, titled Khutwa Khutwa (Step by Step, 1978). He returned to Syria and directed a short documentary for the National Film Organization titled Al-Yaom wa Koll Yaom (Today Everyday, 1980). He worked as assistant director to Mohammad Malas on Ahlam al-Madina (Dreams of the City, 1983) and directed his first fiction feature Nujum al-Nahar (Stars in Broad Daylight) in 1988. Deemed by many to be the most scathing critique of contemporary Syrian society trapped in the iron grip of the Ba'th regime, the film has never been allowed a public screening in Syria. Although not officially banned, the film has been shelved by diktat, and sits in storage under threat of irremediable physical deterioration.

The film was selected at the Cannes Film Festival's Quinzaine des Réalisateurs, and earned the filmmaker great critical praise, including the Golden Olive at the Valencia Festival in the same year.

In 1992, he co-authored the script for *al-Leyl* (*The Night*, 1992) with Mohammad Malas and co-directed with Omar Amiralay and Malas the documentaries *Shadows* and *Light* (1991) and *Fateh Moudaress* (1994). He was unable to make his second feature until 2002. *Sunduq al-Dunya* (*Sacrifices*, 2002) was meant as an hommage to Andreï Tarkovsky's *The Sacrifice*, the exiled Soviet master's last film, and was selected for the Cannes Film Festival's section Un Certain Regard in 2002. Complex and visually stunning, the film has confirmed its maker as one of the Soviet film school's graduates most individual and masterful filmmakers.

Hala al Abdalla Yakoub

Born in the city of Hama in 1956, Hala al Abdalla Yakoub graduated in 1978 from the University of Damascus with a degree in agricultural engineering. She earned another degree in anthropology at the Ecole des Hautes Etudes en Sciences Sociales, in Paris in 1984 and a degree in film studies from Université Paris VIII in 1989.

Yakoub is a deeply-felt presence behind some of Syrian cinema's most compelling cinematic œuvres. She has worked as a close and vital collaborator with Oussama Mohammad, Mohammad Malas and Omar Amiralay. Recently, she has been working with emerging Syrian filmmaker 'Ammar el-Beik on his first fiction feature.

Her career began working as assistant director to Oussama Mohammad for *Nujum al-Nahar* (*Stars in Broad Daylight*, 1988), and Mohammad Malas for *al-Leyl* (*The Night*, 1992). She co-authored and co-directed *Tahta al-Raml, Fawqa al-Shams* (*On the Sand, Under the Sun*) with Malas, a documentary on political prisoners in Syria. She was also co-author and producer of Amiralay's documentary on slain former Lebanese prime minister Rafiq Hariri, titled *Rajol al-Hitha' al-Thahabi* (*The Man with the Golden Soles*, 2000), and a documentary on Lebanese militant singer and composer Marcel Khalifé, titled *Les Défis de Marcel Khalifé* (*The Challenges of Marcel Khalifé*, 1998) directed by Pierre Dupouey. She was the executive producer and artistic collaborator with Oussama Mohammad on *Sunduq al-Duniya* (*Sacrifices*, 2002), with Frédéric Goupil on *Le Sourire d'Hassan* (*Hassan's Smile*, 2003) and with Brice Cauvin for *Du particulier au particulier* (*From the Particular to the Particular*, 2004).

She has been both executive producer and artistic partner on a long list of documentary films. As the general director of Ramad Films, a production company based in France, headed by Omar Amiralay, she has also been the executive producer of a good number of films he directed, including, *Fateh Moudaress* (1994) and *Nouron wa Thilal* (*Shadows and Light*, 1994), *On A Day of Ordinary Violence, My Friend Michel Seurat* (1995), *Plate of Sardines — Or The First Time I Heard about Israel,* (1997) and *There Many Things Still To Say...* (1997). To cite a few of her collaborations with French filmmakers, the list includes *Le taxi collectif de Damas* (*The Shared Taxis of Damascus,* 1996), *Yahya Khadi affichiste à Alep* (*Yahya Khaldi, Postermaker in Aleppo,* 1996) and *Le Chant des norias* (*The Song of Norias,* 1998) directed by Frédéric Goupil. And finally, her collaborations with Lebanese filmmakers include, *Femmes de Hezbollah* (*Women of Hezbollah,* 1999), *Rondpoint Chatila* (*Shatila Roundabout,* 2005) directed by Maher Abi Samra, and *L'Orient au petit feu* (*The Simmering East,* 1999) directed by Jacques Debs.

Currently she has just directed her own feature-length film, with 'Ammar el-Beyk, due for release late in the year 2006. Its provisional title is *Repérages de l'amour et de la mort.*

Samir Zikra

Born in Beirut in 1945 but raised in Aleppo, author, screenwriter and director, Samir Zikra graduated from the Russian State Institute of Cinematography (VGIK) in 1973. During his Muscovite studies, and between the years 1968 and 1973, he directed a number of short fiction films including, *al-Sakran Yanfi* (*The Drunk Denies*) based on a story by Negib Mahfouz, and *al-Matar Sabe'en* (Airport 70) adapted from a story by Arthur Hailey.

The 1973 war with Israel erupted while Zikra was doing his military service and he directed a number of documentary films on that experience between the years 1974 and 1976, including *Lan Nansa* (*We Will Not Forget*), *al-Shuhud* (*The Witnesses*), *al-Bahr Jabhatuna al-Gharbiyya* (*The Sea Our Western Front*). In 1977, he co-authored the script for *Baqaya Suwar* (*Fragments,* 1979) with Nabil Maleh (who directed the film), based on a novel by Syrian auteur, Hanna Mina. In 1980, he directed a documentary on the everyday struggles of women in contemporary Syrian society, titled *'Anha* (*On Her*). In 1981, he directed his first fiction feature, *Hadithat al-Nusf Metr* (*The Half-Meter Incident*), adapted from a novel by the same title by Sabri Moussa. The film is considered a watershed for a generation of new filmmakers in Syria, heralding the turn to auteur cinema while presenting an unapologetic social and political reading of Syrian society. The film received

wide critical acclaim within the region and internationally. It was selected at the Venice Film Festival (Italy), Berlinale (Germany), Journées Cinématographiques de Carthage (Tunisia) and Valencia Mediterranean Film Festival (Spain), where it earned the bronze Olive. In 1983, he co-authored the script for Mohammad Malas's first fiction feature, *Ahlam al-Madina* (*Dreams of the City*, 1983). In 1986, he directed his second fiction feature, *Waqae'h al-'Am al-Muqbel* (*Chronicles of the Coming Year*, 1985). It too traveled widely on the festival circuit earning awards and acclaim.

Zikra worked in television, until he returned to cinema to direct the historical epic, *Turab al-Ghuraba'* (*Land for a Stranger*), in 1998. The film, inspired by a novel of the same name by Faysal Khartash, recounted the life of one of the late Ottoman Levant's most influential thinkers, Abdel-Rahman al-Kawakibi. The film earned the first prize at the Cairo International Film Festival, in addition to other awards elsewhere in the region. Zikra has just released his most recent feature, *'Alaqat 'Aamah* (*Public Relations*, 2005).